Perceiving Artworks

Perceiving Artworks

Artworks

Edited by

John Fisher

Philosophical Monographs
Third Annual Series
Temple University Press, Philadelphia

Library of Congress Cataloging in Publication Data
Main entry under title:

Perceiving artworks.

 (Philosophical monographs)
 Includes bibliographical references and index.
 1. Visual perception. 2. Art—Psychology.
I. Fisher, John, 1922- II. Series: Philosophical
monographs (Philadelphia)
N7430.5.P47 701′.1′5 80-12186
ISBN 0-87722-164-2

Temple University Press, Philadelphia 19122
© 1980 by Temple University. All rights reserved
Published 1980
Printed in the United States of America

Contents

v

Acknowledgments

My special thanks go to Joseph Margolis, General Editor of this Series, who early on was convinced of the usefulness of such a volume and was supportive and encouraging throughout the preparations; to my departmental colleagues in aesthetics for their general interest and counsel; to the Faculty Senate and the administration of Temple University for a leave of absence, part of which was used in the editing of the book; to Grace Stuart for impeccable typing and manuscript preparation; to my wife Ruth for her constant and cheerful tolerance of dark moods that go with difficult deadlines; and to the authors, each of whom was persuaded of the value of the book, and in the midst of a busy academic life prepared a fresh, current essay especially for this collection. What more could an editor ask?

Contributors

Rudolf Arnheim is professor emeritus of psychology of art at Harvard University, at present visiting professor at the University of Michigan, Ann Arbor, and author of *Art and Visual Perception,* University of California Press, 1974.

Monroe C. Beardsley is professor of philosophy at Temple University and author of *Aesthetics: Problems in the Philosophy of Criticism*, Harcourt Brace, 1958.

John Fisher is professor of philosophy at Temple University and Editor of *The Journal of Aesthetics and Art Criticism.*

Margaret A. Hagen is associate professor of psychology at Boston University and editor of *The Perception of Pictures,* forthcoming, Academic Press.

John M. Kennedy is professor of psychology at Scarborough College, University of Toronto, and author of *A Psychology of Picture Perception*, San Francisco, 1974.

Peter K. Machamer is professor of the history and philosophy of science, University of Pittsburgh and co-editor with Robert Turnball of *Studies in Perception,* Ohio State University Press, 1978.

Joseph Margolis is professor of philosophy at Temple University and author of *Art and Philosophy*, Humanities Press, 1979.

Alan Tormey is professor of philosophy at the University of Maryland, Baltimore County and author of *The Concept of Expression: A Study in Philosophical Psychology and Aesthetics*, Princeton University Press, 1971.

Godfrey Vesey is professor of philosophy at The Open University and author of *Perception*, Anchor, 1971.

Marx Wartofsky is professor of philosophy at Boston University and author of *Models: Representations and the Scientific Understanding*, Reidel, 1979.

Nicholas Wolterstorff is professor of philosophy at Calvin College and author of *Works and Worlds of Art*, Oxford University Press, 1980.

Perceiving Artworks

JOHN FISHER

1 Introduction

Perception is a term which can, without violating conventions of grammar or commonly accepted usage, range over an incredibly large expanse of meanings. This is annoying enough to the tough-minded when limited to philosophical applications, which bear significantly on problems of epistemology. It is extensively compounded when applied to art and aesthetics. The problems are not totally distinct, however, and it is for this reason that one might expect contributions to the understanding of the issues of art and perception to come from theorists who have concerned themselves with problems of a philosophical nature, whether they be professional philosophers, psychologists, art historians, biologists, artists, or physiologists. In practice, however, the significant theoretical thinking on art and perception seems to come almost exclusively from psychologists and philosophers. The engagements of the other specialists in their own work has unfortunately deprived us of the benefit of major contributions from these sources. If one is surprised that this is true of physiologists, who have written a good deal about perception, it should be observed that physiologists, in the main, equate perception and sensation, and reduce both to a sequence of events beginning with a stimulated extroceptive organ and proceeding to impulses along nerve fibers through the neuronal network of the cerebral cortex. Indeed it was not until Thomas Reid in the eighteenth century that these distinctions were carefully drawn. Of course, the simple blurring of perception and sensation is often harmless, depending upon the kind of problem which the analysis of

3

perception is intended to solve. In the relationship between an observer and his art it is fatal to coherent understanding of what is going on. This is not, of course, to suggest that sensation and perception are in some way alien to each other, but only to insist that the answer to the problem of what is going on in the sensory process when one stands before a painting with open eyes and clear mind is not the same as the answer to the inquiry into what it means to perceive a work of art.

Nor is that question identical to the inquiry into the perceptual qualities of a work of art; whether there are such distinctive qualities, and what relationship they have to properties of ordinary objects. Nevertheless the possibility of some linkage between the problems must be maintained. Indeed it is, if not obvious, at least arguable, that the terms which designate the alleged aesthetic perceptual qualities of works of art describe observable features of the works. Thus the questions of what the activity of perceiving aesthetically is, and what properties that perceiving manifests, must be paired.

Of course it may be argued that the alleged special process is only ordinary perception colored by emotion, learned preferences, selected or unconscious aesthetic posturing, or other nonperceptual accouterments. A perceptual parallel to the quasi-mystical defense of a view of aesthetic experience shown by some of the followers of Clive Bell will not determine the acceptability of this conclusion. It won't do to say "Well, if you've never perceived anything aesthetically I wouldn't expect you to understand the uniqueness of aesthetic perception." Nor is it a wholly physiological question to be settled by empirical studies of the sensory process or the retina of the eye. On what grounds could one argue that the retina is modified differently when I look at a bronze sculpted by Arp as a chunk of bronze and when I look at it as an Arp bronze, i.e., a work of art, when the physiological data have been shown to be identical? If one identifies the perception of a work of art as such with ordinary perception one must turn not to the sensory process, the uniqueness of which has been repeatedly and justifiably discounted, but to the qualities of the artifact which are thereby revealed. There is nothing in aesthetic perception construed as the ordinary perception of ordinary qualities of certain objects to merit its being considered a unique perceptual experience. Do we perceive certain alleged aesthetic qualities in

objects in the same way that we perceive nonaesthetic qualities, or are we doing what Berkeley insisted we are doing when we say we see a red-hot iron bar; seeing the color and figure, and upon this information, imagining heat? The empiricists were united in insisting that the senses do not grasp anything that they do not perceive. The senses do not make inferences. Thus aesthetic perception, if it indeed be ordinary perception, must be ordinary perception *plus*; plus imagination, plus *schemata*, plus whatever.

But the term perception has a much broader range than sensation (although to use "perception" of a process independent of any direct sensation requires such a hefty pile of conditions and disclaimers to be piled on the linguistic rack reserved for excess baggage that we would do well to avoid it entirely). If we assume that the range includes some specific, qualitatively different mode called aesthetic perception then we have no choice but to explore the nature of the object of which it is the perception. If this consists of an ordinary object possessing ordinary qualities but perceived in a manner different from our perception of, let us say, redness or triangularity, then, because all aesthetic judgments and analyses will have to do with qualities indistinguishable in kind from basic primary and secondary qualities of any object, all aesthetic discourse will become descriptive; descriptive *plus*, to be sure, but nevertheless descriptive. But no one has ever adequately argued that aesthetic terms can be, without remainder, reduced to descriptive features of physical objects. On the other hand, if the object of aesthetic perception is a special quality of certain objects (aesthetic objects, works of art, whatever) then not only must we have the features of the unique aesthetic act, but the features of the unique aesthetic qualities firmly in hand. If there is a perceptual faculty sensitive to a delicately curved line as there is a sensory faculty responsive to the shape of a line, if there is a capability of perceiving warm reds and cool greens, elegant flourishes and dynamic configurations, then these must be features of the object, unless one commits himself to the view that the perception generates the aesthetic object, a view which could hardly be maintained unless one were also prepared to argue that ordinary perception generates the physical world. Thus the problem of perception in art is a problem about (actual, derivative, imaginary, etc.) processes and qualities, about persons and objects, about discourse and objects of

discourse, about sense and semiotics. No contemporary aesthetic theory can avoid the problem.

Until well into the twentieth century, aesthetics in the English speaking world—and indeed to a large extent wherever aesthetics was done—was not an activity in which this examination of the problem of perception prevailed. There were, of course, those like Burke and Hogarth who took seriously the puzzles about perceiving, and others who pursued experimentally the problems generated by the sensory process. Some psychologists did see the relevance of their experimental work to the relatively new subject of aesthetics, which, one should remember, was not a discipline of its own until the last century, in spite of the sometimes profound recorded insights of thinkers as far back as the Greeks. Fechner, Titchener, Münsterberg, Helmholtz, Wundt, Bullough all were pioneers in applying their psychological insights and laboratory findings to art, particularly to visual art. Yet if we compare these efforts with contemporary ones we find the distinction not one of refinement of technique or of method, but of basic theoretical orientation.

It was to the examination of beauty which the earlier investigators were dedicated. For Fechner this meant a turning against Hegel, for whom beauty was *Geist* shimmering through and illuminating the sense world, and a turning to the methods of the physical sciences, space-time relations, material and formal conditions, physical causes and physical effects, structure and quality. These were the regions of the border skirmishes which signalled an oncoming world-war against idealism. Was beauty to be discovered in the mind, or in the objective relationships of sensory elements or qualities? For the early investigator, the issue was already settled, and science, or as close to a science as one could get, was the worthy activity, not reflection on Spirit. What remained to be done was to develop the empirical techniques which would make aesthetics scientific. Thus the endless experiments on the Golden Section, associative factors in aesthetic experience, and the later developments in eye-movement studies, reaction time, color perception, motor aspects of the appreciation of art, and so on.

But theoretically this period was barren. It did nothing to weaken the impressive solid hold which later idealists like Croce and Collingwood had on aesthetic theory. These writers were not only con-

spicuous, but dominant in aesthetics until the time of World War II. Their dominance and their ability to survive the most vigorous attacks by the quantitative methodologies of the experimentalists was due to one thing: they were theoreticians. While the statistical conclusions of Fechner's sampling of ratio-preference with his ten white cardboard rectangles resulted in generalizations, and even some principles, they were not genuinely theoretical studies, and were extremely limited in the range of problems with which an aesthetic theory is obliged to be concerned. The idealists worked in aesthetic theory, the scientists in quantitative accounts, and for this reason the idealists prospered.

Even the empirically oriented aestheticians in America in the second quarter of this century, men like Dewey, Prall, Pepper, and Munro, were in many crucial respects closer to the idealists than they were to the experimentalists. Each located the interesting questions in aesthetics in experience, but none was content with simple inductive procedures. Each, while totally opposed to the theories of Croce and Collingwood, agreed that a theoretical account of experience was necessary.

At the same time a powerful empirical thrust in aesthetics was being generated in an unlikely place, the unfriendly lair of the positivists and the followers of the then recently discovered Wittgenstein, and those of Russell, most of whom were not knowledgeable in, and, for the most part, not strongly interested in the arts. What these foreigners did to aesthetics, not always knowingly, was to move aesthetic thinking toward a stance which took seriously the claim that whatever counts in aesthetics must be related to some form of sensory perception. Soon, partially because of these influences and partially for reasons quite independent of them, empirically crucial entities became central in aesthetic theory, and the problem of perception became a central focus for that theory.

Understandably, the objects of perception vary as we move among the individual arts. The visual arts probably present the fewest difficulties. They deal with artifacts, objects which are locatable spatially, and are, for theoretical purposes, timeless. Literature, music, the performing arts raised and still raise some troubling roadblocks in the way of the development of an overall theory of aesthetic perception. Yet, curiously, it was these media, media which are concerned

with entities which, unlike paintings, are not spatially locatable, and which, unlike sculpture, are said to "take" about so many minutes or hours to be performed or read, which furnished the materials for a significant empirical revolution in aesthetics at mid-century. It was in literature, where the question "What have we here?" supplanted "What was the writer trying to do?" that the issue was raised with an effectiveness which radically altered the approaches to interpretation and criticism, making them suddenly and profoundly empirical. And in the visual arts too the focus quickly moved from mind to the surface of the work itself; not meanings, but qualities, not reflection, but perception. Perhaps the one most influential short piece in the philosophy of art in the last quarter of a century, Frank Sibley's "Aesthetic Concepts," continues to hold importance because it asks (and partially answers) questions about the relations to perception of crucial aesthetic terms which are regularly attached to works of art, terms such as balanced, delicate, graceful, garish, tragic, and so on.

One of the consequences of an aesthetically oriented study of perception is the inevitable awareness of the complexity of the problem. Positivists and materialists, so long as they are dealing with the perception is the inevitable awareness of the complexity of the prob- tion and sensation as synonymous. Indeed "sense perception" became the name for the relationship between an object and a person, and governing conditions were straightforward. The mind was a blank tablet upon which sense wrote, and the sense organ was passive and innocent. Pushed to artistic application this meant the ancient imitation theory of creation and, derivatively, appreciation. The artist paints and the observer sees an object painted as nearly as possible as it is. But it is the theory, not the eye, which is innocent. The artist's eye and the beholder's eye come to their object laden with debris from their pasts, their experiences, and with the residual effects of acculturalization, with *schemata*, as Gombrich argues in his exemplary rejection of innocence in a work (*Art and Illusion*, 1959), which perhaps did more than any other, if not to bring a theory of perception to aesthetics, at least to bring aesthetics to the place where it was forced to consider on every side the problems of perception theoretically. Yet it was not only the art historians, but the psychologists (Arnheim, Gibson, Gregory, Berlyne, and their associates) and the philosophers (Goodman, Beardsley, and a host of

others) who, as the second half of this century began, took seriously the joint role of the experimental and the theoretical in studying the peculiar problems of perception in art. The problems are inescapably philosophical, although in no way does this imply that only professional philosophers can address themselves to them. (Psychologists who think philosophically have contributed enormously to this volume.) The questions address not only the traditional epistemological issues concerning the information conveyed in perception, but also crucial ontological concerns. Reflection makes it evident that the world of pictures differs measurably from the natural world. The naive catalectic view, that what goes on in the perception of pictures is the same as what goes on in the perception of the world is clearly inadequate. Any resolution of the puzzles calls for serious consideration of not only the problem of what pictorial vision is, but also the issue of pictorial representation and the relationship of the pictorial world to the natural world. (The topics of illusion and perspective have traditionally served as paradigmatic of the sub-topics which are associated with this sort of study.) In visual perception of pictures the problems of the perceiving self, the process of perception, and the world of pictures must each be adequately explored before we can claim any significant progress in understanding art and perception.

The collection of essays which follow represents something of the thinking about art and perception which is now going on. A short collection of essays cannot be typical of positions. The important feature of this collection lies not in the inclusion of every view, but in the fact that none of these essays has been published previously, each representing the current thinking of a contemporary who has made earlier contributions to the field. It attempts to display the current state of research on art and perception, and in so doing, to relate this research to its antecedents in contemporary studies in perception. It is not exhaustive of viable contemporary positions. It deliberately, and reluctantly, excludes the rich lode of twentieth-century European reflections on the perception; many of the more recent ones, like the older ones of Merleau-Ponty, are easily and interestingly applied to art. It leaves out Piaget and Lévi-Strauss and Dufrenne and others without suggesting that they have nothing to say, but rather because what F. Scott Fitzgerald said about life is just as true for this topic. It is more successfully looked at from a single window.

PETER MACHAMER

2 Theories of Perception, Art, and Criticism

Theories of perception and theories of art and art criticism bear certain relations to each other. Often consciously, and always implicitly, a theorist who developed a position concerning the nature of art or a theory concerning the function of the art critic accepted some version of a theory of perception. Historically one can find clear instances of the influence of perceptual theory on art theorizing. The relations between the writings of thirteenth- and fourteenth-century opticians and the development of Renaissance artistic theory is one such case. But even where the historical connections concerning individuals or movements is lacking, there still exists the basic connection: *It is impossible to hold a well developed or coherent theory of art or art criticism without at the same time holding a theory of perception.* The argument for this claim will be given in Section III.

Theories of perception can be classified into three groups. This threefold classification is reasonably exhaustive. It is not exclusive in that a given theorist, while holding beliefs that are representative of the class in which he is placed, might in addition hold some principles that would lead by themselves to placement in a different theoretical class.

The lack of clearly exclusive boundaries should not worry anyone. Each instance of one of the three types of theory insofar as it is purely of the type is inadequate as an explanation of perception. Thus, each theorist finds himself surreptitiously drawing upon principles from another class of theory when his own leaves him unaided. To the extent that any theory that purely falls into a class is inadequate, to

that extent the theorist is forced to borrow from alternative theories. This explains the fact that while most theories are basically true to their type, we should expect to find some impurities, borrowed from other classes.

After the taxonomic exercise of sections I and II, the two domains of theory (perception and art) will be drawn together and the connections that exist between the classes in the different domains will be exhibited. This should establish the connections between the two types of theory. The contemporary or historical figures mentioned when discussing a theory are for identification purposes only. In each case the type of theory in question can be traced back further in history.

I

In recent times theories of perception have tended to adhere to one of three types, depending upon what explanatory variable was given the major role in the theory. Since the 1920s, at least, behaviorists and their fellows have emphasized the role of the response variable and associated reinforcing behaviors (R). Since the mid-1950s cognitivists, constructivists, processing theorists, and, earlier, gestalt types, emphasized the organism's contribution and internal activity (O). Yet another type has been emphasized by J. J. Gibson, and his students and friends, who have sought to give pride of explanatory place to the structure of the stimulus or the complex environment in which the organism lives (S).

For example, a behaviorist would "explain" a subject's perceptual adaptation to inverting or displacing spectacles in terms of the patterns of behavior exhibited by the subject prior to adaptation. When the inverting spectacles are first introduced the subject behaves in inappropriate ways. After a period in which the behavior is repeatedly attempted the subject adapts, i.e., comes to be able to ride a bicycle, to touch certain objects, etc. The behaviorist account reads as though the trial behaviors somehow bring about the adaptive responses. Only the subsequent response trials are referred to in the account of adaptation.

In most general terms, a cognitivist would attempt to explain adaptation to inverting spectacles by invoking an hypothesis con-

struction on the part of the subject. The subject finds that his perceptual field is different from what it has normally been. He then begins to construct (albeit unconsciously) an internal hypothesis that accounts for the discrepancies. The hypothesis, in its turn, guides further behaviors. This trial and error procedure continues until such time as the internal hypothesis is sufficient to re-normalize experience and behavior.

A direct, information based theory explains perceptual adaptation by citing the causal effects of the changed stimulus condition. The result of a subject's spectacle wearing is to throw his responses out of spatial coordination with the environment. As the subject moves through the environment or as the environment moves about the subject, the properties of the environment as they really are gradually force the subject to respond (and report) to the real properties. If a wire cube is rotating before a stationary subject with right angle displacing spectacles, the subject picks up a set of stimulus transformations that are unlike those that should occur in a normal world of rigid objects. No real rotating cube-like object would deform its sides during rotation in the way in which this appears. But certain relations that exist between phases of these apparent geometrical transformations of the rotating object are sufficient to define a real cube. The subject gradually becomes responsive to these relations (i.e., he learns) and the result is his perceptual adaptation. The stimulus properties explain the adaptation.

Each of these three approaches has tended to emphasize a particular variable as being *the* factor that needs specifying in an explanation of human perception. In each case this concentration of interest has been combined with the neglect of the other relevant variables. This neglect is often justified by invoking claims concerning the nature of science or the proper business of psychologists, e.g., Skinner's and Gibson's refusal to countenance any relevance to internal psychological processing during perception.

Categorizing psychological theories in this rough fashion is unjust to the particular theorists who represent the type and to divergencies of theory that exist within a group. Gibson, for example, clearly recognized the role of exploratory activity of the organism and the resulting reafference. Some of his followers emphasize the processing assumptions that the organism must utilize in order to respond to

high-level Gibsonian stimulus invariants. Some cognitivists (e.g., Miller, Galanter and Pribram, Sacerdoti, etc.) derive their cognitive structures from action patterns, thus giving some sort of role to responses. But despite such caveats the trifold distinction usefully serves to describe the major forms of interest of most perceptual theorists.

Again this distinction is warranted by an examination of the different experimental paradigms employed by each group. It is, of course, not true that each experimentalist who employs one of these paradigms explicitly avows theoretical allegiance to the related theory. Many experimentalists deny having theoretical biases, or, even, theories. One might, however, implicitly attribute a theory to an experimentalist on the basis of the theoretical assumptions that underlie his experimental paradigm, both in its design and in the manner in which results are interpreted. More cautiously, one might just note the correlation between types of paradigms and types of theories.

The close conceptual and/or ideological connections that exist between theories and experimental paradigms could be developed at much greater length. Below I shall just hint at some of these connections. I introduced the distinction between paradigms to make more plausible the categorization of theories. The differences among experimental concerns does correlate well with the differences between types of theory.

Behaviorists concerned with the R (response) variable have tended to concentrate on discrimination and adaptation tasks. Each of these was thought to have associated clear behavioral criteria that could be correlated with changing perceptual response patterns. Cognitivists and constructivists have spent their time with the tachistiscope and the presentation of minimal or ambiguous stimuli. The briefly flashed form or the illusory or ambiguous stimulus object served well to emphasize the necessity for constructive activity on the part of the organism. Details of the processes of construction were sought through associated latencies or response times. These experimental preferences led this group of theorists to attempt to emphasize and articulate the processing system present in O (the organism).

The Gibsonian, direct information based theorists have emphasized (following Egon Brunswik) the desire for ecological validity.

Pointing out the problems inherent in attempting to generalize any results obtained from situations involving impoverished stimuli, they have sought to study perceptual activity as it occurs over time in the natural environment. This emphasis on the richness of the environment has led them to attempt to isolate higher order stimulus variables, e.g., horizon ratio, texture gradients, etc., that are associated with the perceptual constancies, e.g., size, distance, etc.

Ultimately any attempt to establish a viable psychological theory of perception will have to take into account all three major variables, S-O-R, and their relational and constituative complexities. In addition, it will have to try to avoid the criticisms that have been levelled at each of these theories. But such are not the tasks of this paper.

II

Theories of the nature of art and associated theories of the nature and function of art criticism seem to be analogously categorizable into three types. There are theories that emphasize the effect the work of art produces in the passive spectator. There are those that emphasize the constructive activity of the spectator, what he brings to the work. And there are theories that emphasize what is in the work of art itself. In parallel, the reasons given by critics for the success or failure of specific works, genres or styles describe spectator effects, constructive actions of the audience or properties of the work itself.

For completeness it is worth remarking that there are artist-based theories that are not clearly included in this categorization. Such theories base claims concerning success or failure of a work on the achievement of artistic intentions such as sincerity, perspicacity, etc. This type of theory might fit into a constructivist type. It seems to emphasize properties that the artist contributes to the work that are, in some sense, over and above what is literally in the work itself. In such cases the spectator or audience must judge the work by *attributing* such intentions to the artist and by making decisions concerning their realizations. Similarly, audience-based constructivist theories emphasize the contribution made by the spectator which is over and above what is literally in the work itself. In what follows, I shall not deal with artist-based theories *per se*.

The distinction between theories of the nature of art and theories

of the practice of art criticism is warranted. Many contemporary (as well as past) critics claim they hold no theories or, at least espouse no clear theoretical position. Thus, categorizing their claims in terms of the theories which gave rise to them would be false imputation. Nevertheless, one might plausibly attribute implicitly held theories to such critics based upon the type of reasons they provide to support their evaluations. More cautiously, one might categorize the type of reasons utilized and show that they fit into the taxonomy provided by the theoretical distinctions.

The first class are empathetic or didactic (affective) theories that find the nature of art to be in the effect it produces upon the spectator. The main focus of this class of theories is its almost exclusive concentration of the work's causing certain effects in a reasonably passive spectator. The emphasis may be on either responses that the spectator produces or upon inner states that are brought into being. For both the emphasis is clearly on the nature and character of the effect produced and the consequences brought about by those effects. Criticism for this class consists in ascertaining the worth of work by imposing some quantitative or qualitative measure that is taken to describe the worth or utility of the obtained spectator effect.

Delimiting effects into subcategories divides this type of theory into recognizable instances. Tolstoy's insistence on an art's producing moral enlightenment or Aristotle's insistence on the cathartic effects of tragedy (whether read behaviorally or as an effect on the soul) are two familiar examples. The post-revolutionary Soviet emphasis on constructivism or social realism in the service of social enlightenment is another. Any theory concerned with the behavioral responses or empathetic affects that the work of art effects is of the type.[1] The common theme is that the art work, by whatever process, causes the spectator to go into some peculiar state. The response of the spectator is to come to be in a peculiar state which is then described as, e.g., aesthetic, emotional, or moral.

The second class of theories emphasize the active, creative role of the spectator toward the work of art. The significance or meaning of the art is determined by what the spectator brings to the work, his past experience, prior familiarity and previous learning. The work of art itself is taken to be incomplete, needing to be filled out or completed by active interpretation on the part of the observer. The

interpretation is determined by the spectator's set, schemata or categories. These are the beholder's share theories, where the organism is internally active.

A correlative of this view is that one can classify works of art into various styles by ascertaining the set of assumptions needed by spectators to interpret the work. If two works require the same kind of prior knowledge on the part of the spectator in order to understand (or appreciate) them, then they are of the same style. A spectator's set of assumptions of prior knowledge is contingent upon the cultural and social conditions in which he was raised and through which he learned and on the stage of development in which he is. This view, then, implies that cultural differences and temporal periods related to societal changes are important. For example, a spectator must bring to bear a set of interpretative categories in order to apprehend what a painting represents, e.g., to see it as a portrait of a king.

It is not always clear how, on beholder's share theories, evaluative judgments concerning the worth of a work are to be supported. The introduction of culturally and temporally relative parameters into evaluation contents often has the effect that authors think they cannot make evaluative claims that will be true beyond the specified cultural or temporal boundaries. Such thoughts encourage a tendency toward aesthetic relativism, and the result, as with most relativistic theories, is the abjuring of evaluative judgments *tout court.*

The current doyen of this approach is Ernst Gombrich. Gombrich, in articles and books,[2] has emphasized almost exclusively the role of the spectator. But Gombrich does not see himself as providing evaluations of works of art. As an art historian he is concerned to elucidate the assumptions and prior knowledge that are necessary to comprehend a given work or style.[3] For example, until certain conventions about projective geometrical space had been developed and disseminated, neither artists nor spectators had the assumptions necessary to correctly interpret perspective drawings.

The active interpretive role of the spectator and its relevance for theory is accepted by a very large number of those concerned with theories of art. Most writers who have been concerned with the symbolic character of the work of art have held that man as spectator brings meaning to the work. Symbols as opposed to natural signs require the mind's active interpretation. Paul Ziff worked out a

theory of criticism where the critic, too, had primarily a teaching role. The critic was responsible for teaching the spectator the right manner of aspection.[4] Once learned, the spectator could see the work in the proper way.

It might be thought that Ziff holds a position sufficiently different from Gombrich to warrant classifying him in the third class of theories. He does emphasize that criticism must concern itself primarily (if not wholly) with what is *in* the painting. But unlike our third group, what he takes to be in the painting is ascertained only as result of high level interpretive activity. Like Gombrich, he holds that what is in the painting is incomplete and is in need of completion by the spectator's abilities to organize, to add and construct.

The third class of theories emphasizes the nature and character of the work of art itself. The role of the spectator as an explanatory factor is absent from this theory. Their concern is to analyze what is present in the work of art. Most often this concern is focused through talk about the formal properties of the work.

Within this class there is dispute among authors as to which set, or sets of properties of a work are important. However, the common emphasis is that whatever these properties are they are objectively present in the work. The critic in his evaluation need only describe the relevant sets, connections between sets and the overall character of the work that is constituted by these sets of properties and their relations.

The writings of Clive Bell and Roger Fry are reasonably clear examples of this third class of theories. The search to find the sets of formal elements that yield significant form is an endeavor of the type described.

The theory of perception espoused by Arnold Isenberg suggests that he should be placed into this category. Isenberg argues for a perceptual apprehension of a work of art in such a way that the content immediately grasped constitutes the aesthetic experience. This immediate non-inferential activity is taken by him to be the essence of aesthetic activity.[5]

III

Theories of art or art criticism presuppose a theory of perception. More specifically, each of the three theories of art or art criticism

discussed above presuppose one of the theories of perception originally discussed.

The claim is not an historical one. It is not that the aesthetic theorists who adumbrated particular theories explicitly drew upon, utilized or were aware of the theory of perception that shall be attributed to them. Nor more so, that they were influenced by the persons to whom I have ascribed the perceptual theories. (I do not believe that J. J. Gibson influenced Clive Bell!)

The claim is meant to make one realize the importance of the role that perceptual theory plays in a theory of art or art criticism. This realization has important consequences. For example, perceptual theories themselves are not universally accepted nor uncontroversial. Therefore, in evaluating a theory of art or art criticism one should examine the theory of perception it presupposes. The cogency of the former theory is a direct function of the cogency of the latter. If constructive theories of perception have major flaws (as they do), then Gombrich's claims about the beholder's share must be reevaluated. It seems most coherent, for example, to take certain information about depth as being directly available in the picture.[6] If the texture gradients within a picture are reasonably well specified, then there is no need to assume a human's ability to construct such depth information. This would suggest a reevaluation of the types and amounts of prior information that an observer needs in order to perceive depth in pictures.

The first pair of classes of theory is spectator-affect theories of art and response variable theories of perception. Aristotle's theory of catharsis will serve as an example. Insofar as the function of tragedy is to cause some cathartic effect in the spectator (quite apart from exactly what that effect is intended to be) it is meant to provide the spectator with a pleasure producing relief. On Aristotle's theory the tragedy could be said to function by providing the occasion for certain reinforcing responses on the part of the spectator. In order for this to occur the spectator must discriminate the relevant happenings upon the stage, e.g., that it was a good man that came to grief through a fault of his own. If one believed G. F. Else's interpretation of the *Poetics* the response would be of the type invoked in motor theories of perception.[7]

The general thrust here is that the spectator perceives the drama and by such perception is brought into an affective state with future

behavioral consequences. Again one evaluates the work of art by its effectiveness in establishing such consequences. Interpretations of the *Poetics*, generally, consist in attempts to fill in the details of this consequential story.

All such spectator-affect theories presuppose that it is through perceiving the work that the spectator is caused to behave or respond in certain specific ways. A given specific way may be correlated with properties of the stimulating work that were discriminated. Thus, Aristotle attempts to correlate the cathartic response with constitutative elements of the tragedy, e.g., types of plot, language, etc. If theorists can ascertain (or already have ascertained) what perceptually discriminated properties cause what behaviors, they are then in a position to judge an art work's success. They can either determine if the work has the properties necessary to bring about the requisite behaviors or, they can simply examine behaviors that occur in the presence of art works. More importantly, they can judge the behaviors produced and only license such behaviors as are, e.g., good for the social fabric, conducive to Christian action, etc.

Note that though the stimulus object is mentioned as that which is discriminated, in itself it is not treated as valuable. Its significance and value is determined wholly by the affect produced. This affect, in turn, is significant because of the behavior with which it is associated or which constitutes it.

On this view, the structure of the work of art except as a cause of behavior is not relevant. also irrelevant are the processes through which the spectator responds by behaving. Responsive behaviors, plus the law of effect, dominate the concerns of theorists holding this position.

If one notices that the discriminative stimuli and response patterns are not well correlated in fact, then one might be tempted to bolster the correlations by the introduction of intervening, processing variables. By concentrating on the processing activities of the spectator, the theorist is enabled to explain why some persons respond differentially to the seemingly same stimulus object. Spectators process stimuli differently because they have established different processing rules. Processing rules are established by training, learning, custom, habituation, etc. What the spectator responds to, how the object affects him, depends upon his past experiences.

This second class of theories holds that the work of art triggers off

a set of internal interpretative activities that are part of the specta-
tor's cognitive repertoire. The object's characteristics no doubt limit
what cognitive responses can be triggered but the emphasis of con-
structive theories of perception and beholder's share theories of art is
on the additive, constructive activities of the spectator. The concern
is with what rules of processing are used by different individuals,
different cultures, at different times. The emphasis is not on the
characteristics of the work of art, not upon ensuing behaviors, but
rather on internal psychological processes. These processes are usu-
ally taken to be cognitive in nature and it is this cognitive character
that comprises their value.

Gombrich explicitly avows his debt to psychological theory. Many
others who have utilized this form of perceptual theory have been
equally committed, if less explicit. This is the dominant type of
psychological theory at present.

One aspect of this type of theoretical concern often goes unre-
marked. The emphasis on cultural and temporal differences corre-
lates nicely with cross-cultural, societal, and institutional concerns.
Much of the recent criticism that focuses upon where art fits into the
cognitive and social (psychological) needs of the members of a so-
ciety belongs in this camp. Perception is culturally determined, and
all that is perceived (including works of art) is perceived for social
purposes.

The general defects of this second class of theories of perception
and art serve to direct attention to the distinctive characteristic of our
third class. Direct theories of perception and formal theories of art
redress the balance of theoretical concern by analyzing what con-
structive theories neglect. They analyze the complex nature of the
stimulus or of the work of art itself. Constructivism and beholder
share theories hardly discuss the limits of interpretation or the crite-
ria by which an interpretation is found correct. They pay scant
attention to the intrinsic structure of the perceptual object. By ne-
glecting the characteristics of the object perceived they allow for too
much latitude in the interpretive processes.

Direct, formal theories hold that spectators perceive what is in the
object directly. Observers have no need in normal cases to interpret
or add to scanty or incomplete data. The data are the complex
properties of the object in its environment. They are complete. There

is no explanatory gain given this completeness in considering the processes by which spectators speculate. To understand what people see one must understand the objects seen. This requires an analysis of the kinds of objects. Works of art, in particular, should be analyzed in terms of the properties that are intrinsically true of them; not in terms of relational properties that include a spectator as one of the relata.

Direct theories of perception can differ as to what properties of objects are directly perceived. Formalist theories of art can differ on what basic properties of art works are to be described. Empiricists thought only sensations were directly perceived and some early formalists concurred. But those very limited forms of direct perception came to grief.

Direct theorists need to specify higher order variables for their theory and formalists need complex forms for their criticism. Both need the complexity because both are asking in what does the significance or importance of the object lie. Both answer by citing properties of the object or environment that make it significant. Such properties of object or environment must be complete in order to correlate with significant actions or response patterns. Simple properties, as the behaviorist found, do not correlate well with any behaviors.

I hope enough has been described so that relations between theories of perception and theories of art can be discerned. In each case the theory of perception and the theory of art share certain basic principles. It was these principles that I initially used to generate the original classification of the theories.

That theories of art should presuppose theories of perception, in general, is almost too clear to need argument. Basically, such an argument turns upon the well-noticed fact that humans respond to works of art through their perceptual systems. How they respond to works of art depends, obviously, on the properties of the work, the properties of the human, upon the context and environment in which that response occurs, and upon prior responses and their effects. The details of these connections are treated by the different perceptual theories each emphasizing their own explanatory variables.

If an aesthetic theorist is concerned to describe the nature of art he must describe the properties of the art work, the properties of the

spectator's activities, the context and environment in which the spectator's response occurs and his prior responses and their effects. Since the spectator's response in the case of works of art is a subclass of perceptual responses, one well might expect theorists about works of art to devise theories of art that fall along the lines that perceptual theories take. This is what has been found.

Also one would expect defects in the two theories to run parallel. In some places in the present paper, I have hinted at these. Finally, one should expect that a really adequate theory would encompass all three of the explanatory aspects (S-O-R) emphasized in the three classes of theory. Coherently putting these together should form the theoretical project for future work in theories of perception and in theories of art and art criticism. Some attempts are being made in perception.[8] I await their parallels in the arts.

Notes

1. Many theories take affective spectator responses as central. In this classification I would place Edward Bullough's psychical distance theory, Susanne Langer's insistence that all art must produce sensuous or emotional effects, and Herbert Langfield's response theory.

2. Ernst H. Gombrich. *Art & Illusion* (New York, 1962), and his "The Visual Image," *Scientific American*, 227 (1972), 2–16.

3. Ernst H. Gombrich. *Norm and Form* (London, 1966).

4. Paul Ziff. "Reasons In Art Criticism," in Israel Scheffler, ed. *Philosophy and Education* (Boston, 1958), pp. 234f.

5. Arnold Isenberg. "Perception, Meaning and the Subject-Matter of Art" *Journal of Philosophy* 41 (1944), especially 571 and 575.

6. A general discussion of the depth problem is provided in Richard Rosinski, *The Development of Visual Perception* (Santa Monica, 1977), chapters 2 and 8.

7. G. F. Else, *Aristotle's Poetics: The Argument* (Cambridge, Mass., 1957).

8. Interesting, but unsuccessful, attempts have been made in Ulrich Neisser's *Cognition and Reality* (San Francisco, 1976) and in M. R. Turvey's "Contrasting Orientations to the Theory of Visual Information Processing," *Psychol. Rev.* 84 (1977), 67–88.

My thanks to James Bogen and Richard Rosinski for the intellectual efforts they made on behalf of this essay. Though perhaps not obvious to themselves or others, it is better as a result of their labors.

MARX W. WARTOFSKY

3 Art History and Perception

The theme of this paper is the relation between art history and human vision. The argument I will make is that visual perception has a history, and that historical changes in visual perception are, in fundamental ways, the result of changes in the forms of pictorial representation in art. To put this in its most radical form, my thesis is that human vision is a cultural artifact, created and transformed by the historical practice of representation in art. In effect, we constitute our ways of seeing, and change them, by means of the ways in which we picture what we see. The corollary thesis is that the history of art is a crucial component of the history of perception. From this, it follows, further, that theories of visual perception which attempt to construct the essential, unchanging or ahistorical nature of the human visual system—whether in terms of the neurophysiology of vision, or in terms of cognitive psychology, or in terms of ahistorical epistemologies of perception—are essentially incomplete, and moreover misleading, where not false. The focus of my argument, then, is upon the historicity of human vision, in its relation to historically changing forms of picturing, or canons of pictorial representation.

A word, to begin with, about the punctuational ambiguity of my title, "Art History and Perception": it is intended to suggest *both* a relation between art and history (where "history" connotes the domains of human practice beyond art) and between art-history and perception, that is, between the history of art and visual perception as itself a historical phenomenon. Therefore, either a comma or a hyphen may be placed after the "Art" in the title. The burden of the

23

punctuation is the thesis concerning the historicity of our modes of perception and cognition.

In one sense, none of this is terribly new. That perception is affected by framework, that what we see is in part a function of what we seek, is at least as old an idea as Plato's *Meno*, and smells thoroughly Protagorean. To make a few brief obeisances at appropriate shrines, it is clear that Kant (in the *Transcendental Aesthetic* in the First Critique), Hegel (in the opening passages on sense-certainty in *The Phenomenology of Mind*), Feuerbach (in some richly suggestive passages in his book on Leibniz), and Marx (in the well-known passage on the historicity of human sensation, in the *Manuscripts*) all formulate, in one or another fashion, the view that human perception is framework-dependent. This old idea was given new life, when it was naively reinvented in modern philosophy, or rediscovered in Peirce or in Wittgenstein. Contemporary philosophy of science has had a wild old time with the consequences of the view that observation in science is theory-laden, and that changes in theoretical framework constitute, in effect, changes in what is observable. There is a more serious and sustained tradition in perceptual psychology and in anthropology which struggles with the question of cultural influences on visual perception, and focuses on cross-cultural and comparative empirical studies of visual perception. The literature here is rich, provocative, and growing rapidly.[1] More specifically, there has developed a discussion, indeed, a debate, concerning the relation between picturing and perceiving, involving the trinity of art-history, psychology, and philosophy in the persons of Gombrich, Gibson, and Goodman, respectively.[2] All this is by way of suggesting the general background for the view that visual perception is framework-dependent, and more: that the "framework" in question here is one or another mode of representation in art, or one or another pictorial style.

What, then, is all the fuss about? Much of what is under consideration here seems unproblematic. Therefore, it will be useful to separate out what is unproblematic from what is either highly problematic or worse—namely, totally implausible and outrageous. For only the latter is worth considering seriously here. To begin with the easily acceptable: that art has a history will come as a shock to very few, (though what it means to "have a history" may be subject to radically

different views.) Art historians are doing *something*, after all; and this *something* has something to do with changes, sequences, developments in style, in technique, in modes of representation, in forms of depiction, in conception, content, and convention in the visual arts. Further, it is not exactly outrageous to hold (as some art-historians do) that changes in pictorial style (say, from Byzantine to early Renaissance) are to be understood as changes in "ways of seeing." Nothing very problematic is being claimed when one says that the artist(s) who created the sixth-century mosaic of the empress Theodora and her attendants (in S. Vitale, in Ravenna) had a different "vision" than that of Giotto or Duccio. In a manner of speaking, we may say that they "saw things differently." We generally tend to blur this usage, or to put it into metaphorical soft-focus. So, for example, we *could* say that the Byzantine artist and the early Renaissance painter tended to pick out different features of their subject for representation; or that they interpreted what they saw differently; or again, that they expressively distorted what they saw in their representations of it; or still again, that they used different conventions or codes of symbolic representation. In short, we tend to shy away from the balder view that these artists actually *saw* things the way they represented them.

A good deal of the analytical clarification of the concept of pictorial representation, or of the making of images, involves the distinction between the image and the thing imaged, and usually calls forth the injunction not to mistake one for the other. What once was a theological issue concerning idolatry, and led to the iconoclastic controversy, now has the tamer aspects of epistemological clarification. Pictures are not, after all, the things they picture (when they are representational pictures. Not all pictures are representations). Thus, it would seem to be an elementary error to think that the sixth-century mosaicist actually saw the world (or at least the empress Theodora) in just the way the picture shows. If, in fact, the picture *really* looked like what it was a picture of, it would be a trompe-l'oeil picture, such that Theodora and her mosaic representation could not be told apart. But, happily, they can (even though *we* have never seen Theodora; nor, very likely, did the artist). Similarly, it would seem to be an egregious conceptual as well as perceptual mistake to think that Giotto's or Duccio's world, or their subjects (e.g., Christ, the apos-

tles, the Roman soldiers) "looked like" what Giotto or Duccio pictured them as. Therefore, what we mean when we say that the artists' "ways of seeing" are different, or that "vision" changes, art-historically, must be something less than that the artists actually saw things as differently as they painted or represented them. In fact, we are more likely to say that since all these artists were human, and had human eyes, they all "saw" pretty much the same thing (and pretty much what, and how *we* see). And what we mean therefore is not that *visual perception* itself had changed, between the sixth and fourteenth centuries; but rather (and more comfortably) that changes in "ways of seeing" or in "artistic vision" are really differences in "attitude," or in "the visual imagination," or among ways of symbolizing the seen.

All of this is reasonable. And finally, uninteresting. For it reduces the aesthetics of representation, and the creativity of artistic vision to a series of alternative interpretations of the "same" visual givens, and robs art of its most radical and subversive capacity: to make us see the world differently; or better yet, to make the seen world different, to change it. But this is more than simply to interpret it differently "in the imagination," for what is at issue is a change in actual visual perception itself—in perception proper, so to speak. The implausible and outrageous claim would be that artists working in different pictorial styles actually come to see the visual world in the manner in which they come to represent it; that, in fact, the visual world becomes "pictorialized," as we may say; and that one of the products of the history of styles of pictorial representation is that we come to see the world as a picture, and, as a picture in a given mode of representation. To claim this would be as irrational as to claim that the mosaicist of S. Vitale of Ravenna saw the world as made up of elongated, big-eyed people, or that Giotto's visual perception was Giotto-like, or worse yet, that Picasso actually saw things Picassoesquely. Yet, what it comes to, to say that we see the world by way of our picturing, or that visual perception is an artifact formed in part by dominant canons of representation in art, is to say something very much, (or rather, exactly) like this. And that's what all the fuss is about.

The trick is to make such a view plausible, after taking its initial implausibility fully and seriously into account. And there are several

major objections to be raised against this view, all of which have to be met if it is to be, as I intend, a serious contender for the truth. I see three major objections to this view of the historicity and variability of our modes of visual perception: 1) that it is a version of the "El Greco Fallacy," i.e., that there is a fundamental flaw in its logic; 2) that it runs counter to all the evidence concerning visual perception which derives from the neurophysiology of vision and from physiological optics; 3) that it is falsified by perceptual psychology, specifically, by the well-attested perceptual constancies; and corollarily, that it violates the well-established criteria of representational veridicality or fidelity or of pictorial verisimilitude. Let me call these arguments, respectively, *the argument from logic, the argument from physiology, and the argument from constancy*. I will set each one out briefly, and sketch what I believe meets each of these objections.

1. The "El Greco fallacy" is J. J. Gibson's apt name for the following mistake in reasoning: Since El Greco represented the human figure in an extremely elongated way, this is because he saw the actual figures in this distorted way (because of some defect in his own visual system). The fallacy is clear here: If in fact El Greco did suffer such a distortion of his vision, then his representation of human figures would look "correct" to us (as normal viewers) since it is such an "undistorted" representation which would appear equivalently "distorted" to El Greco's eye, as would the actual figure which it represents. But if this is a fallacy, so too, it would appear, is the view that painters see the visual world in the ways in which they picture it. But here we have to add that the painter's mode of representation or pictorial style (e.g., El Greco's elongation) would have to appear distorted to "normal vision." That is, there would have to be some canon of veridicality or of fidelity in representation, such that the representation could be said to give a "true" or "undistorted" rendition of the visual appearance of its subject to normal vision. We would then be able to compare such a criterially normal representation with the deviant version (e.g., El Greco's). If, in fact, figures appeared to "normal" vision as elongated in the El Greco manner, then presumably El Greco's rendition of them would not appear distorted. It is only on the presupposition of deviance, i.e., of "elongation," that the criticism of the fallacy has its effect. If figures had, in "real life," the proportions of El Greco representations of them, then

of course, El Greco's style would establish the criterion for representational fidelity; it would then be what we are wont to call "realistic," or "correct."

Now, to test what I am about to say, I hold my hand before me, in the position I remember from El Greco's paintings of various saints. I have been in Toledo within the year, and have soaked up, visually, scores of El Greco hands. And as I regard my hand (not an especially thin or bony one), it looks for all the world like an El Greco hand: I am aware of the "longness" (not the "elongation") of my fingers; I see the bent fourth and fifth fingers in the characteristic posture and character of that in the paintings. I notice (really for the first time) that the chiaroscuro modeling of the fingers is just like that in El Greco's paintings. Is nature imitating art? Am I imposing some visual imagination of what El Greco saw upon my "actual" ("real," "proper") perception? Am I illuding myself for the sake of the argument? No. I think, rather, that I have pictorialized my perception, or better yet, *re*pictorialized it—gone from one mode of picturing it to another. El Greco and I have come to see eye to eye, so to speak. There is no fallacy. He saw the figures in their "longness" (not their "elongation" from the normal) and represented them that way, undistortedly therefore, and if we come to see this longness, then the paintings are "veridical" as long as the visual world is seen in the way it is pictured.

The problem with such a resolution of the problem posed by the El Greco fallacy is that it appears to so subjectivize and relativize the notion of representational veridicality or fidelity that *any* representation would be *necessarily* veridical on the claim that the artist (or the viewer) saw "nature" precisely as it was pictured in "art." For in this case, every painting would be a successful trompe-l'oeil; indeed, the concept "trompe-l'oeil" could not have arisen (but that is another, and complicated story). Further, one could object that such a resolution of the problem posed by the El Greco fallacy makes it impossible to distinguish, in principle, between more and less competent ways of rendering or representing what one saw, or between degrees of success or failure in fidelity. My answer to this objection, as to the one concerning subjectivity and relativism, is that the "unit," so to speak, of a mode of representation is not an individual painting, and the "unit" of a mode of visual perception is not an idiosyncratic

vision of the world, (though, as I will argue, individual paintings and idiosyncratic visions can come to be adopted as such "modes"). The "unit" is rather the more complex, socially and temporally extended sort of thing connoted by the term "style."

The perceptual awareness evinced by a given painting or even by a given painter—e.g., mine, of my fingers, by El Greco—is not a one-shot epiphany out of the blue. Rather, it brings to bear a whole tradition of visual training, a sensibility to stylistic difference from some acquaintance with the history of art, and an erstwhile practice in the making of representations and in painting. My seeing eye to eye with El Greco is no simple one-to-one interaction, but a complex social and historical achievement in the development of visual perception, a piece of higher (visual) education for which elementary and secondary schooling are necessary precedents. But this is no claim for my own sophistication in this case. It is instead an acknowledgment that the culture of pictures is an extraordinarily pervasive and advanced culture, and that practically none of us escape it (not even Julian Hochberg's offspring). That we come to see the world El Grecoically, or Cézannishly, or Picassoesquely is a function of the fact that for tens of thousands of years, our vision has been shaped by our envisioning, our perception of things has proceeded hand in hand with our representation of them. Seeing a mastodon in profile, standing still, and from a fixed position is an act of spectation closely tied to the representation of a mastodon in profile on a cave-wall surface. It requires becoming a visual spectator—a "visience," by analogy to an "audience"—educated by the mode of representation (in this case, Magdalenian) to be able to see, in the world, something like a line, an outline, a profile. My own conjecture is that the mammalian eye is certainly evolved for gradients and for edges and contours; but that none of these is yet so visually abstract an element as a line, or a profile, and that the visual perception of lines and of contours as linear profiles is a sophistication introduced into human vision by the culture of pictures in which contours of three-dimensional objects are represented by lines on a two-dimensional surface (a point J. J. Gibson has made, but which needs to be developed further).

But all this is to say that our coming to see the visual world by way of the styles of pictorial representation which we adopt is *not* to have

a historical series of distorted visual "interpretations" of what is really there. Nor is it to work our way progressively from less competent and less veridical to more competent and more veridical forms of representational practice. Rather, it is to come to see things in the world which we would otherwise have missed, or failed to pay attention to; and beyond this, to introduce into the visual world itself elements, objects, and scenes it would not otherwise have possessed. Thus, if artists in fact render what they see, within a given style, that style does not become a distorting veil of convention between the representation and the seen world. Rather, the style becomes a visual probe by means of which new visual realities are discovered.

The El Greco fallacy is a fallacy only within the conditions under which it is described, namely, that there is a normal "look" of things which contrasts with the distorted way in which they are represented. But to the extent that we all suffer (or can achieve) El Greco's vision, then his representational transcription of what he saw, by way of the "longness" of figures, will look undistorted to us. Against this particular canon of representation and its attendant pictorialization of our visual perception, the so-called "normal" figural proportions would appear squat. They do not because our pictorial culture permits us to entertain, without distress, alternative and radically different pictorial styles, and permits us as well to accept them as plausible. What it does not do, however, is to permit us to accept them as equivalently "correct." But this is for the reason that we have adopted one (general) canon of representation as the standard of fidelity. It is the one most generally called "realist." Ostensibly, it is called "realist" (or "naturalistic") because it most closely represents, in painting, the way things look in the world beyond the painting. It is, to use one standard characterization, the most objective representation of the appearance of things. But, as it may already be clear, I would argue that such "realism" is a choice among alternative conventions or styles of representation which is *not dictated* by some independent criteria of perceptual fidelity, but rather *establishes* what we shall take as criteria of fidelity. To call a style of pictorial representation "realistic," therefore, is to choose a concomitant "style" of visual perception as the one which will be regarded as "correct" or "veridical." In short, my argument is the following: Though it is true that those paintings which we take to be "realistic" are so because they

most closely represent the way things look, things come to look the way they do because they are perceived in accordance with the rules of representation embodied in those pictures we take to be "realistic." This obviously has an air of circularity about it, since it claims that things look the way they are represented because they look the way they are represented. And such a circular formulation leaves it moot as to whether things look that way because they are represented that way, or whether they are represented that way because they look that way. The matter is fairly clearly resolved by our ordinary understanding of realism in representational works of art. For here, "realism" means in the common understanding of pictures just what it means in the philosophical understanding, in the epistemological use of the term: namely, that what is represented is the way it is independently of the representation of it.

The analogue, for perception, is of course that things are the way they are independently of our perception of them. In pictorial contexts, however, we have at least two complications: first, it is not a question of the existence of the things represented, but rather, of what we may call their visual properties; second, whereas in speaking of perception, we are speaking of the relation between some *mental image*, or *perceptual judgment*, or *act of perception*, on the one hand, and the *objects of perception*, on the other—(the language chosen depends on one's theory, and I am leaving it open as to which theory of perception one adopts)—in this case, by contrast, we are speaking of the relation between *two* perceptual objects, the painting or drawing, as a representational picture, and the actual object, scene, or person outside the picture, and represented in the picture.

With both of these differences in mind, between the usages of "realism" in art and in epistemology, it may nevertheless be seen that the common acceptation of the art-usage understands our perception of the visual world to be both independent of our ways of representing it pictorially, and also to be the test of the adequacy or veridicality of representations of it. And common sense and common judgment are sound here, for what else could serve as such a test? Yet, I have argued that "realism" is *not* in fact such a matter of visual match between an independently seen world and its representation. Rather, it becomes a matter of what precisely we take to be "independent," or criterial for our view of reality. In effect, it is a matter of how we

establish what we will take to be the "objective reference" of our representations. And this, I would argue, is not simply a choice, but an historical choice, an historically changing choice, and a complex social choice which involves at least as much as what it takes to establish a given style as the dominant one in art.

The choice of what will be taken to be "realistic" therefore involves the complex social and historical act of establishing a "style" of visual perception, or, (to exploit a well-used metaphor, and to borrow it), of establishing a language of vision. It also involves a good deal more than what goes on in the artworld alone. (Externalist art historians provide the grist for that mill, though internalist art historians often find the bread baked from that flour indigestible.) But in a fundamental way which has not been given its due, I argue that such a canon of "objective visual reference" depends upon the adoption of a style of pictorial representation which will be taken to be "correct." Further, I am proposing that what we then take to be the way things look "independently" or "objectively" will be in large part a function of the adoption of that mode of representation.

El Greco's "elongation" or his "expressive distortion" therefore counts only against the background of some alternative canon of "normal" figural representation. And that canon is the one identified with the adoption of the rules of linear perspective in painting and drawing. However, the adoption of linear perspective is closely related to the adoption of a physics and a geometry which are then taken to define the real world, and to characterize the space of that world; and further, the adoption of the canons of linear perspective is also intertwined with the adoption of a theory of vision—i.e., a theory of the eye in terms of its physiological structure and function, as well as a theory of visual perception based on Euclidean geometrical optics and on a theory of image-formation. In short, the adoption of a particular style of pictorial representation—or rather of a family of styles with a more or less common set of rules for "correct representation"—proceeds here together with the adoption of a theory of physical reality and a theory of vision. Pictorial representation becomes a systematic part of a coherent ontological and epistemological construction which includes physics, optics, and psychology, and can be expressed in a unified mathematical way.

It is this world-view which is the historical matrix for a "way of

seeing" which *then* becomes canonical. It is a socially achieved mode of visual perception as well as a theoretical construct in physics, physiology, and optics, and a new rule for the pictorial representation of things. Moreover, it is what we, in what I regard as an historically parochial way, have come to call "*The* Scientific Revolution," (whereas I would propose that it be regarded as "*A* scientific revolution," preceded by several others and to be succeeded by at least one other since that time). What I am proposing, then, is that the adoption of a criterion of scientific objectivity is intimately linked to the adoption of a criterion of "correct" representation, in terms of the rules of linear perspective (and their subsequent modification by artists in the course of visual experimentation, not unlike the modification of ideal laws in physics subsequent to physical experimentation). What goes into the visual "shift" is more than *just* a change in pictorial style. It involves fundamental changes in forms of social and technological *praxis* in conjunction with changes in scientific theory. All of this conduces to a change in world-view in which standards or norms of objectivity, of what is "correct" and what is "mistaken," are established in a wide variety of domains, and in which developments in one field affect changes in another. Thus, Samuel Edgerton has shown, in his recent studies of the Renaissance, the effects of modes of pictorial representation (the introduction of linear perspective) on natural science, engineering technology, and medical science.[3]

But, of course, this works the other way as well. The adoption of a theory of vision then comes to reinforce the canonical status of that mode of pictorial representation which, in effect, embodies that theory in its rules. One of the strongest arguments for the "correctness" of linear perspective is that representations made in accordance with its rules reproduce the very retinal image, or the light flux to the eye which the real objects or scenes represented would produce; and therefore that it is this isomorphism between the seen world and its representation that establishes the "realism" of this pictorial form objectively. If this is so, then it constitutes a serious refutation of the view presented here, that pictorial realism is a social-cultural variable. Let me proceed then to consider this second objection to my view, the *argument from physiology*.

2. The *argument from physiology*, briefly stated, is that visual perception may be described in terms of a causal model, in which the

stimulus of vision is a light flux reflected from the surfaces of objects, and impinging on the two eyes in such a way that it is refracted through the bi-convex crystalline lenses to form an inverted image upon the retina of each eye. Two objects of perception will then be perceptually identical if the causal conditions are identical (and on-the assumption that the receptive mechanism, i.e., the eye and its neural processes) are the same. There is no problem here with variation due to changes in conditions of luminosity, surround, or changes in the subject, since these will change the causal situation, and thus vary the perception (even of the "same" objects). To the jaundiced eye, as Plato already has Socrates say, things will look yellow, of course. But the jaundiced eye is "yellowed" by disease, and thus we may distinguish pathological distortions or perceptual errors from normal vision within the physiological model, and thus reconstruct the way things ought to look, when correctly and healthily perceived. When we do so, then it becomes apparent, on this view, that pictorial representations made in accordance with the rules of linear perspective are the ones which objectively present the normal eye with the stimulus information which most closely matches that received from the objects or scenes represented in such pictures.

It follows, then, that nothing as transient as changes in modes of pictorial representation will fundamentally affect the visual perception of the real world outside the pictures. At most, such changes may lead us to interpret the "same" information differently. But since "interpretation" is parasitic upon some uninterpreted given—otherwise, what could it be an interpretation *of*?—realism in representation is defined in terms of what is *pre*-interpretively presented to the eye. For if realism were itself an interpretation of the given, there would be no sure way to test that interpretation against any other, since we would then have to have independent access to the causal conditions of a given case of viewing, and this access would have to be nonvisual, or we would be caught in an infinite regress. And then, we would have to have a foolproof translation of a nonvisual account of the conditions of viewing into the "language of vision"—and we do not have such an account. Thus, it has to be possible for us to establish the "match" between the scene and the scene-picture pre-interpretively, or immediately. Presumably, such a "match" is established in terms of visual resemblance, so that the criterion that

determines that a picture is realistic is that it "looks like" what it is a picture of. But normally, on this view, pictures look like what they picture just because they re-create the causal conditions for visual perception that most closely match those presented by the things or scenes pictured. Since access to the visual world is not through the medium (or the "lens") of a pictorial representation, but through the eye itself, we thus have an objective visual standard (the way things look) for realism in representation.

I believe this argument from physiology fails for a number of reasons, even simply as an account of visual physiology. But that criticism has been made elsewhere, by me and by others as well, and I will not repeat it here, since it is not necessary to my argument. What, in general is wrong with at least some versions of the argument from physiology is that the human eye is not a recording camera, but part of a live creature whose seeing is shot through with intentionalities. So-called stimulus-information to the eye underdetermines anything even so simple as shape or color, and even more so is this the case for the identities and characters of objects and scenes. But suppose the account of vision this argument gives is substantially correct. Even then, if one admits into the causal network the receptive conditions—that is to say, not only the neurophysiology of the eye but the so-called central processes, the higher cortical activity involved in visual perception and visual understanding—then there is no reason to exclude from such an account, as an element *in* the causal network, the particular filtering or refraction afforded by a "way of seeing," a framework of anticipations and selections of visibles, a system of visual significances learned from the practice of pictorial representation.

I recognize that I have just made a nasty speculative move, and that I am hypothesizing an extension of "physiology" to include "set" (*Einstellung*). But there is enough empirical work in cognitive psychology and in cognitivist-oriented neurophysiology of vision (e.g., Penfield, Lettvin) to permit this to be a reasonable speculation, *within* the neurophysiological model. In this context, I would argue that modes of pictorial representation become incorporated in the higher cortical functions of vision as learned or acquired ontogenetic differences in perceptual activity; and that what we may call "styles of seeing" get mapped into the cognitive systems of individuals as

concomitants and as consequences of the adoption of styles of picturing.

3. An objection to my view similar to that presented in the argument from physiology is what I called, above, *the argument from constancy*. Since I have treated this at some length elsewhere, I will give only the briefest discussion of it here.[4] The argument is this: The eye receives variable information concerning such fundamental parameters as shape, size, and color of objects. This is because the visual angle, distance, and conditions of luminosity change from one station-point of the observer to another. And since we move about and so do some of the things we look at, the projection of visual features of the seen world upon our retinas varies with such changes. These variable projections are the visual "appearances." However, the shape and size of objects does not in fact change with changes in visual angle or distance. "Real shape" and "real size" remain constant, though "apparent shape" and "apparent size" change. (Let us leave the other constancies aside here—e.g., color and object-identity—since they require a more extended argument and different considerations.) The variations in appearance may be reconstructed exactly, with respect to shape and size, since geometrical optics gives us the rules for the projective transformations of such features, from three-dimensional objects to their two-dimensional projections onto plane surfaces. Since the retina is such a plane surface, and we know the geometry of the incident light (or we take it to be the Euclidean geometry); and since we also know the optical geometry of refraction through lenses, and of image-formation, we thus can reconstruct what the so-called stimulus-image upon the retina will be, for any shape or size of a visible. We can therefore formulate the rules for the reproduction of such images upon the retina, including the rules for reproducing the appearances of visual objects, with respect to their shape and size, and, for example, their dark-light gradients under given conditions of illumination. A veridical representation of the way things look will therefore simply reproduce this same projection upon the retina. A fixed image, i.e., an image of a fixed object, or of a stopped projection of a moving object upon the retina of an observer's eye at a fixed station point (thus, at a given visual angle and a given distance) will be computable, and in fact Desargue's theorem gives us this, mathematically. It would therefore seem that the picto-

rial representation of objects and scenes with respect to shape, chia-roscuro, and relative size, becomes an algorithmic procedure, and therefore mechanizable. Indeed (difficulties of lens distortion aside for the moment), the camera is just such a machine, ostensibly, and embodies just the optics of "appearances" which this theory pro-poses. And since the eye is conceived of on the model of a camera—(originally, of a *camera obscura*, before photography develops, and then, by dialectical inversion, the photographic camera is conceived of on the model of this sort of eye)—the retinal image becomes the momentary "snapshot." And the simple error of taking the retinal image as what we "see" then becomes possible for theory. (To be fair, Descartes and Newton already knew that we do not "see" our retinal images with some "inner eye," though they held that we see by way of what such retinal images provide.)

Enter Constancy Theory. Since we do not take the objects we see to be changing in the way that their visual "appearances" change, we somehow correct for the variation, by perceptual judgments concern-ing the invariances through transformation of these appearances. Thus, with visual cues from dark-light gradients or gradients of texture, or from surround-cues, or from coordination with touch, we perceive the constancies of shape, size, etc. underlying these variable appearances, by some "unconscious inference" (in Helmholtz's orig-inal version of this theory). Whether such constancy in perceptual interpretation of the given is innate or acquired is a separate point. In any case, as I have argued elsewhere, it is the rules of linear perspec-tive in pictorial representation which yield those "appearances" in the picture upon which the constancy judgment is exercised *in the same way as it is alleged to be upon the visual appearance of the real objects*. Thus, on this argument, realism in representation is *guaran-teed* by the use of the rules of linear perspective, since these rules give us just the correctly reproduced appearance of the visual world. To a single eye. From a fixed point. Which is not the way we see anything, unless we are experimental subjects in a visual perception laboratory. And not even then. For if the eye were really fixed, without nystag-mus and saccadic eye movements—i.e., without the constant scan-ning and exploratory motions of the eye—we would see—nothing.

J. J. Gibson provides the radical alternative to this view. There is, on Gibson's view, no processing of variable appearances to yield a

constancy judgment. Rather, the eye is specifically evolved to pick up just those higher-order invariances from what Gibson calls the ambient light; and to pick them up directly. The optics of vision, on his view, is not the *physical* optics of the standard theories of vision, but rather the *ecological* optics which conceives the stimulus-information directly picked up by the eyes to be that which a moving, living creature in a three-dimensional world would find most useful and necessary, and for which its perceptual system would have evolved. Thus, constancies are not preserved through variation in appearances, but are directly perceived. A veridical picture then presents to the eye the same stimulus-information as does the visual world, by representing these same higher-order invariances. And linear perspective provides only one such presentation of stimulus-information, of an artificial sort, namely, the sort associated with *seeing the world as if it were a picture*, or, in Gibson's terms, seeing the visual *world* as if it were a visual *field*. Gibson's early suggestion is that the visual field—the domain of "aspects" or "appearances" from a fixed station point—"is the product of the chronic habit of civilized men of seeing the world as a picture."[5] But what Gibson needs to add here is that the world as *pictured* is one in which the visual field has been taken to be the visual world-picture in its canonical form, where this visual field has been defined by geometrical optics and the rules of linear perspective. Thus (as Gibson also points out) things in the distance come to *appear* smaller only when the practice of drawing them or representing them as smaller develops. Paying attention to these appearances or aspects, i.e., to the visual field, is an acquired sophistication of human vision, related to the practice of representation, and specifically, to the practice of representing things in a given way, as the canonically correct way, i.e., "realistically."

I have argued, (on Gibsonian and Goodmanian grounds) that Constancy Theory is based on a mistake, as a theory about the perception of the visual world; but that it is the correct theory about the perception of pictures, where these are made in accordance with the rules of linear perspective.[6] In fact, Constancy Theory cannot fail to be correct then, for it simply is the theory which yields that view of real objects which are taken to be the invariants of which perspective representations are *the* variational transformations. But the fact is that *any* alternative set of transformations may be systematically

constructed to yield these same invariances, or constancies, under the appropriate operation. This is simply a geometrical exercise in alternative perspective systems.[7] Thus, it seems to me that the argument from Constancy does not militate at all against the view that *alternative* styles of pictorial representation may equally well be taken to be "realistic," and that pictorial realism is not dictated by conformity to a particular rule of perspective transformation, nor by a particular "look" which things have apart from picturing. If it is true, as Gibson has argued, that the visual *field*, i.e., the "appearances" or "aspects" of the visual world perspectivally presented, is a function of our making of pictures, and therefore pictorializes our view of the world, then there is no good reason to think that alternative pictorializations are not possible. Constancy is no argument for a *given* set of pictorial rules of representation, if an alternative set will yield the same constancy under transformation. This then leaves "realism" open to choice among alternative canons.

I have thus far attempted to meet three major objections to the view that visual perception is historically variable, i.e., logical, physiological, and psychological objections. Each of these objections is, in its own terms, an argument for the ahistoricity or the transhistorical universality of visual perception. Each of these arguments thus proposes that human vision is essentially unchanging in its modes, once it has evolved biologically. The argument from the El Greco fallacy assumes a common "normal" vision as the condition for showing the fallacy, where "normal" contrasts with the "distortion" in El Greco's figural representation. The argument from physiology presupposes a common visual physiology such that "same cause—same effect" holds for all human viewers, apart from pathological conditions of visual reception. Finally, the theory of perceptual constancy holds that there is only one canonical family of perspective variations upon which constancy operates to provide the shape and size invariances in perceptual judgment which conform to the invariances in shape and size of real objects. The history of representation is, on this "Constancy" view, simply the history of the finally successful attempt to find the "correct" rules for representing this canonical set of visual "appearances" in painting and drawing. Therefore, though art has a history (and, in the West, a successful one, crowned with the discovery of linear perspective), visual perception itself is ahistorical, or

biological, or has universal and fixed *a priori* forms. But if my discussion of these objections meets them, at least to the extent of showing that they do not necessarily hold, and that an alternative view is plausible, then the historicity of human vision, beyond the evolutionary biological level, becomes such a plausible alternative. In this sense, the artifact which most clearly relates to the act of visual perception itself is that of visual representation of what is seen.

The praxis which most directly informs vision is the praxis of making visual representations. But, on the view I present here, visual representations do not function as records of what we see, apart from the representations; rather, they function as guides to seeing, as proposals as to what to look for, as anticipations of visual experience. Pictorial representation, in its active role, does not simply map our visual world, as perceptually given, but rather articulates and forms, or reforms our perceptual capacities themselves. It is in this sense that I suggested that human vision is itself an artifact, the product of our historically changing modes of pictorial representation.

Notes

1. Two important works here are M. H. Segall, D. T. Campbell, and M. J. Herskovits, *The Influence of Culture on Visual Perception* (Indianapolis, 1966), which includes also a fine survey of the literature up to that date; and A. R. Luria, *Cognitive Development: Its Cultural and Social Foundations* (Harvard University Press, 1976). (The literal translation of the Russian title, [publ. 1974, Moscow] is *On the Historical Development of Cognitive Processes*.) Luria writes here: "The research reported here, undertaken forty years ago under Vygotsky's initiative and in the context of unprecedented social and cultural change, took the view that higher cognitive activities remain sociohistorical in nature, and that the structure of mental activity—not just the specific content but also the general forms basic to all cognitive processes—change in the course of historical development." See also David French, "Anthropology, Perception, and Cognition," in S. Koch, ed., *Psychology: A Study of a Science* (New York, 1963), vol. 6., pp. 388–428.

2. See, on this, J. J. Gibson, *The Perception of the Visual World* (Boston, 1950); *The Senses Considered as Perceptual Systems* (Boston, 1966); "The Information Available in Pictures," *Leonardo*, 4 (1971), 27–35; E. Gombrich, *Art and Illusion, a Study in the Psychology of Pictorial Representation* (New York, 1960); "The 'What' and the 'How': Perspective Representa-

tion and the Phenomenal World," in R. Rudner and I. Scheffler, eds. *Logic and Art: Essays in honor of Nelson Goodman* (Indianapolis, 1972), pp. 129–49; "Mirror and Map: Theories of Pictorial Representation," *Philosophical Transactions of the Royal Society of London, B., Biological Sciences*, vol. 270, no. 903 (13 March, 1975), 119–49; Nelson Goodman, *Languages of Art* (Indianapolis, 1968); *Ways of Worldmaking* (Indianapolis, 1978); and the fine discussion of these three views and others in M. Hagen, "Picture Perception: Toward a Theoretical Model," *Psychological Bulletin*, vol. 81, no. 8 (1974), 471–97.

3. See S. Y. Edgerton, *The Renaissance Rediscovery of Linear Perspective* (New York, 1975); "The Renaissance Artist as Quantifier," *The Psychology of Representational Art*, M. Hagen, ed., (forthcoming); "The Influence of Renaissance Art on the Scientific Revolution," (forthcoming).

4. M. W. Wartofsky, "Rules and Representation: The Virtues of Constancy and Fidelity put in Perspective," *Erkenntniss*, 12 (1978), 17–36. See also "Pictures, Representation and the Understanding" in R. Rudner and I. Scheffler, eds. *Logic and Art: Essays in Honor of Nelson Goodman* (Indianapolis, 1972), pp. 150–62.

5. J. J. Gibson, "The Visual Field and the Visual World: a reply to Prof. Boring," *Psychological Review*, 59 (1952), 149.

6. M. W. Wartofsky, "Rules and Representation . . . ," op. cit.

7. See Horacio C. Reggini, "Perspective Using Curved Projection Rays and its Computer Application," *Leonardo*, vol. 8 (1975), 307–12.

GODFREY VESEY

4 Of the Visible Appearances of Objects

Although John Locke was neither the first nor the last philosopher to address a problem which artists and aestheticians as well as other philosophers constantly must face, he exerted a telling influence on its history. In his *Essay* he observed, "When we set before our eyes a round globe . . . it is certain that the idea thereby imprinted in our mind is of a flat circle."[1] According to David Hume, Locke was not alone in thinking that visual perception involves something two-dimensional: "It is commonly allowed by philosophers that all bodies which discover themselves to the eye appear as if painted on a plain surface."[2]

Philosophers, and especially philosophers of art, who say that visual perception involves something two-dimensional usually go on to say that it involves something else, a judgment whereby we get from the two-dimensional to the three-dimensional, the world of solid objects at a distance from the perceiver. At the same time they grant that this account of visual perception does not accord with how things seem to "the vulgar." The vulgar, they explain, mistake what is really something judged for something we just see. René Descartes, for instance, says that the size, shape, and distance of a staff "clearly depend upon the understanding alone," but "are vulgarly assigned to sense." Why? "The reason for this is just that in these matters custom makes us reason and judge so quickly, or rather we recall the judgments previously made about similar things; and thus we fail to

distinguish the difference between these operations and a simple sense perception."[3] Locke gives much the same explanation. The judgment is "performed so constantly and so quick, that we take that for the perception of our sensation which is an idea formed by our judgment."[4]

It is hard to see how this explanation can do what is required of it. In making a judgment a person can be right or wrong. But it makes no sense to say of something imprinted that it is right or wrong. This difference remains however constantly or quickly a judgment ensues on what the advocates of the theory call a "sensation" or "impression."

Perhaps Locke did not recognize the difference because he used the same word, "idea," both for what we would ordinarily call an idea and for what is imprinted in, or on, the mind, the "sensation." Spinoza called Locke's "sensation" an image, and warned about not distinguishing between an idea, as something affirmed or denied, and an image: "I warn the reader to make an accurate distinction between idea, or a conception of the mind, and the images of things . . . Those who think that ideas consist of images which are formed in us by the concourse of bodies . . . regard ideas as lifeless pictures on a board, and preoccupied thus with this misconception they do not see that an idea, insofar as it is an idea, involves affirmation or negation."[5] Locke seems not to have heeded Spinoza's warning.

If Locke's account is rejected then we are back with the admission that our visual experience does not seem to accord with the impression theory. What really happens when we look at a globe, or a painting? Are we wrong about our perceptual experience, or is the impression theory a false theory? Let us discuss these questions separately.

Let us begin with the proposition that our visual experience *does* somehow involve a judgment. Can some account be given of how it does so which does not commit us to the theory that there are two distinct elements in visual perception, something two-dimensional, picture-like, on the one hand, and a judgment, on the other?

I shall approach this question via consideration of two senses of "appearance." What Thomas Reid says in a section entitled "Of the visible appearances of objects" in his *Inquiry into the Human Mind* will provide a convenient entry into the discussion.[6]

I. The Meaning of "Appear to Be"

At the beginning of the section[7] Reid considers the artist's need to acquire "the habit of distinguishing the appearance of objects to the eye, from the judgment which we form by sight, of their colour, distance, magnitude, and figure." Painting, he says, is "the only profession in life wherein it is necessary to make this distinction."

It is necessary for the painter to make the distinction because unless what he captures on his canvas is what Reid calls "the appearance of objects to the eye" the viewer of the painting will not make the right judgments. That is, he will not make the same judgments as he would make if he were viewing the scene itself. Suppose, for example, that the sea is such that one might remark on its blueness. If the painter were to use the same intensity of blue for the sea both near and far then the effect would not be at all realistic. For the sea to be judged to be the same color the painter has to paint it different colors. There has to be a degradation of the color on the canvas to correspond to the distance of the sea in the scene depicted. The masters in painting, Reid says, "know how to make the objects appear to be of the same colour by making their picture really of different colours." It is his use of "appear to be" that concerns us. What is this sense of "appear to be?"

In the *Shorter Oxford English Dictionary*[8] there are eight meanings of "appear" listed. The seventh is "to be in one's opinion; to seem." Does this help? Is "The sea appears to a viewer to be the same color all over" simply an alternative way of saying "The viewer is of the opinion that (or judges that, or thinks that) the sea is the same color all over?" The trouble with this is that the viewer, to whom the sea appears to be uniformly blue in the sense of "appears" in question, may in fact think that the sea merely reflects the color of the sky, or even that colors exist only in the mind. If "appears" is the logical complement of "thinks," so that "X appears ϕ to Y" means "Y thinks X is ϕ," then the thinking involved must somehow be on a different level, or something, to what we ordinarily understand by thinking. Otherwise the "thought" that the sea is uniformly blue, which is the logical complement of its appearing to be uniformly blue, could not consistently be entertained along with the thought that the sea is not really blue at all.

The position we have reached is that when it is said that the sea appears to a viewer to be uniformly blue this is neither a statement about what Reid calls the "visible appearance" of the sea, nor straightforwardly a statement about the viewer's opinion. It begins to look as if "the appearance of objects to the eye" and "the judgment which we form by sight" do not constitute a dichotomy. Both the rationalists and the empiricists of the seventeenth and eighteenth centuries thought in terms of a dichotomous division between sensing and thinking. It begins to look as if there is a sense of "appears" which is the complement neither of "senses" nor of "thinks."

This may become clearer if we consider a different example, the Müller-Lyer illusion (Figure 4-1). In some sense of "appears" one of

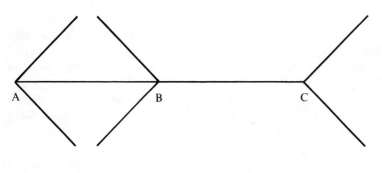

Figure 4-1.

the lines in the familiar Müller-Lyer figure AB appears shorter than the other, BC. It is not the sense in which a lamppost in the distance appears shorter than one a few feet away. That is, the appearance of AB being shorter than BC is not what may be called a "perspectival appearance." If I trace the two lines on a transparent screen between my eye and the lines, the lines in my tracing, as in the original, will be equal in length. Furthermore, "AB appears shorter than BC" does not mean the same as "AB is in my opinion shorter than BC." AB still appears shorter than BC even after I have measured them and found them to be equal.

All the same, opinions do come into it somehow. But how? I said, above, that if "appears" is the logical complement of "thinks" then

"the thinking involved must somehow be on a different level, or something, to what we ordinarily understand by thinking." By considering what our two examples, the apparently blue sea and the apparently unequal lines, have in common, it is now possible to take this a stage further. What they have in common is that we have qualms about both "The sea *is* blue" and "The lines *are* unequal." We say "The sea appears blue" and "AB looks shorter than BC" because we have reason to refrain from the stronger statement. Someone who did not know about the Müller-Lyer illusion being an illusion might well say "AB is shorter than BC" (if the appearance was not misleading in this way we would not call it an "illusion"). What this means is that the appearance, in the nonperspectival sense, can be identified by the use of a hypothetical statement. The appearance is such that *if* the viewer did not know better *then* he would say "AB is shorter than BC." The point of saying "AB *looks* shorter" is to exhibit one's sophistication in the matter. And the same goes for "The sea looks blue." One does not say of a cornflower that it looks blue—unless, of course, one wants to exhibit one's sophistication in the matter of colors being "secondary qualities."

The nonperspectival appearance, then, is identified by reference to a thought from which we wisely refrain, a "would-be" thought. Since it has this connection with thoughts I shall call it the epistemic or cognitive appearance.

That one does not say of a cornflower that it looks blue is a linguistic point, not a psychological one. If someone, looking at a flower, said, "It's blue," on account of what he saw, drawing no inferences, and not lying, then it would be psychologically true to say that it looked blue to him even though it would be linguistically odd to say this if one had no reason to doubt that the flower was blue. The fact that we may have no reason to say of someone looking at a blue flower that it looks blue to him does not mean that it does not look blue to him. Whenever anyone, Y, is in a position to say "X is ϕ" on account of what he sees, drawing no inferences, and not lying, then it is true to say that X appears to him to be ϕ, even if it goes against our linguistic practice of saying "X appears to Y to be ϕ" only if we have a reason not to say "X is ϕ." In this sense, epistemic appearances are coextensive with empirical knowledge, and without epistemic appearances there would be no empirical knowledge.

II. Differences between Epistemic and Perspectival Appearances

There are four related conceptual differences between epistemic and perspectival appearances. (i) Epistemic appearances are subjective, whereas perspectival appearances are objective. (ii) It makes no sense to say that X appears to be ϕ to Y but Y does not know it, whereas it does make sense to say that X presents such-and-such a perspectival appearance to the point of view Y occupies but Y does not know it. (iii) X can appear to be ϕ to Y only if Y possesses the concept ϕ; nothing similar can be said about perspectival appearances. (iv) Epistemic appearances are related to their objects by being true or false of them, whereas perspectival appearances are related to their objects mathematically. All these differences require elucidation.

(i) Reid remarks that "a man born blind, if he were instructed in mathematics, would be able to determine the visible figure of a body, when its real figure, distance, and position, are given."[9] Another way of putting this would be to say that the perspectival appearance of an object at a point of view is a function of the object's real figure, its inclination relative to the point of view, and its distance from the point of view, and is a function of nothing else. To the perspectival appearance at that point of view being what it is it makes no difference whether or not the point of view is occupied by a viewer. The perspectival appearance, in other words, is objective. It is as objective as the object of which it is a perspectival appearance. There could still be perspectival appearances of objects to points of view even if all sentient life ceased to exist.

The epistemic appearance, on the other hand, is subjective. Think, for example, of the well-known figure (Figure 4-2) which originally appeared in the *American Journal of Psychology*.[10] Sometimes it looks like an old woman with a large hooked nose, at other times like a charming young lady with her face turned away over her right shoulder. The old woman's sharp mouth is the young lady's neckband. "Now it appears to be a picture of an old woman" invites the question "To whom?" Epistemic appearances are appearances of objects to beings capable of recognizing them. There would be no epistemic appearances were there no such beings.

(ii) In the epistemic sense of "appears" it makes no sense to say that

Figure 4-2.

the sea appears to be blue to someone but he does not know it, or that line AB appears to him to be shorter than line BC but he does not know it, or that the young lady/old woman figure appears to him to be a drawing of a young lady but he does not know it. On the other hand, in the perspectival sense of "appears" an object can present a certain appearance to someone occupying a certain point of view and he may not know it. Even if he is trying to attend to the perspectival appearance presented to his point of view he may get it wrong. Psychological experiments have proved this.[11]

(iii) I remarked above that epistemic appearances are identified by reference to a thought from which we wisely refrain, a "would-be" thought. We say, for example, "Looking at the Müller-Lyer figure, I would have said that AB was shorter than BC had I not known it to be an illusion." To be capable of such a thought one must possess the relevant concept, in this case that of length. AB cannot appear, in the

epistemic sense of "appear," to me to be shorter than BC unless I possess this concept. Similarly the young lady/old woman figure cannot appear to me to be a picture of a young lady unless I possess the concept of age, and all the other concepts involved in that of age. Epistemic appearances are concept-dependent.

Perspectival appearances, on the other hand, are not concept-dependent. Since they are objective the question of whether or not someone possesses a concept does not arise.

(iv) Epistemic appearances are true or false of their objects. A cornflower appears to be blue, and it is blue. The sea appears to be blue, but it is not really blue; it merely reflects the sky. AB appears to be shorter than BC, but is not; the appearance does not correspond to reality; the appearance, we might say, is nonveridical. If most experiences were nonveridical—or, to put it another way, if seeing did not usually justify believing—we probably would not survive for long. Nature has seen to it that for the most part we see things as they are, and so have little occasion to say "It appears to be. . . ."

Epistemic appearances can be true or false of objects by virtue of being identified by reference to would-be thoughts about them. Perspectival appearances are not so identified. Given an object and a point of view relative to it the perspectival appearance the object presents to that point of view is determined mathematically. It makes no more sense to say that the perspectival appearance is true (or false) of the object than it would be to say that the size of the angle of a triangle is true (or false) of the other two angles, which determine its size.

III. Is The Impression Theory False?

In the introduction I raised the question "Are we wrong about our perceptual experience, or is the impression theory a false theory?" To accept what I have been saying about epistemic appearances is to accept that our visual experience does somehow involve a judgment about what we are looking at, whether in our experience of works of art or in ordinary visual experience. Locke was evidently not prepared to accept this. Doubtless he acknowledged the epistemic sense of "to appear to be" in his everyday life and conversation. But he did not acknowledge it in his philosophy. Why not?

The story goes back to Descartes. He conceived of mind and

matter as two substances the relation between which can only be a causal one. Moreover, the only properties he would allow to matter were ones that can be dealt with by the science of mathematics. Sensible colors, sounds, tastes, and so on, must somehow be fitted into the mind side of the mind/matter divide. They must be what Robert Boyle later called "secondary" qualities.

If the mind is so conceived that its relation to the world can only be a causal one then to perceive something must be to be causally affected by it. Now, most of our everyday talk about the objects of perception does not reflect this. As Thomas Reid remarked, in a passage that could be mistaken for one by the twentieth-century Oxford philosopher J. L. Austin:

> There is a figurative meaning of impressions on the mind . . . but this meaning applies only to objects that are interesting. To say that an object which I see with perfect indifference makes an impression upon my mind is not, as I apprehend, good English. . . . When I look upon the wall of my room, the wall does not act at all, nor is capable of acting; the perceiving is an act or operation in me. That this is the common apprehension of mankind with regard to perception is evident from the manner of expressing it in all languages.[12]

To someone who holds the Cartesian view it must seem that only something we would hardly call "perception" reflects the philosophical truth of the matter. I may say that I "perceive" the indigestibility of something I have eaten through its effects on me, the unpleasant feelings I have in my stomach. Allowing that, being feelings, they are, more accurately speaking, in my mind, this use of "perceive," though to us a rather strained one, must seem to the Cartesian to be the paradigm for philosophically responsible talk of what it is to perceive something. For only this use of "perceive" exhibits the supposed philosophical truth that perceiving is a matter of being causally affected by something.

It seemed to Locke that the strained sense of "perceive" must indeed be the one on which all the rest of our talk about the objects of perception should be fashioned. The example in terms of which he expounds his Cartesian theory of perception is that of eating manna. Of the various meanings of "manna" perhaps "course granular wheat meal" makes most sense in the context. Locke notes[13] that "manna, by the bulk, figure, texture and motion of its parts, has a power to

produce the sensations of sickness, and sometimes of acute pains or gripings in us." He then goes on to declare that "as the pain and sickness caused by manna are confessedly nothing but the effects of its operation on the stomach" so sweetness and whiteness are "but the effects of the operations of manna by the motion, size, and figure of its particles on the eyes and palate." He notes that "men are hardly to be brought to think that sweetness and whiteness are not really in manna," but this does not lead him to question his declared view that sweetness and whiteness are on a par with the "ideas of sickness and pain," ideas which "are not in the manna, but effects of its operations on us, and are nowhere when we feel them not."

Locke's use of the term "ideas ("ideas of sickness and pain") is a clue as to why the manna→gripings model for talk about the objects of perception appealed to him so much. In spite of the causal theory's having been taken over from the rationalist, Descartes, it could be put to use in the interests of empiricism. If the things produced in us through perception are ideas, i.e., the very same things that are the meanings of words, then words have meaning for us by virtue of our present-life perceptual experiences. And the nonempiricist theories that they have meaning for us by virtue of our having encountered Platonic Forms in an earlier nonbodily life, or by virtue of having had ideas put into our minds by God, or by virtue of our having been born with them, can all be happily abandoned.

The stock objection to Locke's identification of the "idea" that is the meaning of the word "pain" with the "idea," the feeling or sensation, that is caused in us when we eat too much manna is that what someone needs, in order to be able to use the word "pain" meaningfully, is not pain, but the *concept* "pain." This is clear in the case of the thought that someone else is in pain. As Ludwig Wittgenstein puts it:[14] "In order to doubt whether someone else is in pain he needs, not pain, but the *concept* 'pain.'"

But what is it to have the concept "pain" if not to have in one's mind some notion of what the word means, a notion presumably acquired by experiencing pain? Wittgenstein says: "You learned the concept 'pain' when you learned language."[15] To understand this remark it is necessary to appreciate how radically Wittgenstein's conception of language, in the *Investigations* and *Zettel*, differs from that of John Locke.[16]

In brief, Locke[17] followed Thomas Hobbes[18] in thinking of language as something to be understood in terms of thoughts. He held what may be called the "thought→speech→thought" or "translation" theory of communication. Hobbes had said, "The general use of speech is to transfer our mental discourse into verbal; or the train of our thoughts, into a train of words." Just as Hobbes distinguished between mental discourse and verbal discourse, so Locke distinguished between "mental propositions" and "verbal propositions." And he held the elements of mental propositions to be ideas, just as those of verbal propositions are words. These ideas are, or are derived by "abstraction" from, the ideas (= feelings, sensation) said to be caused in us when we perceive things, on the manna→gripings model for talk about the objects of perception. If we wonder why it is not generally recognized that there are, besides verbal propositions composed of words, mental ones composed of ideas, an explanation is readily available: " . . . it is very difficult to treat of them asunder. Because it is unavoidable, in treating of mental propositions, to make use of words; and then the instances of mental propositions cease immediately to be barely mental, and become verbal."[19]

Wittgenstein, on the other hand, thought of thinking as something to be understood in terms of language; and of the meaningfulness of a linguistic utterance as something to be understood in terms of a linguistic practice. We are right in distinguishing between a sentence and its sense. But we are wrong in thinking of the sense as something—*some thing*—behind the sentence. It is the sentence, and nothing else, which has sense, and it has sense by virtue of there being an accepted common practice with sentences like it, and others. It is this accepted common practice, not the existence of mental propositions composed of gripings-like ideas, which makes communication possible. An expression has meaning by virtue of its use conforming to the accepted common practice. In this connection we may even talk of rules of language, as if a linguistic practice were like a game. Because the practice is something in which people share, there are behavioral criteria for saying that someone has cottoned on to the use of an expression. A person without the use of his sense of sight would certainly not be in a position to make the same use of color words as the rest of us. Moreover, he would not be in *the same* position as the rest of us to cotton on to their use. But to say this is not to

say that sighted people acquire color concepts by "experiencing" colors. To say this would be like saying that people acquire the concept of the past by experiencing it in memory.

All this about Descartes's doctrine that mind and matter are two causally-related substances, about the manna→gripings model for talk about the objects of perception, and about the empiricist doctrine about how language is meaningful, has been with a view to understanding why Locke could not acknowledge the existence of the epistemic appearances of objects. There are two reasons, one arising from the manna→gripings model, the other from the empiricist doctrine about how language is meaningful.

(i) If seeing something is like eating it with the eye, so that it gives us sensations in our eyes[20] as eating manna gives us "sensations of sickness, and sometimes of acute pains or gripings" in our stomachs, then what physically enters the eye comes to have an importance not only for understanding the physical *mechanism* of visual perception, but also for understanding the *concept* of visual perception. Now the lens in the eye forms an image on the retina, and, granted that physical space is Euclidean, that light travels in straight lines, that the lens in the eye is optically perfect, that the retina is uniformly curved, and so on, the image will be related by the mathematical laws of perspective to the object of which it is an image. If seeing the object is then thought of, as required by Descartes's concept of mind, as the mind being affected by it, that is, of there being an impression not only on the retina but also on the mind, then the obvious candidate for the impression on the mind will be something that corresponds to the image on the retina. For example, if I look at a round globe then the image on my retina will be circular, and there will be no reason to suppose that the idea imprinted in my mind will be anything other than that of a flat circle. Unless one supposes there to be two categorially different kinds of appearances presented to the mind it will then seem that this flat circle must be the only object of visual perception, and the round globe I seem to see, the epistemic appearance, must really be a judgment I mistake for a sensation. I am so used to leaping from the sensation, the flat circle, to the judgment, a globe, and do it so quickly, that I do not notice I have done it.

Before going on to the second reason for Locke's not acknowledging the existence of epistemic appearances I must correct a false

impression I may have given, that all the seventeenth-century philosophers who succeeded Descartes toed the Cartesian line about the mind perceiving things by being causally affected by them. One of the interesting exceptions was Antoine Arnauld. His principal work in philosophy,[21] is a detailed refutation of Nicolas Malebranche's Cartesian theory of perception and of his non-Cartesian, Augustinian, doctrine of "vision in God," the doctrine from which George Berkeley sought to dissociate himself. With regard to the former, Arnauld argued against Malebranche that "objective presence" to a mind does not require "local presence"; and that for something to be objectively present to a mind is not the same thing as for it to be causally active on it. Intermediary entities called "ideas" are needed neither as local presences nor as effects. The only "ideas" are acts of perception, and these in no sense come between the perceiver and the object perceived. The concept of mind is such that we should not wonder how material objects can be present to it.

Locke read Malebranche. His *Examination of Malebranche's Opinion* appeared in 1706. But he had probably not read Arnauld, at any rate by the time he wrote the *Essay*. Reid was familiar with the works of both Malebranche and Arnauld, and expressed views strikingly similar to those in the latter's *Treatise* in his own *Essays on the Intellectual Powers of Man*.[22]

(ii) The reason arising from the empiricist doctrine about how language is meaningful is fairly obvious. Epistemic appearances are concept-dependent, by virtue of being identified by reference to would-be thoughts. Someone who has not the concept of age cannot be expected to see someone as young or old. If, then, someone had to appear old to him for him to acquire the concept "old," he would never get started. Whatever the empiricists' originative material for concept-abstraction may be, it cannot be epistemic appearances. For an object to appear to be ϕ to someone, in the epistemic sense of "appear," he must already have the concept ϕ.

IV. Wittgenstein, and "So we interpret it, and see it as we interpet it."

Locke attempted to explain epistemic appearances in terms of sensations leading so quickly on to judgments that we mistake the judgments for sensations. Given a dichotomous division between sensing

and thinking this would appear to be the only option open to him.

In Wittgenstein's *Philosophical Investigations* there is what can be construed as an argument to show that the explanation cannot work:

> You could imagine the illustration (Figure 4-3) appearing in several places in a book, a text-book for instance. In the relevant text something

Figure 4-3.

> different is in question every time: here a glass cube, there an inverted open box, there a wire frame of that shape, there three boards forming a solid angle. Each time the text supplies the interpretation of the illustration.
> But we can also *see* the illustration now as one thing now as another.—
> So we interpret it, and *see* it as we *interpret* it.
> Here perhaps we would like to reply: The description of what is got immediately, i.e. of the visual experience, by means of an interpretation—in an indirect description. "I see the figure as a box" means: I have a particular visual experience which I have found that I always have when I interpret the figure as a box or when I look at a box. But if it meant this I ought to know it. I ought to be able to refer to the experience directly, and not only indirectly. (As I can speak of red without calling it the colour of blood.)[23]

When Wittgenstein says "Each time the text supplies the interpretation of the illustration," I think he means "Each time the text indicates how we are to treat the illustration." The same figure occurs in several places in a textbook. Sometimes we are to treat it as a drawing of a box, sometimes as one of wire frames. If there are nine straight lines in the figure, then interpreting it as a drawing of a box means, among other things, thinking that the box is not made of transparent material. Otherwise there would be twelve lines in the

figure. The nine-lined figure represents a normal twelve-edged non-transparent box. Interpreting the figure as a drawing of a wire frame, on the other hand, means thinking of there being just nine pieces of straight wire in the frame. In the latter case we apply the figure differently; the rules of projection are not the same. The text indicates how we are to treat, how we are to apply, the figure. This is what interpreting it is.

Having said "Each time the text supplies the interpretation of the illustration. But we can also see the illustration now as one thing, now as another," Wittgenstein imagines someone like Locke—though he does not mention Locke—saying that "I see the figure as a box" means "I have a particular visual experience which I have found that I always have when I interpret the figure as a box or when I look at a box." To which he, Wittgenstein, replies: "But if it meant that, then I ought to know it, I ought to be able to refer to the experience directly, and not only indirectly. (As I can speak of red without calling it the colour of blood.)"

This is not an easy point to grasp. Let me rephrase it. Wittgenstein says that in addition to interpreting (= treating, applying) the figure in different ways, we can also see it in different ways: now as one thing, now as another. The question is: what is it to *see* something *as* something? Does "I see the figure as a box" mean "I am experiencing something, something an artist could put on paper, which I have found I experience when I am prepared, by the text, to apply the figure in certain ways?"

Wittgenstein uses another illustration which may help to make the point clearer, the familiar "duck-rabbit." At one moment I see it as a drawing of a duck, at the next as that of a rabbit. Is the difference one which I could apprehend without any thought of ducks and rabbits? When I say "Now I see it as a duck" am I saying that I have a certain Lockean visual sensation—that is, that the figure appears to me, in a non concept-dependent sense of "appears," in a certain way—which I have found I always have when I am led by the accompanying text to apply the figure in a certain way? If "Now I see it as a duck" did mean this, then the sensation would have to be such as to lead to the judgment "a drawing of a duck" and not such as to lead to the judgment "a drawing of a rabbit." But in that case it cannot be "a sensation of the lines on the paper." For that, on Locke's understand-

ing of how visual sensations are related to impressions on the retina, is the same in the two cases of my seeing the figure as a drawing of a duck and my seeing it as a drawing of a rabbit.

Earlier we considered an objection to Locke's explanation of why our perceptual experience does not seem to accord with the impression theory of perception. His explanation was that "we take that for the perception of our sensation which is an idea formed by our judgment." The objection was that we can be right or wrong in what we judge, but that it makes no sense to talk of something imprinted, an impression or sensation, being right or wrong. This makes it difficult to see how the judgment could be mistaken for a sensation.

Wittgenstein's argument provides us with a related objection to Locke's explanation. On Locke's understanding of visual experience there is no means of explaining, in terms of what he experiences, why a perceiver should at one moment say "a drawing of a duck" and at another "a drawing of a rabbit." Far from explaining how judgment arises out of experience the holder of the impression theory of perception makes the connection inexplicable, whether we speak of the visual experience of a globe, a duck-rabbit, or a Constable painting of a corn field.

Notes

1. John Locke, *An Essay Concerning Human Understanding* (1690), J. W. Yolton, ed., 2 vols. (New York and London, 1961), II. ix. 8.
2. David Hume, *A Treatise of Human Nature* (1739), L. A. Selby-Bigge, ed. (Oxford, 1896), I. ii. 5.
3. René Descartes, *Philosophical Works of Descartes*, tr. E. S. Haldane and G. R. T. Ross (New York, 1955), II. p. 252.
4. John Locke, *Essay*, II. ix. 9.
5. Baruch Spinoza, *Ethics* (1677), tr. W. H. White and A. H. Stirling (Oxford, 1927), II. 49.
6. Thomas Reid, *Inquiry into the Human Mind* (1764), in *Works*, Sir William Hamilton, ed., 2 vols. (Edinburgh, 1846-1863).
7. Thomas Reid, *Inquiry*, VI. 3.
8. *Shorter Oxford English Dictionary* (Oxford, 1964).
9. Thomas Reid, *Inquiry*, VI. 7.
10. *American Journal of Psychology*, 42 (1930), 444.
11. R. H. Thouless, "Phenomenal Regression to the 'Real' Object," *British Journal of Psychology*, XXI (1931), 339-59.

12. Thomas Reid, *Essays on the Intellectual Powers of Man* (1785), A. D. Woozley, ed. (London, 1941), Abridged, II. 4.

13. John Locke, *Essay*, II. viii. 18.

14. Ludwig Wittgenstein, *Zettel*, G. E. M. Anscombe and G. H. von Wright, eds., tr. G. E. M. Anscombe (Berkeley, 1967), p. 548.

15. Ludwig Wittgenstein, *Philosophical Investigations*, G. E. M. Anscombe and Rush Rhees, eds., tr. G. E. M. Anscombe (New York, 1953), I. p. 384.

16. I have discussed this elsewhere: Godfrey Vesey, "Locke and Wittgenstein on Language and Reality," in H. D. Lewis, ed., *Contemporary British Philosophy* (London, 1976), pp. 253-73; and the Foreword in Godfrey Vesey, ed., *Communication and Understanding* (Atlantic Highlands, N.J., 1977), pp. ix-xxii, and have space here to give only a summary account of the difference.

17. John Locke, *Essay*, III. i. 1-2, III. ii. 1.

18. Thomas Hobbes, *Leviathan, The English Works of Thomas Hobbes* (1651), Michael Oakeshott, ed. (Oxford, 1960).

19. John Locke, *Essay*, IV. v. 3.

20. Reid shared Locke's view, but commented: "Though all philosophers agree that in seeing colour there is sensation, it is not easy to persuade the vulgar that in seeing a coloured body, when the light is not too strong nor the eye inflamed, they have any sensation or feeling at all." (*Essays*, II. 18).

21. Antoine Arnauld, *Treatise on True and False Ideas* (1683), in *Oeuvres*, (Bruxelles, 1964-67).

22. Thomas Reid, *Essays on the Intellectual Powers of Man* (1785), ed. and abridged by A. D. Woozley (London, 1941).

23. Ludwig Wittgenstein, *Philosophical Investigations*, II. xi, pp. 193-94.

ALAN TORMEY

5 Seeing Things: Pictures, Paradox, and Perspective

There is a recent issue of a national magazine on the desk in front of me. On the cover is a picture of Albert Einstein. I have no trouble in recognizing it as (a) a picture, and (b) a picture of Albert Einstein. Why should I? I live in a world congested with pictures. Yet, we are continuously reminded by serious students of perception that "Pictures are unique among objects; for they are seen both as themselves and as some other thing, entirely different from the paper or canvas of the picture. *Pictures are paradoxes.*"[1] Worse yet, for the process of picture perception, pictures are "infinitely ambiguous." A two-dimensional image may represent any of an infinite number of possible three-dimensional objects or scenes; and then there is the familiar catalog of laboratory illusions, figure-ground reversals, and the deliberate (and different) spatial legerdemain of Escher and anamorphic art.

If all this complicates our efforts to explain pictorial perception, it also discloses dimensions of perceptual possibilia that are absent or rare in our encounters with the merely real world. Ironically, the picture world is richer than the real world, and the realm of the picturable spills over the world of actual (actual *and* possible) objects as Escher has so tirelessly and tendentiously shown. (There are constraints, however, even in *im*possible worlds. In *Belvedere,* Escher depicts a man holding a Necker cube—a standard "impossible object." Could he have also depicted a man holding or drawing a square circle? It would be interesting to know the logical limits that edge the border between impossible objects that can and those that cannot be pictured.)

59

Pictures, together with visual illusions, constitute the primal epistemic shock for naive realism. In a world devoid of both, the rift between appearance and reality would remain forever unnoticed. Pictures, then, are both perceptual puzzles and epistemic tools, and one may become interested in knowing how the tools work without at first being much concerned with what in fact is pictured. Hence, the philosophy and psychology of picture perception in contrast with iconography and iconology.

I. Pictures and Objects

"Seeing pictures," Richard Gregory concludes, "is very different from seeing normal objects. This means that pictures are *not* typical objects for the eye, and must be treated as a very special case."[2] Thus, picture perception becomes a "problem" to be solved against the backdrop of our understanding of the supposedly less troublesome process of normal object perception. As a methodological tactic this is unexceptionable, but philosophically Gregory's claims are deeply problematic, particularly since they suggest that "normal object perception" is less ridden with ambiguities and paradoxes than the purportedly derivative perception of pictures. But is this so? Consider the following four central contentions:

(1) Pictures are paradoxical (it is said) " . . . in being physically patterns of marks on a flat sheet, but visually both flat objects and three-dimensional objects in a quite different space. This is the essential double-reality of pictures, which makes them unique as visual objects of perception."[3] Philosophers may be inclined to dismiss this ostensible paradox by insisting on a distinction between physical and representational properties and arguing that it is logically impossible for properties belonging to one category to be incompatible with properties belonging to the other, even where properties belonging to different categories are denoted by the same inscription, e.g., "flat." In fact, this seems to me to be a powerful objection. Suppose, however, we concede that pictures are, somehow, paradoxical for the reasons given by Gregory. Does this distinguish them as *unique* objects of visual perception? The argument seems to rest on the contention that pictures appear to have some properties that they do not actually (literally?) have. Real flatness,

only apparent depth, and so on. If *this* is the reason for considering pictures paradoxical objects of perception, then we have equally good grounds for considering real objects analogously prone to paradox. Consider distance perception. A mountain range at sufficient distance from the viewer will appear virtually flat. Moving toward it, it will eventually disclose its "real" property of mass. Now consider a trompe l'oeil painting. Viewed from the right distance (and position) it will appear full-bloodedly three-dimensional. Move forward and it will dematerialize along one dimension revealing its "true" property, flatness. These two situations are logically equivalent and symmetrically inverse. Is one then "paradoxical" and the other not? This is not to argue, or imply, that pictures and nonpictorial objects present us with identical perceptual prospects. It *is* to argue that pictures as a class of perceptual objects are no more paradoxical than real things if the paradox is grounded in the object's appearing, under some stipulated conditions, to have properties that are incompatible with properties that it does in fact have.[4]

(2) "Pictures can present mutually incompatible depth-features. These would be paradoxical even with no hint of a background. Since the artist is free to present any depth-features he wishes in a picture, he can produce a great variety of paradoxes of this kind. But this cannot occur in objects."[5] But it can. Anything that can be pictured can be modelled in three-dimensions to give the equivalent visual appearance from a prescribed viewpoint (similar to the station point of linear perspective). This does not mean of course that it is possible to construct three-dimensional models of "impossible objects," only that models may be constructed to give the illusory appearance of being such objects from the appropriate angle. (Walking around the model would expose the trick.) Gregory, himself, has constructed such an object.[6] Projective geometry and the optical laws governing stereography apply as well here as they do in standard cases of projecting three-dimensional objects onto two-dimensional surfaces.

(3) "Pictures can appear paradoxical when the observer happens or is led to select an inappropriate 'object-hypothesis' for interpreting—seeing—the picture in terms of normal objects."[7] This of course is true also for normal object perception when an "inappropriate 'object-hypothesis'" is selected for interpreting non-pictorial

visual data. We can get it wrong in both ways, and in both, the paradox is only apparent.

(4) "There are other kinds of paradoxes in pictures besides depth-paradoxes. A painting of a ship does not have to be full-sized for the painting to be *seen* as a full-sized ship. When it (or a model) is seen as both its true size and as a full-sized ship, it is perceptually paradoxical."⁸ Does it ever happen that one sees a picture of a ship as "both its true size and as a full-sized ship?" The description is unclear. There would indeed be a problem if the pictured ship were seen as *being* both its true pictorial size and the size of the ship depicted. But that is more impossible than paradoxical. It would be more natural, and less provocative, to say that while we perceive the "real" (paint co-extensive) size of the ship we also see it as a depiction of a much larger object. And what is paradoxical in this? One of the most universal pictorial conventions provides for disparity of scale between picture and object.⁹ There *is* a problem with scale disparity, but it is more an aesthetic concern. Those who have seen reproductions of El Greco's *Christ on the Mount of Olives* and then see the original (National Gallery, London) commonly experience a perceptual shock: the work is artistically monumental and physically small. There is nothing, however, paradoxical in small-scale representations of monumental subjects. At worst, the perceptual shock betrays a sense of tension or lack of congruity between the dimensions of vehicle and content, and reminds us forcefully that representations are neither surrogates nor duplicates, and that iconic conventions may license and encourage deliberate exaggeration in the disparity of scales. (Consider Persian miniatures as an instance of one extreme.)

We began this inquiry with the often voiced contention that pictures are unique and uniquely paradoxical objects of perception. The reasons that are commonly advanced for this view are so admirably presented by Gregory that reflecting on them should enable us to see that, in fact, pictures present us with *no* perceptual paradoxes that are not, or cannot be encountered in normal object perception. The mystery of pictures, if there is one, arises not from their inhabiting just two dimensions but from their status as representations—a class much larger than pictures and in which two dimensions merely marks the logically lower boundary.¹⁰ Pictorial representations have historically been credited with a distinctive status among representa-

tional media, however—a distinction resting on the alleged ability of pictures to represent objects by presenting perceptual appearances that accurately or faithfully mimic the appearances of pictured portions of the world. Although this notion of pictorial fidelity may seem obvious and incontestable it has some formidable philosophical hurdles to clear.

II. Railroad Tracks and Telephone Poles: The Problem of Perspective

Perception and representation are correlative possibilities.[11] The great Renaissance artist-theoreticians, Brunelleschi, Alberti, Piero della Francesca, and Leonardo all thought of the practice of painting and design as a virtual mirror image of the scientific study of visual perception; and much of Renaissance theorizing about the visual arts is derived directly or indirectly from medieval optics. Geometrical laws governing visual perception were described, inverted, and transformed into rules for the production of faithful images of natural scenes and the concept of art-as-imitation-of-nature was given new vitality and renewed plausibility through the construction of a systematic mathematical basis for pictorial representation:

> The mathematical bond between the traditional perspectival theory of vision and the newly forming theory of painting named after it was provided by the idea of the picture as a section of the pyramid of sight. This idea is what enabled Alberti to formulate the problem of depiction as one of applied plane geometry, for his rules of construction clearly stem from the connection he saw between the intersecting picture plane and the intersecting measuring rod of the surveyor (considering the surveyor's rod as an infinitely "narrow" plane intersecting the lines of sight to an object). Surveying and perspective represent two modes of seeing: seeing when measuring a three-dimensional object at a certain distance from the viewer, and seeing a three-dimensional object through a "glass" on which its outlines can be traced. The affinity between the two consists in the fact that the surveyor's sighting, the first mode of seeing, may be interpreted as a special case of the second one. The surveyor's measuring rod and the sightings obtained on it present, in fact, a profile, or one cross section of a visual pyramid when thus interpreted. Alberti made this interpretation; and by this bold stroke of mathematical imagination, he came to model the pictorial representation of things upon the method of geometric surveying.[12]

At long last painting had caught up with music and architecture as a quantitatively respectable occupation. Studying the geometry of visual perception and veridically depicting the seen world were, for Leonardo and his contemporaries, complementary means of investigating and expressing their knowledge of fundamental physical laws and of nature itself. It is not surprising that in this atmosphere the concept of pictorial fidelity was enshrined as the dominant artistic paradigm.

Fidelity is to pictures what truth is to propositions, and just as traditional philosophy preeminently supports a correspondence theory of truth, traditional art theory supports a correspondence theory of fidelity—the correspondence rules being, roughly, those of geometrical or linear perspective.[13] Traditional theories are traditionally challenged, however, and the perspectivally grounded paradigm of fidelity has lately come under heavy siege from philosophers who would have us believe that fidelity is in the eye of the beholder, and that the beholder's share of pictorial perception is governed by habit, convention, history, ideology, or theory.

In what follows, I shall consider only what I take to be the most central and potentially telling arguments against the Renaissance paradigm of pictorial fidelity. If it happens, as I believe, that these arguments are substantially unsound, the possibility of a non-relativistic, non-conventional model of pictorial fidelity will be substantially reinforced.

Various grounds for skepticism toward a mathematically based concept of pictorial fidelity can be located in the literature. I shall restrict my attention to the representative arguments of Nelson Goodman and Marx Wartofsky.

In *Languages of Art*,[14] Goodman, in keeping with his general views on the conventionality of representation, rejects the canonical view that the laws of perspective provide standards of fidelity that transcend differing styles or systems of representation. He is concerned in particular to challenge the claims of E. H. Gombrich and James J. Gibson. As he notes:

> Gombrich derides "the idea that perspective is merely a convention and does not represent the world as it looks," and he declares "One cannot insist enough that the art of perspective aims at a correct equation: It wants the image to appear like the object and the object like the image."

And James J. Gibson writes: ". . . it does not seem reasonable to assert that the use of perspective in paintings is merely a convention, to be used or discarded by the painter as he chooses, . . . When the artist transcribes what he sees upon a two-dimensional surface, he uses perspective geometry, of necessity."[15]

The standard accounts of perspectival representation reduce, crudely, to this: A static object or scene, drawn in correct perspective, will present to an appropriately stationed observer an optic array (a bundle of light rays) isomorphic with the array delivered by the object itself. And since the stationary eye cannot, without further information, distinguish between identical optic arrays, the match between object and picture is sufficient to ensure pictorial fidelity. (Compare Alberti's suggestion that a painting be thought of as a window through which we may see a segment of the visible world.) On the reasonable assumption that there is nothing conventional or relativistic about Euclidian geometrical optics, this matching of optic arrays from object and depiction would seem to provide us with an unimpeachable standard of pictorial fidelity. The principal obstacles to this conclusion are these:

(1) *Optimal conditions of observation are artificial and restrictive.* For a picture in strict perspective to "work," it should be viewed with a single stationary eye through a peephole from a precisely prescribed angle and distance. These restricted viewing conditions are necessary to ensure maximal correspondence between the array delivered by the picture and the array delivered by the pictured object (also to be viewed from a prescribed station point). Goodman objects that even under these remarkable conditions we do not have an ultimately faithful representation. "The basic trouble is that the specified conditions of observation are grossly abnormal. What can be the grounds for taking the matching of light rays delivered under such extraordinary conditions as a measure of fidelity?"[16] He suggests that under conditions no more artificial than these, a picture far out of perspective could be made to yield the same pattern of light rays as the object with the use of specially contrived lenses, and concludes "[W]ith clever enough stage managing we can wring out of a picture drawn in perspective light rays that match those we can wring out of the object represented is an odd and futile argument for the fidelity of perspective."[17] What this example actually demon-

strates is that perspective can be intentionally distorted and then restored through the use of appropriately designed optical apparatus, and this is precisely the technique employed in "anamorphic" art, in which shapes amorphous or anomalous to the unassisted eye become clearly recognizable objects when viewed with the aid of one or another varyingly shaped mirrored surface.[18] Fidelity is *not* preserved by the intentionally distorted picture taken alone; but it *is* preserved by the picture-plus-ancillary-apparatus. What counts is what gets to the eye, not what route it takes, and the artist is entitled to determine the appropriate conditions for viewing his work. Optical tricks with normal object perception also bear this out as, for example, one may get an undistorted view of the world either "directly" or through a pair of distorting lenses the second of which optically compensates for the distortions of the first. The fidelity of perspectival pictures is not in the least threatened by these considerations.

In contrast with the severely restricted viewing conditions imposed in the interests of optimal matching of optic arrays, pictures are normally seen by persons who are free to move about, approaching the picture from an unlimited number of positions. Goodman remarks that "To paint a picture that will under these conditions deliver the same light rays as the object, viewed under any conditions, would be pointless even if it were possible."[19] True, but that is hardly to the point. Pictures are two-dimensional representations, and it is plainly impossible for them to deliver matching optic arrays for a three-dimensional object seen under constantly varying conditions. (Only moving pictures have a shot at doing that.) No theory of pictorial fidelity should be required to encompass the impossible, and yet that is often what seems to be asked of the theory of perspectival fidelity. What the theory *does* provide is commonly ignored or distorted, viz. an *ideal limit* or norm for pictorial fidelity.

> [W]hen all the conditions postulated by the system are observed, as is hardly ever the case in practice, artificial perspective achieves a scientific accuracy and truth to nature which is quite outside the scope of any other system. Under such conditions, the diminution outwards from the visual centre of all visible frontal surfaces is taken care of by the natural foreshortenings of the representational surface.[20]

That the ideal conditions for ultimate fidelity are never realized in practice is hardly good grounds for rejecting the model. Fidelity in

pictures, like fidelity in friends, is a matter of more or less, and the construction of an absolute standard is compatible with the contingent frailty of both pictures and persons. Moreover, the respectability of unrealizable but approachable limits within a system is widely acknowledged; and no physical chemist would complain that perfect equilibrium in a solution is a confused, conventional, or useless concept on the grounds that it is never fully realized. In general, arguments advanced against an objective standard of pictorial fidelity show only that it is an ideal limit of pictorial representation, not that it is either a confused or hopeless relativistic notion.

(2) *Laws and Rules: Pictures drawn in perspective look wrong.* Marx Wartofsky, echoing Goodman's arguments, writes " . . . pictorial representation in accordance with strict linear perspective *looks* wrong." And "The fact that painters have, from the start, modified the rules of strictly geometrical linear perspective bespeaks a certain autonomy in the choice of norms, and in the modification and elaboration of norms in our representational practice itself."[21] He claims further that in perspective representation "the 'likeness' or 'fidelity' of image to object is itself a construct no less subject to rules of representation than any other *non*-perspectival representation. It is just that the rules are different."[22] Goodman had earlier maintained that the "laws of geometry" dictate that telephone poles (or the edges of a façade) moving upward from the eye should be drawn converging, just as railroad tracks moving outward from the eye are drawn, but that " . . . so drawn, they look as wrong as railroad tracks drawn parallel. . . . The rules of pictorial perspective no more follow from the laws of optics than would rules calling for drawing the tracks parallel and the poles converging. In diametric contradiction to what Gibson says, the artist who wants to produce a spatial representation that the present-day Western eye will accept as faithful must defy the 'laws of geometry'."[23]

It is difficult to determine just what the force of these objections is supposed to be. The appeal to what "looks right" (or wrong) *simpliciter* is an odd one coming from an admitted relativist, since the post-Renaissance norm of fidelity adopted by our culture is avowedly that of linear perspective, and a picture drawn in strict accord with those standards ought to look "right." Claiming that it fails to do so is, in effect, to appeal covertly to some pre-theoretical or ahistorical criterion of pictorial fidelity, and that is inconsistent with

the principles of conventionalism. Where a picture drawn in strict perspective looks "wrong" to us, is it not possible that the anomaly has nothing to do with the failure of fidelity but rather with complex and subtle questions of aesthetic content and context, with iconographic or formal flaws that are not, strictly, distortions of fidelity at all? As long as the description "looks wrong" is left as a primitive, unanalyzed entry in the discussion, these questions will remain untouched.[24] (For an historical example of a pictorial system looking right to a culture unacquainted with it, see (3) below.)

The issue of depicted railroad tracks versus depicted telephone poles is somewhat clearer. Goodman's contention is that the disparity shows that the laws of geometrical optics do not determine representational rules and that " . . . the behavior of light sanctions neither our usual nor any other way of rendering space; and perspective provides no absolute or independent standard of fidelity."[25] The straightforward reply to this is that the example is misconceived and the conclusion unwarranted. The reason that railroad tracks are drawn converging is that they extend, on relatively level ground, to a vanishing point at the horizon line where they appear to converge. Telephone poles are comparatively short, and the sky, devoid of horizon lines, provides inadequate background information for us to perceive the very slight convergence in the upward trajectories. If parallel poles were extended, say to a thousand feet, the convergence would be apparent, and a faithful representation would show them that way using converging lines on the picture plane. As for the edges of a façade, one has only to look carefully at a rectangular skyscraper from the base to see the apparent convergence. This commonly experienced illusion in fact led Giotto to utilize "negative perspective" in the design for his Campanile in Florence to offset the usual appearance of such tall buildings: that the edges are converging and the building tilting backward. The compensatory design simply widens the tower as it ascends. What is of importance here is that a faithful depiction of Giotto's Campanile from a normal street-level position would require parallel lines in the picture to present the same appearance as the diverging lines of the Campanile do for the immediate viewer.[26] If the picture is to *salvar le apparenze*—and that is what counts where fidelity is concerned—it must represent the appearance of parallel edges as parallel lines. That

the sides of the Giotto Campanile diverge while the lines of its depiction do not is a result of the disparity of scale between object and picture, and this difference is predictable by, *not* in defiance of, the laws of geometrical optics. If the depiction were as large as the edifice, the edges of both would ascend at the same angle. (Scale disparity is often a blessing.) In short there is nothing conventional in the correspondence between image and object where fidelity of appearance is preserved.

A further and related objection to the objective fidelity of perspectival depiction rests on the contention that the "rules" of perspective are themselves a product of historical or cultural contingencies, that they comprise but one among many alternative and equally valid representational systems or pictorial norms. It is impossible to deal at length with the issue here, but there is one consideration that seems to me to be singularly telling. The rules of linear perspective are the only systematic set of representational rules derived from and grounded in an *optical theory of vision*. These rules are neither conventional nor optional, neither arbitrary nor "autonomously chosen norms" of fidelity; they are simply, if roughly, prescriptions for pictorial representation by inversion of the laws of geometrical optics, and unless a viable alternative optical theory of vision is established, no other representational system can lay claim to a similar law-like foundation. Other systems may have other and more noble purposes than mere fidelity, of course, even purposes that exclude fidelity, but the idea that fidelity is always relative to a particular representational system is simply gratuitous.[27] We may invent and utilize any system of representational rules we like, as the history of art amply illustrates. What we cannot do is *invent* a system that faithfully mirrors the world of appearance. That system is law-governed and discovered, not invented and adopted.[28]

(3) *Pictures in perspective are intelligible only to those who have learned to "read" them.* Goodman writes, "Pictures in perspective, like any others, have to be read; and the ability to read has to be acquired. The eye accustomed solely to Oriental painting does not immediately understand a picture in perspective."[29] This aspect of the conventionalist argument has already provoked substantial reaction and the collective weight of cross-cultural and psychological studies of picture perception now bears heavily against this view.[30]

Since the view persists, however, it is worth adding to this cumulative testimony a remarkable historical counterexample. In 1720 the Shōgun of Japan, Tokugawa Yoshimune, authorized the importation of European books (excluding books on religion). For the first time Western studies in physics, zoology, and botany became available to the Japanese reader. These books contained copperplate illustrations that precipitously exerted an enormous influence on Japanese art.

> Japanese people learned, by comparing the illustrations with those in Japanese scientific books, that the Dutch pictures were true reproductions of real objects. Traditional Japanese paintings, compared with the lifelike illustrations of Dutch art, were by no means true to life. Japanese painting came to be condemned by some Japanese artists as false and not worthy of the name of art.[31]

Progressive artists of the period launched a movement for realism in art and gave form to their doctrines in brushwork and copperplate printing.

The theory that a painting ought to be a faithful reproduction of the object depicted also influenced well-known artists committed to the traditional style of Japanese painting, and they quickly discerned that:

> [T]he chief elements of the Western technique of realistic depiction were perspective and shading. By these and these alone, they insisted was true realism possible. Ukiyo-e artists, always ready to learn and comply with a new vogue, were the first to adopt the technique of Western perspective. They at once made and sold pictures done with this technique, which they called *Uki-e*, or "relief pictures," meaning pictures of three-dimensional effect. Hokusai, Kuniyoshi, and Hiroshige used even the technique of shading, along with perspective.
>
> Japanese art essentially is decorative and not realistic. This remained true even with artists of the Edo Period, not to mention the ancient paintings. For example: Kanō Tan-yū made innumerable sketches of nature, but when he was working in earnest he painted in a decorative, conventional style, as if he had forgotten his sketches. Ogata Kōrin, too, painted sketch albums, but his screens and hanging scrolls were more like graphic patterns than copies of nature. It is true that these artists, unlike those of preceding periods, founded their art upon a realistic view of nature, gotten with their own eyes. This was one of the characteristics of

"recent-age" Japanese painting. This attitude, however, was submerged in tradition whenever they painted serious works.[32]

There had not, until this period, been true perspective in Japanese art, viz. perspective in which distant objects are shown smaller than those closer to a fixed point of view. There was, however, a form of "reverse perspective," *gyaku-enkin*, which depicted distant objects larger than nearer objects, and a "floating point of view" in contrast with the Renaissance fixed station point.

Not only is the unqualified claim that "the eye accustomed solely to Oriental painting does not immediately understand a picture in perspective" contingently false, the untutored eye also seems well able to see that the unaccustomed picture is a more faithful representation of the customary world than a painting in the more familiar pictorial style. If perceived fidelity in pictures were predominantly a function of familiarity, i.e., of historically conditioned, habitual modes of representation, as conventionalists would have us believe, this striking event in the history of Oriental art would never have taken place.

The fact that traditional Japanese art exhibits a form of perspective at variance with standard linear perspective is wholly irrelevant here. Goodman, himself, remarks (correctly) that anyone can find out for himself how easy it is to read pictures drawn in reversed or otherwise transformed perspective, but this shows only that differing pictorial styles or systems, like differing writing styles or differing symbolic systems, can be understood by the same person or culture; it says nothing about which style or system is more accurate or faithful to the realm of reference. And if those who are familiar with alternative systems of pictorial representation commonly opt for one as preeminently productive of fidelity, that is as decisive as we could hope.

(4) *Selection and Subjectivity: There's More to Seeing than Meets the Eye*. The conventionalist's position, schematically, is this: Both seeing and picturing involve selection. Perception and representation are equally subject to the filters of habit, history, interest, attention, and abrogation. The naive eye is blind, the uninterpreted image nonexistent, the perfect picture a chimera. The artist does not, cannot, xerox what he sees, nor do we perceive the world as an image etched on the tissues of the retina. Habits of expectation and accul-

turation, genetic and psychological determinants affect the ways we perceive and the ways we depict the world. What, finally, we "see" is a construct issuing from the process of selection subjectively guided by habits and motives remote from the rigid laws of Euclidean optics; and the pictured world is a product of preferred systems of representation, artistic temperament, historical styles, and the limitations of material and technique.

What is left, then, of the ideal of pictorial fidelity? Even if all of these deeply problematic contentions were acceptable, the answer is, surprisingly, everything. Pictures, however peculiar, are a part of the real world. The influence of selection and subjectivity is operative on both and does nothing, as conventionalists seem to believe, to obviate the identity-of-optical-array standard of fidelity. What is selectively organized by the perceiver from natural stimuli will be comparably organized from artifactual stimuli. In the *limiting* case, the eye (or mind) unable to discern and uninformed of the causal origins of its input, will perform the same transformations for pictures as for objects. Thus, even if our "habits of seeing" were varied and relative, the matching optical array standard of fidelity would remain intact, such habits being, necessarily, unable to reach beyond the image to discriminate between object and picture.

There is, of course, no such thing as a "perfect likeness." No picture can exactly replicate the optic array from a natural scene except under severely restrictive and perhaps aesthetically uninteresting conditions. But, to repeat, there is nothing absurd or unapt in the concept of a standard of fidelity that is unrealized in practice. What is not realized can still be approached, and that is as much as we have a right to expect.

Pictures are neither uniquely paradoxical objects of perception, nor are they necessarily conventional vehicles of representation. Sometimes, at least, they come very close to unambiguously presenting an evident aspect of the nonpictorial world. If this conclusion seems remarkably unexceptional it should be remembered that getting there requires the traversal of some formidably arduous terrain.

Notes

1. R. L. Gregory, *The Intelligent Eye* (New York, 1970), p. 32, (italics added).
2. Ibid., p. 50.

3. Ibid., p. 58.

4. "Euclid said that a rectangular object at a distance looks round. Five centuries later Sextus Empiricus (A.D. c. 200) referred with some insistence to this illusion: 'The same tower appears round from a distance, but square from close at hand' . . . What this sceptical philosopher apparently failed to notice, however, is that round objects may also look square." M. H. Pirenne, *Optics, Painting & Photography* (Cambridge University Press, 1970), p. 171, fn.1.

5. Gregory, pp. 58–59.

6. Ibid., p. 55.

7. Ibid., p. 59.

8. Ibid.

9. See Pirenne, p. 180.

10. Here and throughout I have used "picture" in an intentionally unrestricted and ordinary sense, viz. in a primarily "representational" sense without trying to exclude pictures of nonexistent or imaginary objects. Are "abstract" paintings and designs pictures in that sense? Ancient and unsettling arguments surround the issue, and I shall only suggest here that perceptible spatial relations (including depth) in, say, the canvases of Josef Albers can be thought of as representational elements of the work—representational not of concrete things in an abstract manner nor of abstract concepts in symbolically visible form, but representational of spatial relations themselves.

11. The correlations are so striking that they led to the development of an *überhaupt* representational theory of perception in the 17th century—a theory that conflates correlation and causation and holds that internal impressions stand in a representational relation to whatever causes them.

12. Joan Gadol, *Leon Battista Alberti* (Chicago, 1969), p. 40.

13. The history and technical aspects of the theory of linear perspective are outside the scope of this paper. See, Leon Battista Alberti, *Della pittura*, L. Mallè (ed.) (Florence, 1950); Piero della Francesca, *De Prospectiva Pingendi*, N. Fasola, ed. (Florence, 1942); B. A. R. Carter, "Perspective," in H. Osborne (ed.), *Oxford Companion to Art* (Oxford, 1970); Samuel Y. Edgerton, Jr., *The Renaissance Rediscovery of Linear Perspective* (New York, 1975); D. Gioseffi, "Perspective," in *Encyclopedia of World Art*, vol. XI (New York, 1966), 183–221; Leonardo da Vinci, *The Notebooks of Leonardo da Vinci*, J. P. Richter, ed. (New York, 1970); John White, *The Birth and Rebirth of Pictorial Space*, 2nd Edition (Boston, 1967).

14. Nelson Goodman, *Languages of Art* (Indianapolis and New York, 1968).

15. Ibid., pp. 10–11. References to Gombrich are from *Art and Illusion*, pp. 254 and 257, and Gibson, "Pictures, Perspective, and Perception," *Daedalus* (Winter 1960), 227.

16. Ibid., p. 13.

17. Ibid.

18. See, Fred Leeman, *Hidden Images: Games of Perception · Anamorphic Art · Illusion* (New York, 1976).

74 / Alan Tormey

19. Goodman, p. 14.
20. White, p. 125.
21. Marx Wartofsky, "Rules and Representation: The Virtues of Constancy and Fidelity put in Perspective," *Erkenntnis*, vol. 12 (Jan. 1978), 21.
22. Ibid., p. 22.
23. Goodman, p. 16.
24. Wartofsky's claim that pictures drawn in perspective look wrong is supposedly supported by Pirenne's discussion of Raphael's *School of Athens*. In fact, Pirenne's conclusions support only the view that Renaissance artists frequently deviated from the exact rules of perspective with the use of a *single projection center* because they " . . . must have expected their pictures to be viewed from various positions—under which conditions the spectators are aware of the position, shape, and other characteristics of the surface of the picture." Pirenne, p. 132.
25. Goodman, p. 19.
26. We could, similarly, build railroad tracks to look parallel as they recede into the distance, although this would probably make travel by train even more precarious than it already is.
27. That representational systems may be developed and chosen for reasons having nothing to do with faithful depiction is a possibility usually overlooked in conventionalist arguments. For further consideration of this issue and a discussion of pictorial realism see, Alan Tormey and Judith Tormey, "Seeing, Believing and Picturing," in *Perception and Pictorial Representation*. Calvin F. Nodine and Dennis F. Fisher, eds. (New York, 1979).
28. It is occasionally suggested that, once we are sufficiently familiar with non-Euclidean geometries, we may learn to see the world in accordance with one or more of them. I have so far seen no coherent argument for this fantasy.
29. Goodman, pp. 14–15.
30. See, in particular, John M. Kennedy, *A Psychology of Picture Perception* (San Francisco, 1974); Julian Hochberg, "The Representation of Things and People," in *Art, Perception and Reality*, Gombrich, Hochberg & Black, eds. (Johns Hopkins University Press, 1970), pp. 47–94; J. Hochberg and V. Brooks, "Pictorial Recognition as an Unlearned Ability: A Study of One Child's Performance," *American Journal of Psychology* 75 (1962), 624–28. Margaret A. Hagen and Rebecca K. Jones, "Cultural Effects on Pictorial Perception: How Many Words is One Picture Really Worth?" in *Perception and Experience*, R. D. Walk and H. L. Pick, eds. (New York, 1978), pp. 171–212.
31. Ichitaro Kondo, "History of Japanese Painting," in *Painting, 14th–19th Centuries: Pageant of Japanese Art*, vol. II, Popular Edition. Edited by Staff Members of the Tokyo National Museum (Tokyo, 1957), pp. 54–55.
32. Ibid., p. 55. It is instructive to compare this with White's description of

Giotto's revolutionary frescoes in the Upper Church of San Francesco: "It is a simple optical truth that as soon as it is possible to see more than one side of any cubic object, all the visible surfaces will recede from the observer and will be foreshortened. This is equally true whether the visible surface be two or three, as in a solid cube, or as many as all six, in one that is transparent. The convention, considered up to now, which allows one face to remain unforeshortened, parallel to the representational plane, was, for a time, progressively discarded by those artists who were inquiring more acutely into what it was that they could actually see, who were looking more intensely at the individual objects in the world about them, and who were trying to represent those objects more faithfully than their predecessors." *The Birth and Rebirth of Pictorial Space*, p. 34.

NICHOLAS WOLTERSTORFF

6 The Look of Pictures and Its Relation to the Pictured

"It looks like a man on a horse," we say, when asked to describe Titian's painting *Charles V*. And anyone familiar with the painting knows that it not only *looks like* a man on a horse but that it *represents* a man on a horse, the man being the Emperor Charles V. The question which naturally comes to mind when we put these two convictions together, the one pertaining to the look of the picture and the other to what it pictures, is whether the look of the picture has anything to do with what it pictures. The tradition on the matter is that the two are essentially connected. Recently, however, Nelson Goodman in *Languages of Art* has contended that they have nothing to do with each other. My goal in what follows is to defend the tradition against Goodman's attack. I shall do so not by attacking Goodman's attack but instead by constructing a "look-like theory" of pictorial representation which answers his objections. For certainly traditional accounts of the relation between the look of the picture and what it pictures leave much to be desired. For example, representation does not *consist in* looking like, as the tradition has sometimes suggested. By the end of our discussion we shall see that though the look of the picture does not single-handedly determine what it pictures, yet only with a design that looks like a man on a horse can one picture a man on a horse.

I

Let us begin with some considerations on the look of pictures. Consider the array of curved lines in Figure 6-1. A fundamental fact

76

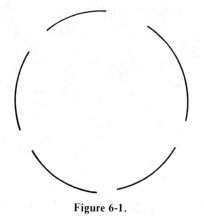

Figure 6-1.

about us human beings, explored especially by the gestalt psychologists of perception, is that we tend to see this not as an array of independent lines but rather as an instance of a certain pattern. Specifically, we tend to see it *as a circle*. In fact, the sheet of paper being seen by the reader does not exhibit a circle; nor, more importantly, does it look as if it does. Clearly it exhibits only an array of definitely distinct curved lines. In spite of that, we see the array as a circle—or at least, there seems no better way of describing our experience. Seeing-as of this sort consists of two-dimensional pattern completion.

A different situation is presented to us by Figure 6-2. We can see this either as an array of crosses having black arms and white centers or as an array of crosses having white arms and black centers. To see it in the former way is definitely to see it differently from seeing it in the latter way. One has a peculiar sense of "switching" when one changes the way in which one sees it—partly due to the fact that one's visual focus moves from one set of points in the design to another. The design itself is ambiguous; it can be seen either way.

This second case of seeing-as consists then of two-dimensional pattern *resolution* rather than of two-dimensional pattern *completion*. What makes the resolution case different from the completion case is that what we see really does look as if it is cross-shaped designs with black arms and white centers, or cross-shaped designs with

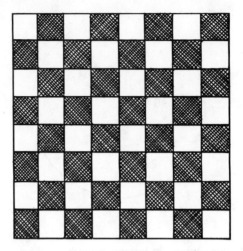

Figure 6-2.

white arms and black centers; whereas, by contrast, what we see does not really look as if it is a circle.

But now consider Figure 6-3. We are all capable of seeing this as a cube—that is, as an object of cube shape. Indeed, most of us find it difficult to look at this and *not* see it as a cube. And if we do not see it as a cube, we probably see it as an empty box with three of its sides missing, seen from below left and looking into the box.

Now there is probably no strong experiential sense of a difference between seeing this array of lines as a cube and seeing that array above as a circle. But there is in fact a striking difference between the two cases which shows up on analysis. I can actually see a circle (i.e., circular design) on a sheet of paper—or at least something which so far as I can see is a circle. For a circle is a two-dimensional shape which can be instantiated or exhibited on a plane surface. Accordingly when a piece of paper contains a design which is not actually a circle, and when I then see the design as a circle, I see it as something that a piece of paper *could* exhibit or instantiate. But a cube—a three-dimensional object of cube shape—is obviously something that that design on paper cannot be. So when I see the design as a cube, I am seeing it as an object of a sort that an inscription of a design on a

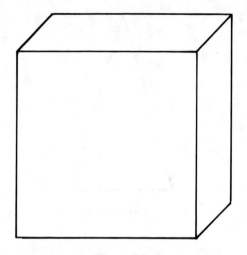

Figure 6-3.

plane surface cannot be identical with. Let us call this latter sort of seeing-as, *two-dimensional representational seeing*. Two-dimensional representational seeing consists of seeing a design on plane surface as a three-dimensional object or spatially related array of three-dimensional objects; or alternatively, it consists of seeing a design on plane surface as a number of plane surfaces related recessively, or as a plane surface part of which is nearer the viewer than another part. One of the goals of certain twentieth-century painters—a goal which has proved surprisingly difficult to achieve—has been to produce canvasses which not only do not invite, but are not even susceptible of, two-dimensional representational seeing. (It should be noted that seeing-as, in the sense of pattern resolution, is also relevant within the context of representational seeing. Our cube design can be seen either as a cube or as an incomplete box.)

Perhaps an example of planar recession would be helpful. Consider Figure 6-4. This can be seen just as a triangle. But also it can be seen as a figure on a ground—as a triangular shaped plane surface in front of a white background. And yet another way of seeing it is just the reverse: One can see it as a triangular hole in the plane of the paper, through which we see another plane behind it. Of course one

Figure 6-4.

does not need nicely outlined shapes in order to see what occurs on a flat surface as a figure on a ground. One could just have amorphous patches of color—a black surface, say, with an amorphous blob of red in the center. In such a case it takes little effort to see the red as in front of the black. Incidentally, it's also possible to see our triangular design not as an example of planar recession but as a three-dimensional object: One can see it as a road receding into shape.

An even more interesting example of planar recession is Figure 6-5. It is almost impossible not to see this as a corrugated surface alternately advancing from and receding toward the ground of the paper's plane (or, as alternately receding from and advancing toward the viewer, and "standing on" the ground of the paper's plane so that the vertical lines are at right angles to this plane). In this case, however, what we see as plane surfaces are seen as lying at something other than a right angle with respect to the plane of the paper's surface. There are, indeed, two ways of seeing it thus. One can either see it as the parallelogram on the left having its right edge ahead of its left, the one to the right of it as having its left edge ahead of its right, etc, or one can see it in just the reverse fashion—as the parallelogram on the left having its left edge ahead of its right, etc.

The phenomenon of seeing a design as a three-dimensional object or array of three-dimensional objects, and that of seeing a design as planes receding in space, can be combined. Our cubic design can be

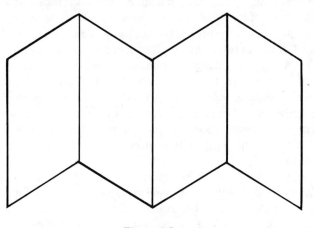

Figure 6-5.

seen as a cube in front of the plane surface of the paper. Central in the artistic endeavors of the Western Renaissance "perspectivists" was their attempt to bring these two phenomena together. It was consistently their goal, however, so to construct their paintings that we would see the objects as *behind* the plane of the painting's surface rather than in front of it. The picture was to be seen as a window onto the reality beyond. In that way they differed from the Byzantine artists, who wished their designs to be seen as objects in front of the plane of the surface.

Go back now to our cube design. It is extremely difficult not to see this representationally. And if one sees it representationally, it is most readily seen as a cube. But now suppose that we wish to describe more closely that particular representational seeing of it. What we can say is that we see it as how a cube would look when viewed from slightly above and to the right, with the plane of two of its facades parallel to the plane of the paper. In short, we see it as how it would look when viewed from a certain angle. When, in a case of representational seeing, we see the design in question as how a k would look when viewed from *such-and-such an angle*, let us say that that case of representational seeing has an *implied visual angle*. In particular, the

implied visual angle of our representational seeing of that design as a cube is from slightly above and from slightly to the right and with the plane of two of its facades parallel to the plane of the paper.

For most cases of representational seeing there is an implied visual angle. But there are exceptions. If, in a particular case of representational seeing, I see a design as a uniformly colored sphere—nothing more—then though I see it as a sphere I do not see it as a sphere *viewed from some particular angle*. The reason of course is that a uniformly colored sphere provides us with no way whatsoever of specifying angles of vision. (If the sphere is shaded, I may see it as viewed from some angle with respect to the line of the light falling upon it.)

It may be noted, while we are on the matter, that in that form of seeing-as which is pure two-dimensional pattern completion, there is never an implied visual angle. I see the array as a circle, say. But I do not see it as how a circle would look when *viewed from such-and-such an angle*. Of course I do actually view the design on paper from a particular angle. So *the actual visual angle* from which a design on plane surface is seen on a given occasion must be sharply distinguished from *the implied visual angle* of a given case of representational seeing of that design. I may see the paper with the cube design on it from head on, so that the line from midway between my eyes to the center of the design is at right angles to the plane of the paper. Nonetheless I see the design as how a cube would look when *viewed from above and to the right*.

What must be added at once is that the actual visual angle at which I see the design on paper has an impact on my representational seeing of the design. If the angle is acute enough I may be able still to see the design but not to see it representationally. And conversely, in the case of certain anamorphic designs, I can see them representationally only if I view them at very acute angles.[1] Further, some designs on paper are such that if I view them with the paper at one angle, I representationally see one thing, and if at another angle, I representationally see something different. There is a charming anecdote from the history of art which nicely illustrates this point—though it happens to be concerned with sculpture rather than with two-dimensional designs:

> The Athenians intending to consecrate an excellent image of Minerva upon a high pillar, set Phidias and Alcamenes to work, meaning to chuse

the better of the two. Alcamenes being nothing at all skilled in Geometry and in the Optickes made the goddesse wonderfull faire to the eye of them that saw her hard by. Phidias on the contrary . . . did consider that the whole shape of his image should change according to the height of the appointed place, and therefore made her lips wide open, her nose somewhat out of order, and all the rest accordingly . . . When these two images were afterwards brought to light and compared, Phidias was in great danger to have been stoned by the whole multitude, untill the statues were at length set on high. For Alcamenes his sweet and diligent strokes beeing drowned, and Phidias his disfigured and distorted hardnesse being vanished by the height of the place, made Alcamenes to be laughed at, and Phidias to bee much more esteemed.[2]

To give a detailed description of what we see a design as, when seeing it representationally, we must often, of course, adopt strategies beyond that of specifying the implied visual angle. Let us see how such descriptions might go, observing first that any such description can always be fitted into this general structure: I see this design as how a k which is ϕ would look to a person of sort P viewing it under conditions of sort C. (Implied visual angle fits under the conditions.)

Sometimes we can increase the specificity of our description by attaching (additional) modifiers to the common noun for which "$a\ k$" stands in. There's not much of this sort that we can do in describing more closely what we see our cube-design as. But if one representationally sees a design as a man, it may be that one sees it not *just* as a man but as a man who is standing, with one arm raised above his head, etc. Secondly, we can sometimes specify, or describe with greater specificity, the sort of person. It may be that one sees the design not just as $a\ k$ but as how a k would look to a person with astigmatic vision, or as it would look to a person intensely interested in the textures and the lighting of things. Thirdly, we can sometimes specify, or describe with greater specificity, the sort of conditions. One may see the design not just as $a\ k$ but as how $a\ k$ would look when viewed in a fog, or when viewed from a considerable distance. Parts of Turner's paintings can be seen as ships viewed in a fog; and often parts of Brueghel's paintings can be seen as people viewed from a great distance. In this last case, we might say that for the representational seeing in question there is an *implied visual distance*; and we

might put implied visual angle and implied visual distance together and call it *implied visual vantage point.*

Suppose that we see a given visual design as not just one object but as an *array* of objects, and that for our representational seeing of each of these there is an implied visual angle and distance. It may be that these implied visual vantage points all converge, so that there is just one, convergent, implied visual vantage point for the entire design. With their experiments in vanishing perspective the Western Renaissance painters attempted to construct their canvasses in such a way as to force us, the viewers, to see their designs as an array of objects viewed from one, single, convergent, implied visual vantage point, and as receding from the plane of the picture's surface. Thereby, of course, they at once gave a powerful unity to their productions. But we must never so fall under their spell as to think that a condition for aesthetic excellence in representational painting is that there be a single implied visual vantage point. In Hugo van der Goes' masterpiece in the Uffizi, *The Adoration of the Shepherds*, the implied visual vantage point floats around in a most marvelous way.

Obviously what some design is representationally seen as will often depend a great deal on surrounding designs. The very design which in one context we see as a man viewed from a considerable distance may, if put into a different context, be seen as a man viewed from relatively close up.[3]

In our attempt to give a close description of what a given design is representationally seen as we can often choose from a variety of combinations as among the phrases replacing "a k" in our formula, the phrases specifying the sort of person, and the phrases specifying the sort of conditions. When I see a certain design as a cube-shaped object, I may, to describe the matter more closely, say either that I see it as how a serrated-edged cube would look to a person of normal vision, or as how a smooth-edged cube would look to a person of astigmatic vision. These may be two equally correct descriptions of the very same case of representational seeing. They need not be descriptions of two different cases of representational seeing. I do not think it will ever happen, though, that a case of seeing our design as a cube-shaped object will also be a case of seeing our design as a three-sided box. "I see it as a cube" and "I see it as a three-sided box" will never both be correct descriptions of one case of representational

seeing of our design. For one can only engage in seeing it as a cube and seeing it as a three-sided box in succession, not simultaneously. That is enough to show their distinctness.

Instead of saying that I see some two-dimensional visual design as a horse, I might say that it *looks* (*to me*) *like a horse.* How is such a claim to be understood? Well, it too, I think, should be understood as a description of how I see the design in a given case of representational seeing. For I am not saying that that design, or that design on that paper, looks as a horse would look. On some occasion, staring off into the distance while out in the country, I may see some objects and say, "They look to me like horses." What I would mean is that they look to me as horses would look under these circumstances. (I might, in addition, be *suggesting* that they *are* horses.) But that is not what I would mean in the case before us. For only under the most extraordinary circumstances would a sheet of white paper with some pencil marks on it look as a horse would look under these circumstances. Neither am I saying that I apprehend some (relatively close) similarity in the design before me and a design characteristically instantiated by horses. For I might in fact apprehend that there is some such similarity, yet the design not look to me like a horse. It is rather that upon seeing the design representationally—as an object— I describe more closely what I see it as by saying that it "looks like a horse." And that is to say nothing different from saying that I see it as a horse.

It might be thought that a mark of a significant difference is the fact that when using the "looks like" locution we can speak of degrees: "It looks quite a bit like a horse." "It looks very much like a horse." One cannot more or less see a design as a horse, nor can one see a design as more or less of a horse. One can, though, see it as something quite a bit like a horse. And that is no different from its looking quite a bit like a horse. So both "something quite a bit like a horse" and "something which looks like a horse" can replace the "*a k*" in our formula. And, when thus replacing it, they would mean the same thing.

No doubt people differ in their tendencies to representational seeing. A design that one person tends readily to see as so-and-so, another person may not tend to see representationally at all, or may tend to see representationally as something else, or may see as

so-and-so only with difficulty. No doubt it is also true that what one person can representationally see as so-and-so, another person cannot see that way at all. Probably there are differences from culture to culture on these matters as well. For it is worth noting that representational seeing is in part a matter of training and of psychological set. Probably some readers never saw our cube-design as a three-sided box until we pointed out that it could be seen that way. Perhaps our remark prodded some of those who had never seen it thus, to do so. Though doing so, they may have done so only with difficulty. But then one can practice seeing it thus; and gradually one will become more and more adept at doing so.

We have concentrated our attention on visual designs on plane surfaces and on the correlate of these, two-dimensional representational seeing. But one can also see a block of wood as a horse. In the relevant sense of "look-like," it can look like a horse. So from all the cases of *seeing-as*, we can pick out, as cases of *three*-dimensional representational seeing, those in which we see some three-dimensional object as a so-and-so, when it neither is that nor looks to us as if it is. With the obvious modifications, most of what we have said about two-dimensional representational seeing applies also to three-dimensional representational seeing. There are some interesting differences, though, the principal one being that implied visual vantage point disappears in full-bodied sculpture. Though I see the block of wood as a horse, I do not see it as how a horse would look when viewed from some angle or other, or from some distance or other. I do of course actually see the lump of wood from some angle and distance; and perhaps some angle and some distance are aesthetically preferable. But though my seeing of the lump of wood will always have an *actual* visual vantage point, my representational seeing of it will never have any implied visual vantage point. I am inclined, indeed, to think that implied perceptual conditions in general—not just implied visual vantage point—become irrelevant when we deal with sculpture. However, conditions concerning the nature of the implied perceiver remain relevant. We can see the block of wood as how a horse would look to someone totally uninterested in texture.

For each of us, then, there is a stock of visual designs which we *tend* to see representationally, whether ambiguously or not; and an even greater stock which we are *able* to see representationally, given

the right assistance and training and effort. Though one person's stock, with respect both to ability and tendency, differs from another person's stock, there is also, within a given society, a massive overlap in both respects. And surely there is also a large overlap between the members of almost any pair of societies that one could pick.

It is from the stock of designs that can be seen representationally by human beings that the artist who pictures must choose his designs—on pain of not picturing. It is true that a given artist's range of options is narrower than this. He must choose from a subset thereof; and we shall see what that subset is, for a given artist. But those are the outer limits. Because of this intimate relation between picturing and representational seeing, Leonardo da Vinci was giving good advice to the fledgling artist when he advised him, in a famous passage, to practice seeing things wherever he happened to be:

> You should look at certain walls stained with damp, or at stones of uneven colour. If you have to invent some backgrounds you will be able to see in these the likeness of divine landscapes, adorned with mountains, ruins, rocks, woods, great plains, hills and valleys in great variety; and then again you will see there battles and strange figures in violent action, expressions of faces and clothes and an infinity of things which you will be able to reduce to their complete and proper forms. In such walls the same thing happens as in the sound of bells, in whose stroke you may find every named word which you can imagine.[4]

II

Earlier I said that only with a design that looks like a man on a horse can one picture a man on a horse. That same contention can now be put thus: Only with a visual design that can be *seen as* a man on a horse can one picture a man on a horse.

A full explication of this thesis requires, however, not only such explanatory remarks as I have offered on *seeing-as*, but also some explanatory remarks on representation. I do not contend that my thesis holds for all that might reasonably be called "representation" (or "picturing"). Accordingly, I must explain which phenomenon it is that I have in mind. The remarks in this section will be addressed to that.

In the first place, the sort of representation I have in mind must be distinguished from that sort of representation which, by artists and

critics, is also called *rendering*. Consider, for example, Rembrandt's painting *Bathsheba*. In all likelihood, Rembrandt's wife Hendrickje served as model for this painting. Accordingly, it can be said that Rembrandt represented Hendrickje, as well, of course, as representing Bathsheba—with this one painting *Bathsheba*. But in saying this we are using the word "represent" to express two quite different concepts.

Rembrandt represented Hendrickje in the sense that she was Rembrandt's *model* for his creation of the painting. Or to put it in other words, Rembrandt created the painting by producing a *rendering* of Hendrickje. Using something as a model, that is, producing a rendering of something, is a form of *guided making*. The relation between Rembrandt, Bathsheba, and the painting is different. Bathsheba did not function as a model for Rembrandt in the creation of his painting. Rather, Rembrandt's representing Bathsheba consisted in his using part of his pictorial design to *stand for* Bathsheba.

What points up with particular clarity the difference between the relation of Rembrandt, Hendrickje, and the painting, and the relation of Rembrandt, Bathsheba, and the painting, is this: If the world projected by way of the painting is to occur, Bathsheba must exist and must be as the painting shows her to be.[5] But Hendrickje need not exist. The world of the work requires the existence of Bathsheba; it does not require the existence of Hendrickje.

Secondly, I shall take as the basic concept in my discussion not that of a *picture* but rather that of *picturing*—not that of an object which is a picture of something, but rather that of an action of picturing something. In fact, I have already been doing this. Here I cannot give a full rationale for this move. Let me simply observe that our ordinary concept of *a picture of X* is in fact parasitic on our ordinary concept of *someone picturing X*. When in the American Southwest we come across some incised pattern on a rock and wonder whether or not it is a picture, we are wondering whether someone pictured something by incising this pattern. And when we go on to ask whether it is, say, a picture of a condor or of a horse, the answer to our question is determined by reference to what its maker pictured thereby. We may for years take it to be a picture of a horse. But if someone then presents evidence to show that probably its maker pictured a condor thereby, that establishes that probably it is a

picture of a condor and not of a horse. It is true that we speak of "seeing pictures" in the clouds—or on damp walls. But in speaking thus we are using a secondary sense of "picture," according to which one can see a picture of so-and-so in such-and-such without there being a picture that one sees. For to see a picture of a cat in the clouds, in this sense of "picture," is just to see the clouds *as* a cat.

Now *picturing something* is always an action that one performs *by* performing some other action. One never *just* pictures something. Titian pictured a man on horseback by, within a certain context, laying down pigments on canvas in a certain design. Always an action of picturing something is what I shall call a *generated* action. And what I mean when I say that some person P generated *ψ-ing* by *φ-ing* at *t*, is just that P performed *ψ-ing* by performing *φ-ing* at *t*.

There are various species of action-generation which may be distinguished. There is, for example, what might be called *causal* generation, illustrated by a situation in which I ring the bell by pushing the button. Here my act of pushing the button *causes* the event of the bell's ringing. And the generated act of my ringing the bell consists of my bringing about that event of the bell's ringing.

Much more important for our purposes than causal generation, however, is a species of action-generation which I shall call *count-generation*; for picturing something is always a count-generated action. In count-generation, the agent's performance of the generating action *counts as* his performance of the generated action. For example, my uttering, in a certain context, the words "I give up," counts as my acknowledging defeat in our checkers game. Likewise, my signing my name at the end of my tax form counts as my affirming that the claims made there are true and complete to the best of my knowledge. And so also, I contend, Titian's laying pigment on canvas, in a certain design and within a certain context, *counts as* his representing a man riding a horse.

A full treatment of our subject matter would require an analysis of this concept of one act counting as another, with the aim of getting a better grasp on the concept. For our purposes here, however, it will be satisfactory to depend on our ordinary grasp of the concept.

Now of course there are arrangements other than that of having us sign our names that the government could have instituted for us to affirm that the claims made in our tax forms are not deceptive. And

likewise there are other ways to represent a man on a horse than by laying down pigments in the design that Titian did. To say this, though, is to invite the question: What are such arrangements? What are such "ways"?

They are, it seems to me, *ordered pairs of actions*. Consider some ordered pair of actions, $\langle \phi\text{-}ing, \psi\text{-}ing \rangle$, the second of whose members, ψ-ing, is an action which can be count-generated and the first of whose members, ϕ-*ing,* is an action by the performance of which ψ-ing can be count-generated. Such a pair, $\langle \phi\text{-}ing, \psi\text{-}ing \rangle$, may be called *an arrangement for ψ-ing.* And such an arrangement may be said to be *in effect*, for P at t, just in case if P would perform ϕ-*ing* at t, his doing so would count as his ψ-*ing*. The pair,

(1) \langle Signing my name to my completed tax form, Affirming that the claims made in my form are true and complete to the best of my knowledge \rangle,

is thus an arrangement for *affirming that the claims . . .*[6] And clearly this arrangement was in effect for me when in fact I signed my name. Not only was it in effect. It was *used* by me. I performed the former action, and my doing so counted as my performing the latter.

I have explained that the basic concept in my discussion will be that of an action of picturing (representing) something, rather than that of a picture of something. And I have also explained that rendering something will here not fall within the purview of our concern, even though we regularly refer to this action with our word "represent." Now, thirdly, I must differentiate two kinds of non-rendering representation, for in this essay we will have opportunity to discuss only one of these two kinds.

Suppose that someone, looking at Titian's painting *Charles V*, says that Titian has represented a man on a horse. In saying this, he may be claiming that there did or does exist a man and a horse such that Titian represented *that* man and *that* horse, and furthermore, represented that man *as on* that horse. His claim, in short, may be expressible with the following existentially quantified sentence, in which we quantify over things represented:

(2) $(\exists x)(\exists y)(x$ is a man and y is a horse and Titian represented x and represented y and represented x as on y).

But our museum-goer *need* not be making such a claim with those words. For one can just make a picture of a man on a horse without there *existing* any man and any horse which one has pictured. Of course, if our museum-goer happens to notice the title of Titian's painting, he will probably suspect that there actually did exist a man whom Titian represented. (About the horse he may well keep an open mind.) But nonetheless, when he says that Titian represented a man on a horse he *need not* be claiming that there existed a man whom Titian represented.

This point is clearer, perhaps, though in essence no different, in the case of representations of things of a sort that don't and never did exist. For example, it is clear that the people who created the Unicorn Tapestry, now hanging in the Cloisters in New York, represented a unicorn thereby. But when I say this, I don't mean to claim that there existed a unicorn which they represented. For I believe that there have never existed any unicorns, and thus, that there have never existed any which have been represented. So if that was what I had been claiming, I would have been speaking falsely. But in fact I am making a true claim when I say that a unicorn was represented by the makers of this tapestry. In saying that a unicorn was represented one can make a true claim even though there never existed any unicorns, and thus, even though there never existed any which were represented. But so too, in saying that a horse was represented I can be making a claim which is true even though there existed no horse such that it was represented. In such a case, of course, the "failure" does not stem from the fact that there have never existed any horses *to be* represented, but rather from the fact that of the horses that exist, none was in this case represented. One can just make a picture of a horse without there existing any horse which one has represented. But once one sees that one can say truly that someone represented a horse even when there neither did nor does exist a horse which he represented, then one can see that such a non-quantificational claim can be truly made even when, as a matter of fact, one could also claim truly that there existed a horse such that it was represented.

These reflections lead to the conclusion that our word "represent," when applied to those who picture, expresses two quite different concepts when applied to pictures). When applying the one concept we are making a claim as to which existent entity was represented.

When applying the other, we are making no such claim. It will be convenient henceforth to call the former concept—i.e., that concept of representation which allows for quantification in the way indicated—*q-representation*; and to call the other concept, *p-representation*.[7]

Here in this essay I shall have to confine myself to a consideration of the nature of p-representation. What I say will be relevant at many points to an understanding of the nature of q-representation as well. But space forbids my pursuit of those lines of relevance. For the sake of convenience I shall often, in what follows, use "picturing" as a synonym of "p-representing."

III

We have seen that when someone p-represents a horse, there may or may not exist a horse which he represents. That is, he may or may not have q-represented a horse. But if that is so, of what then does p-representation consist? What is it to p-represent a horse?

Goodman's suggestion in *Languages of Art* is that p-representation of a horse consists in the instantiation of a visual design of a certain sort—one, namely, which we just so happen to call "a picture of a horse." It has nothing whatsoever to do, he says, with the look of the picture or the look of the pictured. Or to shift the example: It is Goodman's view that when I say that someone represented a unicorn, meaning thereby that he p-represented it, I am simply making a claim about the *kind* of picture that he produced—specifically, that it is a picture which exhibits a visual design of a certain sort. We English-speaking people just so happen to apply the term "picture of a unicorn" to pictures that exhibit designs of the sort that this one does. It would be less misleading if we called them "unicorn-pictures" rather than "pictures of a unicorn"; for this latter phrase tempts us to search for the unicorns represented when there are none.

We can turn to the history of art for an illustration showing that this will not do. In the early medieval period one finds artists producing pictures which might appropriately be called "Apollo-pictures." For these pictures instantiate a very distinct sort of design whose provenance lies in designs of that sort having been regularly used by classical artists to represent Apollo. Now to represent Apollo is to

engage in p-representation; for Apollo does not and never did exist. But the medieval artists, though they used this very same Apollo-design, did not p-represent Apollo thereby. They represented Christ. And that at once shows that p-representing Apollo is distinct from instantiating the Apollo-design—that producing a picture of Apollo is distinct from producing an Apollo-picture. Goodman's identification of these two phenomena cannot be correct. When we claim that p-representation took place, we are claiming that a design was *used* in a certain way. We are not (simply) making a claim about the kind of design used.

The same point could have been made by reference to ambiguous designs. Many designs are such that they can be used to represent a variety of things. Yet on a given occasion it may be decisively one thing and not another that is represented. One of my children once drew a series of pictures of a family of lions—father, mother, children. He concluded the series with a picture of the hole in which they lived. The design he drew was just a circle—a highly ambiguous design with respect to what it represents. Yet I take it that he did in fact represent the hole in which a family of lions lived. Such p-representation—for that is what it is—cannot be explicated simply by appeal to the kind of design instantiated.

An alternative suggestion as to the nature of p-representation begins with the ontological thesis that there *are* things which don't *exist*, so that reality, or being, is more comprehensive than existence.[8] The person affirming this thesis would hold, for example, that though unicorns do not exist, there nonetheless *are* unicorns, and that though Apollo has never existed, there nonetheless *is* Apollo. P-representation is in one way or another explained then by appeal to such non-existent objects. Sometimes the ontological thesis underlying this approach to p-representation is put by affirming that there are *merely possible* as well as actual (existent) objects. It seems clear, though, that a theory of p-representation which makes use of the claim that there are things which don't exist will also have to allow impossible objects into its ontology. In some of his prints, M. C. Escher represented *impossible* buildings. There couldn't be such buildings as he represents.

This family of theories concerning the nature of p-representation cannot be swiftly disposed of. Some of them founder on the particu-

lar way in which they attempt to make use of the supposed being of non-existent objects. But the fundamental issue posed by this family of theories as a whole is just the tenability of the ontological claim that there are things that don't exist. A full consideration of such theories cannot evade an address to the tenability of that thesis. To engage in such an address, however, requires the raising of deep and complex issues. Here I shall simply have to say that the thesis seems to me *not* acceptable, for reasons adduced by Alvin Plantinga in chapters VII and VIII of his *The Nature of Necessity*. The person unmoved by Plantinga's reasons will have to regard what follows in a hypothetical light: What might a theory of p-representation look like if it did not affirm that there are nonactual (nonexistent) entities.

So once again, what is the nature of p-representation? Well, suppose I wish to assert that the door to my study is closed. In the appropriate circumstances I might do so by drawing a picture of a closed door. The act of my drawing the picture in that particular manner and circumstance would *count as* an act of my asserting that my study door is closed. If I perform the action while believing that my study door is not closed, I will have lied. One can commit perjury by drawing a picture.

We in our culture are surrounded by examples of assertions being made by producing occurrences of pictorial designs. Consult any guide for the field identification of flora or fauna. Characteristically for each species the guide will contain both a paragraph describing properly formed members of the species, and a design picturing a properly formed member of the species. The design functions exactly like the paragraph. By producing it, or arranging to have it produced, the author asserts, say, that the common loon looks thus and so. Accordingly he can make a mistake with his pictorial design as well as with his paragraph. Again, in a handbook on grafting the author may wish to explain what the *veneer crown graft* (Tittel's graft) is like. He may do so either with a pictorial design or with a paragraph, or with both.

What I have said about asserting something by producing a picture applies, *mutatis mutandis*, to issuing commands, to asking questions, to making promises. By producing a picture of a closed door I can command that my study door be closed, or ask whether it is closed, or promise that it will be closed. Likewise by producing a

picture of a closed door I can invite others to take up the attitude of fiction toward the state of affairs of my study door's being closed. Is this not how the illustrations accompanying some work of novelistic fiction are to be taken? The illustrator is not asserting, commanding, asking, or promising. He is inviting us to take up a fictional attitude toward certain states of affairs. He is doing so by producing a picture rather than a sentence. And to a considerable extent the states of affairs that he presents for our consideration are the very same as those that the novelist presents. The point is too obvious to belabor: By producing a picture one can perform on a state of affairs one of what J. L. Austin called "illocutionary actions."

This same point is made by Ernst Gombrich in an interesting passage in his *Art and Illusion*. The point is made, however, in a slightly askew fashion; and it will help to get matters straight before us to consider what he says. In discussing *The Lackawanna Valley* by the nineteenth-century American painter George Inness, Gombrich says about the painting that it:

> . . . was commissioned in 1855 as an advertisement for a railroad. At the time there was only one track running into the roundhouse, "but the president insisted on having four or five painted in, easing his conscience by explaining that the road would eventually have them." Inness protested, and we can see that when he finally gave in for the sake of his family, he shamefacedly hid the patch with the non-existent tracks behind puffs of smoke. To him this patch was a lie . . .
>
> But, strictly speaking, the lie was not in the painting. It was in the advertisement, if it claimed by caption or implication that the painting gave accurate information about the facilities of the railway's round-houses. . . .
>
> . . . the terms "true" and "false" can only be applied to statements, propositions. And whatever may be the usage of critical parlance, a picture is never a statement in that sense of the term. It can no more be true or false than a statement can be blue or green. Much confusion has been caused in aesthetics by disregarding this simple fact. It is an understandable confusion because in our culture pictures are usually labeled, and labels, or captions, can be understood as abbreviated statements.[9]

When Gombrich says that "the lie was not in the painting" he surely speaks truth. A painting tells no lies. For it tells nothing at all. But rather than saying that the lying is done by someone making and

presenting that painting in a certain manner and circumstance, Gombrich seems to locate the lie in the accompanying words. That is because he assumes that in this respect sentences are different from pictures—that sentences can tell lies. In fact, that visual design which is the sentence "The door is closed" no more states anything than does a picture of a closed door. It is we who use it to assert true things—and false things. Of course, one might wish to say that a sentence is *true on some occasion* just in case by the uttering of it on that occasion one would assert something true. But then the same can be said for the picture.

There is also the suggestion behind Gombrich's words that it is *only* when words are added, or introduced, that pictures are used to assert. That likewise seems false. Certainly it is true that when by producing a picture of something one asserts something, the particular manner and circumstance in which it is produced often incorporates the use of words. But that seems not at all essential. Further, in all such cases one might cast the situation in the opposite light: It is by incorporating some picture into the manner and circumstance in which we use certain words that we assert something. Lastly, it is regularly the case that when we assert something by uttering some sentence in a certain manner and circumstance, that circumstance incorporates the use of other, explanatory, words. Individual isolated sentences are scarcely more satisfactory for the performance of illocutionary actions than are individual isolated pictures.

And now I can present my thesis as to the fundamental nature of p-representation. Always when someone pictures (p-represents) something, he takes up an illocutionary stance toward certain states of affairs. (We may say that he *indicates* those states of affairs.) The way I presented the examples above may have encouraged the conclusion that the indication of some state of affairs is incidental to picturing. In fact it is essential. In an earlier article of mine I introduced the concept of world-projection. Using that concept, my thesis here can be expressed by saying that there is no p-representation without world-projection. Always when p-representation takes place, a world is projected. If we assume, as I do, that states of affairs and propositions are identical, we can say that p-representation is always *de dicto*.

Specifically, in picturing a man on a horse one introduces the state

of affairs of *there being a man on a horse*. And likewise, in picturing a unicorn one introduces the state of affairs of *there being a unicorn*. Unicorns have never existed. Nonetheless there is the *state of affairs*, or *proposition*, that there is a unicorn—this proposition being false. And so at once we see how a *de dicto* theory of p-representation can handle, with ease, those special cases of such "representation of what never existed" in which the "thing represented" is impossible of existing. Though there cannot be such buildings as Escher represents, nonetheless there is the proposition that there is a building of such and such an impossible sort. It just happens to be a necessarily false proposition.

IV

If pictures and words alike can be used to assert that there is a horse, and to invite one's audience to take up a fictional attitude toward there being a horse, etc., then wherein lies the difference between using a picture to assert that there is a horse and using words to do so? For that there is a difference is obvious. Or, to use another example, wherein lies the difference between the pictures and the paragraphs in a field identification guide for birds, if both are used to assert propositions? It is in the answer to this question that we shall spy the relevance of what a picture looks like to what it is used to picture.

Suppose that someone has performed some action which *counts as* his performance of some illocutionary action on some proposition (state of affairs). Specifically, suppose it counts as his introduction of the proposition *that there is a unicorn*. What is necessary for his act of so doing to be a case of *picturing*?

Obviously one thing necessary is that his generating act consist in the *instantiation* of some *visual design* in a certain context. Picturing does not occur apart from performing a certain type of action on a visual design—namely, an action of *instantiating* a design in a certain context. But more is necessary than this. What is also necessary, I suggest, is that the design in question *look like* a unicorn—that it *be capable of being seen as* a unicorn. Only with a visual design that can be seen as a unicorn can one p-represent a unicorn. If the instantiated design cannot be seen as a unicorn, then one has not pictured a unicorn by instantiating that design.

But *who* must be capable of seeing that design as a unicorn? For as we saw earlier, what one person is capable of seeing as a so and so, another may not be capable of so seeing. So whose ability for representational seeing is relevant to the determination as to whether picturing has occurred?

"The artist's," one is initially inclined to say. "The artist's abilities for representational seeing are the relevant ones." Suppose, though, that an artist *does* have the ability to see some design as a unicorn but that he has never, in fact, seen it thus, and doesn't *know* that he is capable of seeing it thus. Suppose that he doesn't know that *anyone* is capable of seeing it thus. The potential of the design for being thus seen is simply unknown to him. I think the proper conclusion is that that design can then not be used by him to picture a unicorn.

Are we, perhaps, to demand that the artist *actually have seen* the design as a unicorn? No, that will also not do. Suppose, for example, that an artist produces a large-scale design which he knows can be seen as a unicorn, by himself and others, but which he has never in fact seen thus, never having stood far enough back to get the necessary perspective. Surely he might nonetheless have pictured a unicorn.

Closer to the truth, I think, is this: If an artist is to picture a unicorn, he must instantiate a design which he *knows* can be seen by him as a unicorn. But even this seems too constrictive. For might an artist not picture a unicorn by instantiating a design which he knows can be seen by many in his society as a unicorn but which he is incapable of seeing thus? Perhaps his vision is no longer keen enough, or perhaps he suffers from the quirk of just not being able to see this particular design as a unicorn. It would seem that nonetheless he can use this design to picture a unicorn. Accordingly, I suggest that if an artist is to p-represent a unicorn, he must instantiate a visual design which he knows that he or others in his society can see as a unicorn.

In the light of these conclusions let me introduce the concept of a *pictorial arrangement* (an arrangement for p-representation). Given that certain visual designs which can be seen by one person as a so and so cannot be thus seen by another, the concept will have to be relative to a person at a time. Suppose, then, that some action,

ψ-ing, can be generated by the performance of some action ϕ-ing, so that $\langle\phi\text{-}ing, \psi\text{-}ing\rangle$, is an arrangement for ψ-ing. Suppose, further, that the generating action, ϕ-ing, consists of instantiating (in a certain sort of context) a visual design D. And suppose that to perform the generated action, ψ-ing, is to perform some illocutionary action on the proposition *that there is a k*. Then the arrangement, $A = \langle\phi\text{-}ing, \psi\text{-}ing\rangle$, is a pictorial arrangement, relative to person P at time t, if and only P at t knows that he or others in his society can see D as a k.

From our preceding discussion it follows that P at t pictures *a k* only if P at t uses an arrangement for the performance of some illocutionary action on *there being a k* which, relative to him at that time, is an arrangement for picturing. It would be pleasant if this were a sufficient as well as a necessary condition for picturing. Unfortunately, it is not. For suppose that P is using a language some of whose sentences are pictorial designs—designs which can be seen by P and/or members of his society as three-dimensional objects. Specifically, suppose that in this language the sentence normally used to assert that there is a unicorn looks like a unicorn. Suppose, further, that P knows it can be seen thus. Now suppose that in the course of using this language P asserts, in the fashion normal for that language, that there is a unicorn. His inscribing of that unicorn-like design counts as his asserting that. He has then made use of an arrangement for indicating that there is a unicorn which is, for him as that time, a pictorial arrangement. Yet I take it that he has not pictured a unicorn. It is sheer coincidence that in this language the sentence to use for asserting that there is a unicorn looks like a unicorn. One cannot in this fashion, coincidentally, picture a unicorn.

Why not? What is missing? What is missing, I suggest, is a certain intention. For picturing to take place, the agent must *intend* that his indication of the state of affairs of *there being a unicorn* shall be performed by the instantiation of a design that looks like a unicorn. It is this *intention* that is missing in our case of the man who coincidentally uses a design that looks like a unicorn. He may well have intended to indicate the proposition that there is a unicorn. And he may well have intended to inscribe the visual design that he did. What is missing is the intention that his indication of that state of

affairs shall be performed by the inscription of a design that looks like a unicorn. And if, on the contrary, this intention is present, then he has pictured a unicorn.

V

A point made persuasively by Ernst Gombrich, in *Art and Illusion*, is that, as a matter of psychological fact, an artist never has available to him, for the purpose of constructing his pictures, the whole stock of visual designs which can be used to picture. On the contrary, even the most facile of artists works with a surprisingly limited subset of these. The members of the particular subset that an artist works with are called, by Gombrich, his artistic *schemata*. The repertoire of schemata that an artist works with is in part the result of his being influenced by the particular artistic tradition in which he stands; but in part it is also the result of his own idiosyncrasies. Sometimes artists are self-consciously aware of these schemata. Their awareness will come out in rules for drawing that they offer to fledgling artists, in canons of proportion that they formulate, etc. For example, some at least of the Byzantine icon painters were aware of the fact that they were working with a canon of proportion according to which the distance from hairline to crown of head always constituted about a third of the face in their paintings. Other times, artists have been totally unaware of their particular schemata.

Gombrich theorizes that an artist's repertoire of schemata influences what he tries to picture and how he pictures it. Actually Gombrich has two somewhat different things in mind when he says this, for by an artist's "schemata" he means two rather different things. Sometimes his point is that the artist's rendering and picturing is influenced by what one might call *pictorial motifs* which are acquired from here and there in the history of art and which retain considerable invariance across their occurrence in different styles. After giving some examples of this tendency he says that

> These examples demonstrate, in somewhat grotesque magnification, a tendency which the student of art has learned to reckon with. The familiar will always remain the likely starting point for the rendering of the unfamiliar; and existing representation will always exert its spell over the artist even while he strives to record the truth. Thus it was remarked by

ancient critics that several famous artists of antiquity had made a strange mistake in the portrayal of horses; they had represented them with eyelashes on the lower lid, a feature which belongs to the human eye but not to that of the horse.[10]

On other occasions when speaking of schemata for picturing, what Gombrich calls a "schema" is not a stylistically invariant pictorial motif but rather the style of an artist. His point then is that an artist's style influences what he tries to picture and how he pictures it. In considering a painting by the Chinese artist Chiang Yee of a scene in Derwentwater we find Gombrich saying this:

> We see how the relatively rigid vocabulary of the Chinese tradition acts as a selective screen which admits only the features for which schemata exist. The artist will be attracted by motifs which can be rendered in his idiom. As he scans the landscape, the sights which can be matched successfully with the schemata he has learned to handle will leap forward as centers of attention. The style, like the medium, creates a mental set which makes the artist look for certain aspects in the scene around him that he can render. Painting is an activity; and the artist will therefore tend to see what he paints rather than to paint what he sees.[11]

What we find clearly stated in this quotation, and hinted at in the preceding one, is Gombrich's additional theory that artistic motifs and styles function as *visual stereotypes*. Motifs and styles influence how that which is seen is pictured. But also they influence how that which is pictured is seen. Indeed, they influence our seeing whether or not we try to picture. They influence the visual perception of beholders as well as that of artists. Having looked at Piranesi, we find that London has acquired here and there a Piranesian look. Having looked at the Dutch landscape paintings, we find that the sky of Western Michigan on occasion has the look of the sky in a Dutch landscape. Neither the artist nor anyone else approaches visual reality with naked eye. And part of what influences how we all—artists and spectators alike—see the reality around us is the motifs and styles in the pictures we have seen.

Thus Gombrich theorizes that the artist, head and eye filled with artistic schemata, allows these to function both as visual and as pictorial stereotypes, only now and then noticing, and recording, the discrepancy between stereotype and reality. Speaking about "the

procedure of any artist who wants to make a truthful record of an individual form," Gombrich says this:

> He begins not with his visual impression but with his idea or concept: The German artist with his concept of a castle that he applies as well as he can to that individual castle, Merian with his idea of a church, and the lithographer with his stereotype of a cathedral. The individual visual information, those distinctive features I have mentioned, are entered, as it were, upon a pre-existing blank or formulary.[12]

VI

In the preceding sections we have considered matters from the side of the artist, asking what conditions must be satisfied if he is to picture. Let us now shift perspective and consider matters from the side of the spectator. What are some of the characteristic problems which arise when we, the spectators, try to tell what has been pictured—that is, what the artist is to be counted as having indicated pictorially? In other words, what are some of the characteristic problems that arise when we try to decide which pictorial arrangement was used in a given case? Of course this is to presuppose that it has in fact been determined, in a given situation, that picturing was taking place. And often *that* determination is itself a difficult, problematic matter.

(1) For one thing, it is often unclear which visual design is functioning as a sign. A picture—a concrete physical object—instantiates many designs. And though sometimes it will be clear which is the functioning design, other times it will not be. Two roots of such obscurity are worth singling out for attention.

A picture will not display the functioning sign to all observers under all conditions. It will display it only if someone of a rather definite sort looks at it under conditions of a rather definite sort. What goes into being a person of the requisite sort is having the requisite perceptual apparatus, but also having the appropriate visual training so that one knows what to focus on. And what belong to the requisite conditions are such matters as being seen in the proper light, being seen from the proper angle and distance, etc. We might say that for each case of picturing there is a *canonical mode of apprehension*—the way the picture must be seen if the functioning design is to be apprehended.

This point—that for cases of picturing there are canonical modes

of apprehension—is especially evident from that little anecdote about Phidias and Alcamenes which we cited a few sections back. Looking at Phidias' statue from ground level did not fall within its canonical mode of apprehension. If it had, Phidias would justly have been accused of representing a woman with lips wide open. But in fact he is not to be accused of that. The canonical mode of apprehension for his statue includes seeing it from well below. Only then can one apprehend the functioning design. Other examples of picturing which make it clear that cases of picturing have canonical modes of apprehension are the already mentioned anamorphic pictures. To view them so as to apprehend the functioning design one must see them at extremely acute angles, or in curved mirrors, and so forth.

How do we determine the canonical mode of apprehension for a given case of picturing? How do we know that looking at an etching from fifty feet off is outside the canonical mode of apprehension? How do we know that looking at a painting by late Titian from close up with a magnifying glass is outside the canonical mode of apprehension? How did the Athenians know that the canonical mode of apprehension for Phidias' statue was from well below? The clues are of many different sorts. But often what is involved is the existence of certain conventions for looking at art of different styles—that is, the existence of certain coordinations of action as between the picturer and his public. Such conventions, where they exist, constitute part of the context within which the picturer works. Of course a given artist may choose to depart from all the extant conventions by painting in a radically new style for which there are no such conventions. He may then either inform people of the canonical mode of apprehension for his pictures; or he may leave them to find out for themselves. And if the latter, the public may be perplexed until finally they arrive at a way of apprehending the paintings which makes good sense of them. Either way, characteristically the artist's new style will induce the birth of new conventions for looking at paintings in this fresh style. A great deal of what goes into learning to appreciate representational art, contemporary as well as traditional, is learning and practicing the canonical modes of apprehension for different styles of painting.

But then secondly, even when the picture in a given case of picturing is being viewed within its canonical mode of apprehension, we may still not know, fully, what is the functioning design. For we may

not know which features of the object and of how we see it are functioning representationally and which are there for other reasons—perhaps to make the painting's surface aesthetically worthwhile, or perhaps because they are unavoidable features of the medium used. Those wide black bands surrounding the figures in Rouault's paintings are not functioning representationally; they are not part of the picturing designs. And that swirling, jabbing, highly three-dimensional texture of the paint in Van Gogh's late paintings was—usually at least—also not functioning representationally. It was not part of the picturing design. Its function was to give to the surface of the painting an intensely expressive, highly textured, quality so as thereby to make that surface aesthetically important in its own right.

(2) Sometimes we do not know what is the artist's repertoire of pictorial designs—that is, which of all the designs which *can* be used to picture are available to him within his schemata. We do not know which designs belong within his representational style, and we do not know his skill in using his style. This too can lead to uncertainty as to what the picturer is to be counted as having pictured. Suppose that we come across some petroglyphs in southwestern United States, left by some primitive Indian tribe. We may have concluded that what is here pictured is a condor with wings outspread. But the picture is in the "stick" style. So that leaves us with the question of whether it is the *skeleton* of a condor that is pictured or a *full-fleshed* condor. If we know that the picturer was not limited in his repertoire to such stick designs, then we would probably conclude one thing. If we know that he was limited to that, then we would conclude a different thing. So too, if we know that the repertoire of the late Byzantine icon painters was limited to designs in which the distance from hairline to crown was one third of the entire face, we will not count them as picturing a narrow range of rather strange looking human faces. And if we know that in Duccio's repertoire there were no devices for showing shadows, we will not count him as always showing the Madonna in a blaze of absolutely uniform illumination. Rembrandt's repertoire—both in terms of designs available to him within his style and in terms of his skill in putting down those designs—was immense. And so the very same design produced by his hand and by the hand of a primitive Indian would rightly lead to different conclusions.

(3) What may be called the *pictorial situation* of the picturer differs from artist to artist; and our knowledge of that situation also enters into our judgment as to what to count the artist as having pictured. If we do not know the relevant part of his pictorial situation, we are often left with uncertainty.

Given the facts about our human makeup, there are for every artist, at a given time, many pictureable states of affairs which he himself cannot picture at that time, even if he had the total repertoire of visual designs at his command; for he is not aware of them. And within the set of ones that he can picture at a given time, there are ones that he would be very unlikely to have pictured at that time. By the *pictorial situation* of a given artist at a given time I mean, then, the states of affairs which at that time he could have pictured and which he would not have been unlikely to have tried to picture.

There being unicorns did not belong to the pictorial situation of the Southwestern Indians; but *there being condors* did. *There being such a god as Olmec* did not belong to the pictorial situation of the European medieval painters; but *there being unicorns* did. And in the pictorial situation of the Aztecs there were gods of the sort described in their myths. Knowing the pictorial situation of a picturer often helps us to know what he is to be counted as having pictured. And conversely, if we do not know what the pictorial situation of an artist was like in relevant respects, we will often be at a loss to tell what he pictured.

Often, of course, what serves to clarify and resolve what is pictured is accompanying words, or other features of the context. But sometimes it remains incurably ambiguous and unclear what was pictured. No investigations along any of the above lines, nor any others, help at all. And sometimes—as in the case of picture puzzles—such ambiguity is deliberate. But we should not exaggerate the unclarity and ambiguity. It is perfectly clear that with his *Bathsheba* Rembrandt pictured a woman bathing. So clear is this that if seventeenth-century Amsterdam had had a law against picturing women bathing, Rembrandt would indisputably have violated it. He could no more have gotten out of the charge by claiming that he was merely making a design, or picturing something else than a woman bathing, than someone can get out of a perjury charge by claiming that he just happened to be rolling certain English sentences over his tongue, or just happened to be using the sounds of English to assert something

quite different from what his accusers suppose. So too, it was often perfectly clear in ancient Byzantium that the iconoclastic laws had been violated; and often it was perfectly clear in Jewish communities that their laws against the making of images had been broken.

Notes

1. Cf. Fred Leemann, *Hidden Images,* tr. E. C. Allison and M. L. Kaplan (New York, 1976).
2. Ernst Gombrich, *Art and Illusion* (Princeton University Press, 1961), 2nd edition, pp. 191–92.
3. Cf. Gombrich, op. cit., p. 232.
4. Gombrich, op. cit., p. 188.
5. See my "Worlds of Works of Art," in the *Journal of Aesthetics and Art Criticism,* XXXV, 2 (1976), 121–32.
6. Actually the generating action is more complex than this, involving also certain features of context.
7. I adapt this terminology from Kendall Walton in his "Are Representations Symbols?" in *The Monist* (April, 1974), 236.
8. See especially Robert Howell, "The Logical Structure of Pictorial Representation" in *Theoria,* Vol. XL (1974), Part 2, 76–109; and John G. Bennett, "Depiction and Convention," in *The Monist* (April, 1974).
9. Gombrich, op. cit., pp. 67–68.
10. Gombrich, op. cit., p. 82.
11. Gombrich, op. cit., pp. 85–86.
12. Gombrich, op. cit., p. 73. Cf. p. 88.

MARGARET A. HAGEN

7 Representational Art and the Problem of What to Depict

What kind of image must an artist produce if he or she wishes the audience to recognize the depicted contents of the work? From the perceptionist's point of view, this question becomes, By what means does a picture represent an object successfully? What is it about picturing that produces determinate perceptions in viewers? Perceptionists, be they psychologists or philosophers, generally seem to offer two sets of apparently mutually contradictory answers to these questions.

Nelson Goodman[1] argues that pictures succeed as representations because they are constructed and read according to an arbitrary but shared code. In a similar vein but from a different point of view, Sir Ernst Gombrich[2] argues that pictures succeed as representations, look "lifelike," insofar as they are constructed according to prevailing artistic schemata and judged by shared social criteria of "convincingness." He does not argue that either schemata or criteria are rooted in objective reality, but simply that pictorial schemata are abandoned when the images they produce no longer look convincing, presumably because new schemata are being adopted simultaneously. Even Richard Gregory[3] has written that successful picturing is an impossible mystery because it allows of no means for confirmation or disconfirmation of the object hypotheses which it stimulates. In ordinary perception, such means are provided through observer locomotion or object movement. Neither Goodman's nor Gombrich's variation on the picture-as-arbitrary-code position assumes an objective physical relationship between the contents of the

107

picture and the nature of the object pictured. Gregory assumes such a physical relationship, but sees the visual stimulus even of ordinary perception as too impoverished to warrant determinate perception without considerable constructivist activity on the part of the perceiver.

Rather flatly contradicting both of these assumptions, is the position occupied by James Gibson[4] and his many disciples and "derivatives" like Kennedy, Farber, Purdy, Rosinski, Sedgwick, and Hagen, and by Ralph Norman Haber. These theorists argue that a picture succeeds as a representation because it contains the same kind of information for determinate perception as is provided by the ordinary environment. The information carried by pictures is necessary to determinate perception and sufficient without recourse to cognitive constructions.

Debate on these issues has no obvious end in sight, because it consists chiefly of accusations of failure on the part of the opposition to consider *the* critical or crucial variable or domain which is subject to change from moment to moment. Rather than continuation of the debate, a more useful option would seem to be that offered by consideration of the primary producers of the objects in question— the artists themselves. However, the writings of artists concerning their endeavors are of a heuristic value equal to that of the efforts of philosophers and psychologists. If we are to learn anything about successful picturing from artists, we must go to what they do and not to what they say they do.

We can predict, however, from the writings of philosophers and psychologists what a visual analysis of artistic works should reveal. If pictures "work" as representations by means of a socially shared but arbitrary component code, then pictures should make little or no sense to persons outside the culture of their creation. But what persons are these? If the present reader is suggested as a possible viewing audience, then it is more than likely that he or she is an educated adult from a Western technological society. It might be argued that the education of such an individual has been so comprehensive as to include exposure to all extant artistic code systems. Thus, our reader possesses at least tacit knowledge of the functioning of these systems and cannot be considered naive with respect to them. We might suggest as a possible visual analyzer of art works, a

member of a completely closed culture with its own indigenous art style or, alternatively, a member of a relatively closed culture whose personal exposure to other styles is nil. Gombrich describes such a person, a nineteenth-century Japanese artist, and his initial response to Western post-Renaissance pictures drawn in perspective. On first encounter, he found Western perspective pictures completely incomprehensible, but in a short period of time not only were their contents recognizable to the artist, but the perspective mode of depiction became his preferred style. But one might argue that this artist's initial confusion was a simple function of habitual cultural bias and uneducated visual attention characteristic of any similarly culture-bound individual and of little use in revealing the nature of successful depiction as suggested by visual analysis of various art styles.

Some writers have suggested that the only truly appropriate audience for this task of visual analysis of style is the completely naive observer from a culture with no indigenous or imported (or intruded) two-dimensional representational art. There are two basic difficulties with this suggested observer: firstly, there are very few such people in the world these days; and, secondly, unfamiliarity with pictures is confounded with unfamiliarity with pictorial materials. Muldrow, in Deregowski, Muldrow and Muldrow[5] reports an interesting attempt to test the pictorial perception of a tribe in remote Ethiopia. These Ethiopians, completely unfamiliar with paper, examined only the medium and missed the message.

From the above, it seems clear that there is no simple way to use pictorially naive peoples to test the hypothesis of the pictures-as-code theorists. Of course there are many more difficulties in testing such populations than have been listed, and the reader is referred to methodological reviews by Miller,[6] Hagen,[7] Hagen and Jones,[8] and Jones and Hagen[9]. The absence of an appropriate test group does not necessarily refute the hypothesis, but it does suggest that an indirect approach through examination of the major alternative hypothesis might be of greater heuristic value.

The major opposing hypothesis states that pictures function as representations of the depicted object or scene because they resemble those objects and scenes in ways critical to perception. One of the clearest statements of this position can be found in Gibson,[10] who

argues that pictures succeed as representations because they carry the same kind of information for the observer as the pictured contents. By information, Gibson means certain specifiable relations in the light to the eye reflected from the object, which relations are in one-to-one correspondence with some aspects of the object and are invariant across certain transformations. A good example is a textured surface at a certain slope with respect to the observer. As long as the gradient of texture, size, or density remains the same, the slope is the same; when the gradient changes, the slope of the surface has changed.

Voices criticizing this position, such as Arnheim's,[11] point out that the assertion of information resemblance ignores the manifest dissimilarities between pictures and their contents. Unlike the objects they supposedly resemble, pictures are flat, static, and subject to none of the gradients of translation occasioned by motion parallax and motion perspective proper to voluminous objects. It may be argued that these dissimilarities seriously limit the number and type of possible resemblances between pictures and subject, and constrain the artist in the choice of pose or aspect to depict. It is not the case that any view of any object randomly chosen will function as a successful representation of that object. Arnheim[12] has argued that for a picture to succeed as a representation of an object, it must present that object in its most characteristic aspect. The least characteristic is presumably that aspect which fails to evoke for the viewer the depicted object.

Is this assertion correct? If we examine the incredibly varied creations of artists across cultures and history, is it true that recognizable depictions of particular objects always employ a certain aspect or aspects to accomplish that depiction? If so, such a degree of agreement across artists argues persuasively for a culture-free phenomenon and supports the hypothesis that "the most characteristic aspect" can be determined empirically, if not theoretically, and that it is sufficient for, if not necessary to, determinate perception through recognizable depiction. In addition, the correlation of the absence of such empirically determined aspects with the absence of determinate perception argues that the presence of "the most characteristic aspect" is necessary to successful depiction in the absence of other sources of information about the nature of the depicted object.

A suitable set of pictures for analysis is provided by Figure 7-1 which shows hands taken chiefly from paintings in the permanent collection of Boston's Museum of Fine Arts. We will ask two questions about each picture segment within the Figure: 1) Is the picture recognizable as a hand, and 2) Is such recognizability a function of the presence of the "most characteristic aspect" of hands? It is quite obvious that each hand or pair of hands is recognizable as such, but it is not quite so obvious why this is so. It has been suggested above that each of these different styles of depicting hands is really the product of an arbitrary code of depiction familiar to the (gentle) reader through his or her Western liberal arts education. Tooled with the knowledge of these various codes, the reader is simply mentally constructing the meaning of each symbol assemblage as a hand or pair of hands. The idea is a provocative one and enjoys, in various forms, the discipleship of many perceptual psychologists as well as philosophers. However, it has been argued strongly and repeatedly by Gibson,[13] as well as by many other scientists in a great variety of fields, that it is unparsimonious (if not downright silly) to argue the existence of a hypothetical construct without first demonstrating that such a construct is demanded by the data. In this case, it is both uneconomical and unnecessary to hypothesize a process of mentalistic construction of meaning before showing that such construction is demanded by the impoverished nature of the stimulus material presented. If sufficient structure for the meaning of the stimulus is already present in the stimulus itself, then it needn't be added in a constructivist process.

Is sufficient structure present in these hand pictures? The structure suggested above is necessary to and sufficient for pictorial recognition of hands is the structure that comprises the most characteristic aspect or view of a hand. Do these successful depictions contain it, or any consistently present structure that might be construed as most characteristic? At first glance, the answer is No. There is no single aspect, most characteristic or otherwise, that is consistently present across the range of diverse styles. Closer examination of the hands reveals certain things: there is generally visible a palm or hand back, some number of digits, and a thumb, and specifiable spatial relations between or among two or three of these components. But these several components are not visually present in any simple way. There

Figure 7-1. The cover from the *Illustrated Handbook,* Museum of Fine Arts, Boston. Most of the hands are painted, but several are sculpted or in relief. Courtesy of the Museum of Fine Arts, Boston, composite by Carl Zahn.

is no simple single photographic aspect like a snapshot. There is no simple enumeration of what some theorists are pleased to call distinctive features, e.g., wrist, palm, five fingers, and a thumb. The component parts are not all always present in the pictures. Worst of all, there are no simple metrical relations among wrist, palm, back, digits, and thumb preserved across the pictures. Of course, all of these "failures" of structure are familiar contributors to the old problem of visual constancy of the distal world, given the ever-changing nature of the proximal stimulus. The solution to the problem offered by perceptionists from Helmholtz[14] to Gregory[15] (excepting that of Gibson and the gestaltists) has been that the observer constructs a stable constant world from the inconstant stimulus through the addition of products of past experience, mental structures, usually chains or networks of associations. Despite the differences between associationistic structures and arbitrary code systems, the constructivist processes hypothesized by most traditional perceptionists and certain philosophers are essentially the same for the recognition of pictorial material. Each assumes the structurally impoverished nature of the pictorial stimulus.

Perhaps some light on the nature of structural impoverishment might be shed by an examination of some pictures of hands that do not "work," that do not allow for successful recognition of the depicted contents. Figure 7-1 also shows several examples of pictures of hands which do not look like hands. Yet, given the explicit instruction that the objects pictured are hands, they certainly look more like hands than they do like basketballs, cats, or chairs. Also, whereas there is not sufficient hand structure present to specify a determinate hand percept, there is sufficient structure depicted to constrain the range of possible subjects for the depiction. Thus, there is sufficient structure present to suggest both hands and a host of other objects, but not just any object of whatever form. The structure present is ambiguous and multivocal, but it is by no means a generator of random percepts. Given the membership of hands in the set of objects possibly depicted, the instruction that the picture does indeed show hands is not met with incredulity, as would be the case with Figure 7-2. There is no way that the cat depiction of Figure 7-2 can ever *look* like a human hand, although it is of course possible to draw a cat picture that is at least suggestive, particularly in the presence of added contextual information. Figure 7-3 shows such a cat-hand and

Figure 7-4 shows the cat-hand in a hand context. The importance of this old perceptual trick is not to demonstrate that guessing in the face of inadequate information occurs, but that the guessing is neither random nor limitless. The constraints can be increased, of course, by the addition of context, as is evident in Figure 7-4. Even our impoverished hand pictures become clearly and determinately hands in the right context. But the question of interest is not what context or which instruction will disambiguate a multivocal picture, but what is missing from the picture in the first place so that it requires additional perceptual aids. What is missing from an unrecognizable picture of human hands, and what is present in a recognizable one?

Figure 7-3. Picture of cat in isolation.

Figure 7-2. Unambiguous drawing of a cat.

Figure 7-4. Picture of a cat in a context suggesting identification of the cat as a hand.

Perceptual theory offers us several candidates for the critical structure, some mentioned explicitly above and some only implicitly. The hypothesis that the presence or absence of the most characteristic aspect of the object is critical to the success or failure of pictorial recognition has guided our examination of hand (and cat) pictures across a diversity of styles. It is clear that the presence of the most characteristic aspect of an object cannot be critical to pictorial object recognition, because no such thing exists. It is possible to find as many as half a dozen or so examples of a single pose among the hand pictures of Figure 7-1, but no single pose even approaches a majority of the seventy-odd views presented. Thus, the "most characteristic aspect" has not even been shown to exist, much less to function critically for object recognition. Yet, this hypothesis cannot be completely false, for it is true that some aspects or views of objects "work" better to promote identification of object character than do others, and so must be at least *more* characteristic in some sense than those others.

It has been argued [e.g., E. J. Gibson][16] that it is more useful to think of such aspects as assemblages of *distinctive features* rather than in a more gestaltist sense. Thus, an aspect is more or less characteristic as it shows more or fewer distinctive features of the object. [See E. J. Gibson[17] for a lucid exposition of the concept of distinctive features as it is used in modern perceptual theory.] The problem with this argument is that examination of Figure 7-1 reveals that the short list of features that can be generated from one picture is not identical to the list generated by another. Nor is it the case that a picture functions successfully as a hand picture if it contains some specifiable subset of the hand feature list. Components of an image identifiable as fingers when placed in specifiable spatial relationships to each other and to a thumb are not identifiable as fingers when placed in other spatial relationships both with and without the thumb. Thus, the question of the role of distinctive features in pictorial object recognition is tied to the role of spatial relations among features. The two taken together will determine certain sets of possible images which do not differ importantly from the subsets of possible aspects of views labelled "characteristic" or "most characteristic." Thus, the distinctive feature hypothesis is subject to the same failings as the previous hypothesis considered above.

A somewhat grander conception of the process of object recogni-

tion rests on the assumption that all objects have some sort of visual *canonical* form which must be present for successful depiction. The canonical form is a prototype for the object, possessing all feature relations distinctive to the object and lacking those that are ambiguous, shared, irrelevant, or noninformative. There should be a single canonical form for each object, best depicted as an outline drawing lacking all distracting detail. That outline drawings provide information more quickly than shaded drawings or photographs has been demonstrated by Ryan and Schwartz.[18] Evidence that canonical form operates in the perceptual process has been provided by a recent series of studies by Hagen and Elliott.[19] Adults were presented with a series of drawings of regular prisms from several different points of view. Each series for a single viewpoint contained six members varying in degree of perspective convergence from extreme foreshortening (0.0) to no convergence (1.0). (See Figure 7-5.) The viewer's task, under a variety of conditions (simultaneous view, successive view, viewing in triplets, constrained and unconstrained monocular view, and binocular view), was to choose the most natural and realistic drawing or to choose the most accurate drawing. Regardless of viewing condition or instructions, the adults' picture of choice, 75% of the time, was that showing either no convergence or minimum convergence. This study has been replicated with colored photographs of ordinary objects and the results are essentially the same. Analysis of the stimulus pictures reveals that the most natural, realistic-looking and accurate pictures are created when the artist or photographer is at a distance from the subject ten times as great as the average dimension of the subject. Thus, to produce a "good-looking" picture of a 3-inch cube, the artist should stand 30 inches away; for a 2-foot cube, 20 feet away ($D = 10S$). But does the consistency of the viewers' judgments necessarily argue for the existence of visual canonical form? It should be noted that the $D=10S$ formula is that prescribed by Leonardo in his notebooks to artists who wished to produce natural-looking pictures free from perspective distortion. It may be that the canonical form suggested by this study is simply a function of artistic bias within the Western tradition and reduces to preference, prejudice, habit, or stereotype. However, it is interesting that Einstein independently wrote essentially the same prescription for natural-looking pictures in a letter to Maurice Pirenne,[20] written in 1955. Neither Einstein nor Leonardo explains the reasoning behind the generation of the formula. We know that the rule is an

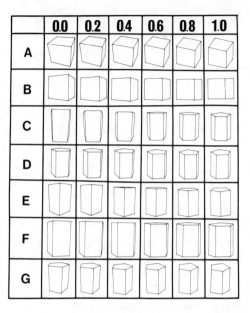

Figure 7-5. Picture sets whose members vary in degree of convergence from extreme foreshortening (0.0) to parallel perspective (1.0). From M. A. Hagen and H. B. Elliott. "An Investigation of the Relationship Between Viewing Condition and Preference for True and Modified Linear Perspective with Adults." *Journal of Experimental Psychology: Human Perception and Performance*, 2 (1976).

undeniably good predictor of the realism judgments of Western adults, but we don't know why. Perhaps because the formula produces canonical form, or perhaps because it minimizes distortion, or perhaps because these are one and the same thing. If they are, the demonstration of that fact will depend on a much better description of what we mean by canonical form than we have at present.

An attempt to be more specific about the necessary properties of prototypical form for image-making comes from a fairly recent work by Arnheim.[21] Arnheim, in an elaboration and exposition of the "most characteristic aspect" notion, gives us instead the concept of *renvois*. For any object, there is an indefinitely large number of projective views of that object available to the perceiver. Arnheim argues that a certain subset of these views contains what is called *renvois*; that is, there are referencing aspects which point beyond the given aspect to adjacent, subsequent ones. Aspects with *renvois* also make reference to the simplest three-dimensional solid which could have generated them; likewise, the structural skeletons of projections with *renvois* are directly related to the structure of the object depicted.

As a promissory note, the concept of *renvois* is very exciting. We know intuitively that it must be true in some sense. Families of

projections of single objects are indeed describable in terms of degree of similarity of adjacencies, not that perceptual theory is very far advanced in determining which similarities are perceptually, ecologically, valid. The primary difficulty with the *renvois* notion lies in describing accurately what is meant by a direct relationship between the structural skeleton of a projection with *renvois* and the structural skeleton of the solid object. *All* projective views of an object have a direct relationship to the parent object determined by projective transformations that are reversible. So what distinguishes a view with *renvois* from one without? Arnheim gives us no help on this question, but James Gibson[22] does.

As was suggested above, Gibson, in his theory of Ecological Optics, argues that we perceive the persistent properties of objects and events, despite the constant flux in the proximal visual stimulus by means of invariants in the light to the eye specific to those properties. Thus, we perceive the constant shape of an object despite its myriad perspective appearances, by picking up the invariants in the light reflected from the object specific to that shape and persistent across transformations occasioned by observer motion. For example, an object is made up of textured surfaces at various slants relative to each other and relative to the ground plane. As the observer moves laterally in front of the object, or around it, or whatever, there is in the light reflected to the eye a particular gradient of rates of translation of optical texture across the retina specific to each of those differently slanted surfaces. It is argued that these gradients of translation are invariant even while the perspective appearances of the surfaces change. Moreover, it is argued that there are even certain properties of the perspective shapes that remain invariant across certain observer locomotions in the absence of visible surface texture. It is these invariants which specify, provide information about, the persistent properties of the world.

The theory of Ecological Optics is the boldest reformulation of the problem of perception since the revolt of the gestaltists against the doctrines of Helmholtz and his followers (who still comprise the majority of American perceptionists). It is not clear, however, how much help the theory provides for the problem of pictorial perception. The heart of the theory is invariant information made available to the observer by transformations of the optic array. But the transformations provided by observer locomotion in front of a picture will

not generate any of the invariant information necessary to specify the persistent properties of the contents of the picture. On the contrary, they will specify the picture as a rather flat, framed, pattern of pigment hanging on the wall—which is not what we mean by picture perception. However, one could argue that the invariants in pictures that make object identification possible are somewhat different in nature from ordinary invariants, or stand as the limiting cases of certain transformations. Then, representational pictures succeed because they contain the necessary invariants for object depiction.

But consideration of the hands in Figure 7-1 and the chairs drawn by children in Figure 7-6 points out a serious difficulty with this argument. If the presence of certain invariants for hands and chairs makes these pictures appear similar to each other as hands and chairs, what is it that makes them look so different from each other? If the styles of depiction of the various cultures of the world depend for successful representation solely on the presentation of invariants, then why don't they all look more or less alike? Since invariants are always relations among components, never the components themselves, differences among styles cannot reduce to differences in the assemblage of parts. When invariant relations among parts are fragmented, as in Cubist art, the images produced do not succeed as representations. (This is not to argue that a Cubist style that did preserve critical invariant relations could not succeed.) One might argue that the differences among styles lie in the number of invariants depicted so that the most representational picture contains the most invariants. This raises the issue of what we mean by "most representational." After all, any representational picture of a hand is a successful picture of a hand because it contains the relevant invariants for hand. What distinguishes among the hands in Figure 7-1? It's certainly not invariant structural relations. These pictures are differentiated not by the quality or quantity of invariant relations preserved, but by the character of the *variant* information presented. Photographic realism presents the variant aspects of optical information in a uniquely effective way capable of producing a trompe-l'oeil effect like that of Figure 7-7. The existence of trompe-l'oeil displays, paintings, or otherwise, poses an insoluble problem for a theory dependent entirely on invariant information for successful perception.

Ecological Optics is a theory designed to explain perception of the

Figure 7-6. Drawings by school children asked to reproduce from memory a three-dimensional picture of a chair drawn in correct perspective. From Rudolf Arnheim, *Art and Visual Perception: A Psychology of the Creative Eye*, courtesy of the University of California Press.

ordinary environment, not pictorial perception. But unless one wishes to postulate a completely different perceptual process for the identification of objects and events in pictures, any descriptively adequate perceptual theory must account for pictorial perception as

Figure 7-7. The trompe-l'oeil painting, "Old Models," 1892, by William Michael Harnett, American, 1848– 1892). Oil on canvas, 54 × 28 in. By courtesy of the Charles Henry Hayden Fund, Museum of Fine Arts, Boston.

well. An adequate account of pictorial perception means not only an account of the means by which diverse styles successfully represent objects, but an account also of that diversity which distinguishes among styles. We need a theory which describes similarities and differences among artistic styles within a single explanatory framework derived directly from a general account of ordinary perception.

The Generative Theory of perception and representation provides just such a framework. It conceives of similarities and differences among representational artistic styles in terms of invariant and variant aspects of appearance derived from a common core of ecologically constrained projective geometry. In perception, ecological projective geometry reduces to the solid angular analysis of the light coming to the eye: what is traditionally called natural perspective. Since Gibson, the unit of analysis in natural perspective is no longer points but structural relations persistent across change, what Gibson calls the formless and timeless invariants. But the context of non-change, of invariants, consists of change, the changing momentary appearances of things, equally derivable from natural perspective. Gibson's emphasis on invariant information for perception has seriously underestimated the importance and availability to awareness of the variant components of the optic array. An adequate theory must consider three separate but interrelated aspects of natural perspective: first, the fundamental importance of the existence of natural perspective in implying the existence of a rule or generator which operates as a conjunction of the permanent properties of objects and the transformations they can undergo, thus generating both invariant and variant projective components; second, the formless and timeless invariants themselves, which specify the permanent properties of objects; and third, the variants of natural perspective, the changing momentary appearances of objects. Conceiving of natural perspective as consisting of generators, invariants and variants allows for a descriptively adequate account, not only of similarities and differences among artistic styles, but also of a variety of heretofore unrelated perceptual phenomena.

The psychological availability of generative rules for the variants and invariants of natural perspective is evidenced by the facility with which novel scenes and events are perceived by both adults and children, even under extremely limited conditions of observation such as tachistoscopic presentation. Recent work on the categoriza-

tion of objects under transformation [e.g., Perkins,[23] Cooper,[24] and Perkins and Cooper[25]] and the ever-growing body of mental rotation literature [e.g., Shepherd and Metzler[26]] also support the theory. Further evidence is provided by the ability of ordinary perceivers to recognize instances of projective ambiguity and equivocality, to be tricked by pictorial illusions, to imagine quite accurately what familiar scenes look like from unfamiliar angles of view, to detect perspective distortions, to attend to visual angles relations rather than objective size, to locate the ego in pictures, and to determine the locus of the visual field. Both variant and invariant aspects of appearance are clearly available to perceivers, and the generative character of this ability is obvious from the tasks listed above which come from 100 years of perceptual experimentation.

The categorization of the world's styles of representational art in terms of perceptual similarities and differences is hardly a standard task in mainstream perceptual psychology, but it is the problem posed by this paper, and Generative Theory addresses it successfully. The categorization of style involves consideration of three aspects of the works: first, the station point assumption; second, the relative weighting of variants and invariants; and third, the relative emphasis on two versus three dimensional aspects of the works. Consider first the station point problem. Every artist engaged in representational depiction must assume a station point relative to the subject—even if the subject exists only in the mind's eye. The station point assumed may be single or multiple, central or eccentric, close to or far from the subject. Every representational style can be categorized in terms of the most frequent or characteristic assumption employed. For example, Figure 7-8 shows a fairly typical example of an Egyptian Old Kingdom tomb mural showing the assumption of multiple station points within and across figures, all quite central and at a relatively great distance from the subject. It should be remembered that at a distance ten times as great as the mean longitudinal (pictorially orthogonal) dimension of a fairly regular object, the perspective diminution from the front to the back of the object is less than 10%. Thus, the assumption of a station point at a distance greater than ten times the object size reduces the perspective diminution to almost nothing. In this sense, optical infinity is very close indeed. Old Kingdom paintings are nearly always characterized by station points at optical infinity, so there is almost no perspective foreshortening in

Figure 7-8. Egyptian Old Kingdom tomb painting, from H. A. Groene-wegen-Frankfort, *Arrest and Movement*, Faber and Faber, London.

Figure 7-9. Photograph of a man shot with a 50 mm lens on a 35 mm single lens reflex Nikon.

ancient Egyptian art. The assumption of a station point at optical infinity also characterizes much pre-Western-influence Japanese art, producing the parallel perspective so odd-looking to Western eyes, accustomed to a closer station point. The Western post-Renaissance assumption of a middle distance station point is only a convention, with no greater or less perceptual validity than a long-distance assumption—or, for that matter, a very close one. Figure 7-9 is an ordinary 50 mm lens photograph of a man with his hands raised, shot at about 18 inches from the subject's near hand. Again, Western adults, accustomed to a different station point assumption, usually judge this to be a "trick" photograph. Westerners also are quite conventionally attached to the assumption of a *single* station point and thus do not consider multiple viewpoint works, such as the Egyptian mural, to be natural or realistic looking. However, multiple station point styles are more common in the world's art than are single station point styles, just as long distance and central points of view are more common than short or eccentric ones. As soon as one abandons the idea that the conventional Western assumption of a single, middle-distance, central station point is somehow more basic, more valid or more "visually true" than the alternative, equally conventional assumptions, then the true kinship among art styles in terms of station point relations can be seen. Each of the assumptions is equally true to actual relations on the visual angle curve, to various aspects of natural perspective. As Goodman[27] remarked in a different context, realism in art is a matter of habit, of familiarity, and not of specific resemblances between the art and the world it pictures. Generative Theory, of course, assumes that structural resemblances in the light reflected to the eye from painting and painted are indeed the necessary basis for any judgment of realism in art, but judgment of *degrees* of realism is dependent on familiarity or cultural bias.

Cultural conventionality is not restricted to selection of a characteristic station point, but operates also to determine the choice of options provided by the second factor in categorizing style: the relative weighting of variant and invariant components of natural perspective. Some art styles, and again, the works of Ancient Egypt are a good example, show a very heavy stress on the invariant structural relationships among figure parts, and very little on the variants, the changing momentary appearances of the object. Thus, the man depicted in the upper left corner of Figure 7-8 shows an eye and

shoulders in frontal view, hips, legs, and face in profile, and an inside profile view of both feet. Each of those views was assumed to be most characteristic of the body part in question. Each of these "character-istic" views, when combined with certain legitimate projective trans-formation, will generate projective families of views of the body parts. Thus, these views have *renvois* in the generative rather than the essential sense of the term. No art style is ever strictly one of invar-iants depiction, because such a thing is not possible. Every aspect of an object which is invariant in the sense of having *renvois*, is also necessarily a variant of appearance. It is theoretically possible to create a picture with variant information alone, but not a *representa-tional* picture of a *recognizable* object. Figure 7-10 shows another Egyptian human figure painting from a much later period with a much greater emphasis on variant features of the body—in this case, the momentary appearance of the dancer.

Neither variants nor invariants have priority perceptually, nor is

Figure 7-10. A New Kingdom Egyptian dancer, from J. Capart, *Lectures on Egyptian Art.* Reprinted by courtesy of the University of North Carolina Press.

the one aspect of natural perspective derivable from the other. Yet, it might be argued that from the point of view of artistic development (given that one believes in such a thing), the emphasis on either invariants or variants came first, and the shift from one to the other reflects growth or progress or development. It doesn't seem possible to argue this viewpoint if one accepts the definition of variants and invariants in terms of components of natural perspective. Each must always have been available to every perceiver, and thus to every artist. Also, as noted above, it is not possible to separate completely invariants from variants even within a single art work, but only to talk of relative emphasis. Even in terms of historical priority, there is no evidence that emphasis on invariants precedes emphasis on variants, or vice versa. Figures 7-11 and 7-12 show two very different examples of Ice Age cave art, Figure 7-11 from Altamira, Spain, and Figure 7-12 from Cueva del Civil in the Spanish Levant. The Altamira paintings look so "modern," so "Western" in their attention to both variant aspects of appearance like foreshortening, and invariant aspects like organic integrity, that they were declared fakes upon discovery 80 years ago. On the other hand, the drawing from the Cueva del Civil looks startlingly "modern" because of its relative *inattention* to structural invariants and emphasis on momentary appearance in an action sequence. This heavy emphasis on variants, on momentary appearance, is considered to be a modern Western concern since the Impressionists, but can obviously be frequently found earlier and elsewhere.

The Cueva del Civil painting looks modern and Western to us for still another reason. The artist has shown attention to two-dimensional compositional demands in perfect balance with three-dimensional demands. Every painting not only depicts objects and surfaces in space, but is itself an object, a relatively flat surface, bounded by a frame, the edge of the canvas, or other surfaces. Two-dimensional demands require consideration of the flat pattern appearance of a single figure, of several figures together, and/or of all the figures in the composition relative to the surround. No piece is ever rendered without attention both to these factors and to the problems posed by depiction of three-dimensional voluminous solidity and/or layout in depth. Pictures vary considerably in the degree to which two- or three-dimensional concerns dominate the composition. The Cueva del Civil painting shows a remarkably tense balance between the

Figure 7-11. Ice Age Cave paintings from Altamira, Spain. After A. Walter Fairservis, *Cave Paintings of the Great Hunters*.

cueva del Civil

Figure 7-12. Cave art from the Spanish Levant, Cueva del Civil. After Walter A. Fairservis.

128 / Margaret A. Hagen

Figure 7-13. Design from a Kwakiutl painted box front. From B. Holm, *Northwest Coast Indian Art: An Analysis of Form*, courtesy of the University of Washington Press.

two-dimensional visual patternings, both of single figures and the group as a whole, and the three-dimensional action pattern in depth. The success of the equal distribution of the artist's attention to the two domains of composition is striking in this work. A more commonly occurring distribution of effort is exemplified in Figure 7-13 which shows a design from a Kwakiutl painted box front. It is the usual practice in Northwest Indian art, primarily a decorative art, to structure the composition in terms of the surface to be covered. Organic regularities of the voluminous solid depicted are certainly preserved in a lawfully prescribed manner, but such three-dimensional concerns are clearly secondary. In much of Western post-Renaissance art, however, the opposite emphasis seems to be true; two-dimensional compositional concerns seem to play second fiddle to three-dimensional perspectival concerns, at least until the post-Impressionist era. (Little agreement among art historians is anticipated.)

Since the points of comparison among paintings given by the Generative Theory are on continua and do not allow for dichotomous (or otherwise categorical) classifications of works and styles, disagreement about placement of works within the system is inevitable. What is important is that placement of any representational picture within the three-point system is *possible*, not that it is debatable. Any painting, any cohesive style of representational painting can be cat-

egorized in terms of: 1) the station point(s) assumed; 2) the relative emphasis on variant and invariant projective aspects; and 3) the balance between two- and three-dimensional compositional concerns. Thus Generative Theory gives us a unique system for anlayzing the perceptual similarities and differences among works of representational art, entirely in perceptual terms. It allows us to recognize quite surprising degrees of kinship among apparently quite diverse styles and to explain that kinship in terms of aspects of natural perspective. Generative Theory also reestablishes natural perspective as the explanatory structural umbrella for all perceptual tasks and phenomena, including the production and perception of representational pictures. The only important caveat in using the Generative Theory system to classify paintings is that one must not forget that the analysis is *only* perceptual. It may seem to the perceptionist, and often does, that there is little besides perception worth discussing, particularly when the subject is painting; but art is also cognitive and affective. The goal, even of representational art, by no means is reducible to representation alone. Representation is the primary concern of this paper, but it is not clear that it has ever been the primary concern of art.

Notes

1. Nelson Goodman, *Languages of Art* (Indianapolis, 1968).

2. E. H. Gombrich, *Art and Illusion: A Study in the Psychology of Pictorial Representation* (Princeton University Press, 1972); *The Story of Art* (London, 1972).

3. R. L. Gregory, *The Intelligent Eye* (New York, 1970); also *Eye and Brain* (New York, 1971).

4. J. J. Gibson, *The Perception of the Visual World* (Boston, 1950); "What is Form?" *Psychological Review*, 58 (1951), 403–12; "A Theory of Pictorial Perception. *Audio-visual Communication Review*, 1 (1954), 3–23; "Pictures, Perspective, and Perception." *Daedalus*, 89 (1960), 216–27; "The Information Available in Pictures." *Leonardo*, 4 (1971), 27–35.

5. J. B. Deregowski, E. S. Muldrow, and W. F. Muldrow, "Pictorial Recognition in a Remote Ethiopian Population" *Perception*, 1 (1972), 417–25.

6. R. J. Miller, "Cross-cultural Research in the Perception of Pictorial Materials." *Psychological Bulletin*, 80 (1973), 135–50.

7. M. A. Hagen, "Pictorial Perception: Toward a Theoretical Model," *Psychological Bulletin*, 81 (1974), 471–97.

130 / Margaret A. Hagen







8. M. A. Hagen and R. K. Jones, "Cultural Effects on Pictorial Perception: How Many Words is One Picture Really Worth?" in R. D. Walk and H. L. Pick, eds., *Perception and Experience* (New York, 1978).

9. R. K. Jones and M. A. Hagen, "A Perspective on Cross-cultural Picture Perspection," in M. A. Hagen, ed., *The Perception of Pictures, I* (New York, 1980).

10. J. J. Gibson, "The Information Available in Pictures," 27–35.

11. R. Arnheim, *Art and Visual Perception: A Psychology of the Creative Eye, (The New Version)* (Berkeley, 1954, 1974); *Visual Thinking* (London, 1969).

12. Arnheim, *Art and Visual Perception*.

13. Gibson, *The Perception of the Visual World; The Senses Considered as Perceptual Systems*.

14. H. von Helmholtz, *Treatise on Physiological Optics* I, II, III (1895 third edition) ed. J. P. C. Southall (New York, 1962).

15. Gregory, *The Intelligent Eye*.

16. E. J. Gibson, *Principles of Perceptual Learning and Development* (New York, 1969).

17. Ibid.

18. T. Ryan and C. Schwartz, "Speed of Perception as a Function of Mode of Representation," *American Journal of Psychology*, 69 (1956), 60–69.

19. M. A. Hagen and H. B. Elliott. "An Investigation of the Relationship Between Viewing Condition and Preference for True and Modified Linear Perspective with Adults," *Journal of Experimental Psychology: Human Perception and Performance*, 2 (1976), 479–90.

20. M. H. Pirenne, *Optics, Painting and Photography* (Cambridge, England, 1970).

21. Arnheim, *Visual Thinking*.

22. In Gibson, "Pictures, Perspective, and Perception"; "The Senses Considered as Perceptual Systems"; "The Information Available in Pictures."

23. D. N. Perkins, "Visual Discrimination Between Rectangular and Non-rectangular Parallelopipeds,"; *Perception and Psychophysics*, 12 (1972), 396–400.

24. R. G. Cooper, "The Development of Three-dimensional Shape Perception and Shape Constancy in Pictures." Presented at Minnesota Conference on Pictorial Perception, 1976. Unpublished manuscript, University of Texas at Austin, 1977.

25. D. N. Perkins and R. G. Cooper, "How the Eye Makes up What the Light Leaves Out." In M. A. Hagen, ed. *The Perception of Pictures, I* (New York, 1980).

26. R. N. Shepherd and J. Metzler, "Mental Rotation of Three-dimensional Objects," *Science,* 171 (1971), 701–03.

27. Goodman, *Languages of Art*.

JOHN M. KENNEDY

8 Depiction Considered as a Representational System

The last decades have seen a vigorous debate on the nature of depiction, and we who are deeply interested in pictures must be glad that we have had the work of intellectual titans to enrich our understanding of picture perception. The debate has ranged widely; serious thinking has followed careful observation and experiment.

Ideas about depiction grew from Gestalt theory,[1] ecological optics,[2] cognitive theories of perception,[3] nominalist stances,[4] and analytic philosophy,[5] as well as art history and theory, most notably in the extensive work of E. H. Gombrich.[6] Some of these ideas have stimulated a burst of effort by experimental psychologists recently to gather evidence on perceptual processes special to pictures, the development in children of the capacity to use information from pictures, cross-cultural and even cross-species factors in picture perception.

Rather than asking what value was placed on pictures, or which painter influenced whom, or what techniques evolved when, the debate that has stirred philosophers, psychologists, anthropologists, aestheticians, and educators has centered on the picture per se. As a physical object, what is it? What kinds of perception are involved in looking at a picture? For example, the experimental psychologist has been asking, in many guises, whether pictures can make sense to people who have no special training in "conventions" of picturing. The question presupposes a definition of a picture, and in effect suggests that a certain kind of physical object can represent another object for an untrained, naive person.

The heart of the matter is our understanding of the physical nature of the displays we call pictures, and the kinds of psychological factors we call on in perceiving them. Accordingly, the task of this review is to examine pictures, in their many kinds, as they seem to bear on physics, optics, and perceptual phenomena. How much of the account of depiction should be cast in purely physical terms, and how much can only be scaled when psychology is given a place in the discussion? That is the fundamental question we can use to integrate this assessment of pictorial perception, to select key issues and distinctive kinds of pictures for discussion.

It is wise to open an assessment with the conclusion to which it will lead. Here it is:

Depiction is possible because of elements such as lines and contours that have special powers over perception, whether they are deployed in patterns that specify an object or not. Specification can be physical (matching a layout physically) or projective (matching the directions from a vantage point). Human understanding of human agency is involved in depiction. The keys to pictures are elements, patterns, human agency, and human understanding. To deny roles of some kind to projection, vantage points of various types, the varieties of human agency and communication and understanding, would be to miss interesting parts of the range of pictorial representation. Depiction has two sides, for it rests on physical factors and yet it is in the realm of man-made things and is understood by the user in its relationship to human intention. As a consequence, depiction is a representational system in which one side can be played off against the other.

What follows is a defense of the opening claims. Of course no one would deny that at least some pictures involve projection from a station point and are made by a person with a purpose. So the defense here needs to aim higher if it is to be worthwhile. In the end, the record will show in simple, commonplace pictures and in unsuspected examples how depiction is a human system of representation. What is to be examined is how the perception of pictures involves a person using psychological factors to determine the meaning of physical matters.

Some drawing tasks will be considered briefly here but nothing would be gained by belaboring at length that drawings are made by

people, or by examining children's drawings in detail only to arrive at what I believe to be the case that not much is known about infants' drawing. Also it should be noted that nothing is being claimed here about humans as opposed to animals. Animals sometimes share with us features of our kind of understanding. The phrase "human understanding" refers to those psychological capabilities without which civilization would be impossible.

I. The Etcetera Principle in Pictures

In language we have a handy way for indicating everything by giving a few examples and adding etcetera, and so on and so forth, or even ad nauseam. A poem by e.e. cummings ends cutely with ego dreaming of your hair, your eyes, your hands, and of your etcetera.

There is an equivalent in pictures.[7] We can show a wall by drawing in, say the top and bottom and a few illustrative bricks (Figure 8-1). In a happy example mentioned by Arnheim a child drew the outline of a skyscraper and began drawing the row upon row of windows. After a few rows were filled in the child apparently grew bored with his tedious task and wrote "etc."[8] It is not necessary to write "etc." of course—he could have completed a few rows and the rest would be understood.

Similarly, we can let the outline for a figure trail off. The ends of the lines are not taken as the ends of the body. A head where the neck lines trail off is not decapitated. Also, as in Figure 8-2, we can draw a crowd by drawing a few people in recognizable detail and squiggles alongside will be taken to be further figures of the crowd.

There are three cases here. In one, empty space in the picture has a connotation of filled space in the referent. In the second, the end of a line does not mean the termination of the referent. In the third, a squiggle that is meaningless on its own stands for another of the same kind as the others of its context. In all, the series denoted by marks present in the display is taken as continued. The extant and recognizable marks act as signposts for the remainder. And the remainder, considered on its own—be it empty space, the end of a line, or a squiggle—does not have the distinctive characteristics of the appropriate referent.

If pictures were creatures that could only capitalize on the laws of

Figure 8-1. A brick wall. Its bricks are exemplified by a few instances, rather than shown in their entirety. Sketch by E. Sacca.

Figure 8-2. Hunters. Some members of the crowd are indicated with marks that are disambiguated by the presence of patterns specifying people. Sketch by J. M. Kennedy.

informative light in the everyday, nonpictorial world then the etcetera principle in depiction would not be possible. At the best, if a close fit with the terrestrial environment were demanded, where the bricks were not visible in the wall or lines trailed off, it would be necessary to account for their nonvisibility by taking the referent to be obscured by something like plaster on the wall or mist swathing the figure. Such an accounting is not necessary. Instead the perceiver notes the bricks as "examples" and the unstated remainder of the body to be "irrelevant."

The notions of "example" and "relevance" are psychological rather than physical. There may be physical marks on the display to specify that an item is to be taken as an example, but the presence of such specificity is not enough to reduce exemplification to a purely physical matter in this case. There are different kinds of specificity, one kind being purely physical and one being psychological. A purely physical one is entailed when light is specific to its source, having no other possible origin in the universe. The psychological one is involved when a mark is understood to be an example of a type.

The etcetera principle should be distinguished scrupulously from a case mentioned by Gombrich discussing Rembrandt.[9] An early Rembrandt might show gold braid on a uniform in meticulous detail. A later Rembrandt might show similar braid with a few daubs, wisely positioned. From a distance the quick daubs are indistinguishable from the detailed braid, a handy fact for a painter to know to save labor. The etcetera principle however does not rest on two things of different complexity being indistinguishable. The empty spaces, squiggles, and trailing lines of a sketch are perfectly plain for all to see. They will not be confused with an ornate rendering of the same matter. The crux is that what is obviously nonspecific is not taken to be vague, ambiguous or empty in the referent, but rather is filled with some particular thing, just as the dots in

$$A = 1/2 + 1/4 + 1/8 + \ldots$$

are referring to an exact sequence, without leading us to see the set of marks $1/16 + 1/32 + 1/64 \ldots$ on the paper.

II. Metaphor

Just as handy as the etcetera principle in language there is the metaphor that calls on what we know closely and tells us to apply it in

new circumstances—at length in clever metaphors. So too in pictures there are metaphors.

Pictorial metaphor using whole objects or standard signs is too well known to need much discussion here. If the correct symbolic object is portrayed we may know that the picture concerns Death, Night, or the Holy. Put a halo around someone's head in the picture and it can be taken as not literal; around El Presidente's head it tells us something tongue-in-cheek perhaps.

For our purposes here, metaphor should be shown to be more than a method for commenting with particular signs on well known political figures or stock scenes from history. It should be something in commonplace depiction, where the basic parameters of form and location of an object are concerned, rather than restricted to implications of theatrical objects like owls, cornucopias, or crescent moons. Bruner argued that pictures are not amenable to transformation, unlike language.[10] If shape transformations are useful and commonplace in pictures, then Bruner's view will be refuted at the most basic level of depiction—the portrayal of layout.

Consider strip-cartoon devices for representing movement.[11] In one case the object is shown in a posture which would be adopted in mid-step or flight. The balance of the form is specific to a moving body.[12] In another kind of case a posture can be presented which is not ever realized by the object. For example, a spinning wheel can be shown by curving the spokes. The curvature can be taken by the viewer as not literal, as a device for telling that the wheel is turning rather than as a straight presentation of curved spokes. In like vein, extra arms can be drawn to suggest a housewife busy at a task or extra legs to show the paddling run of a dachshund. Schematic outlines one after another behind a runner are not his ghostly competitors but tell of his own speedy racing. A twisting line behind an aeroplane tells us about its aerobatics, not about a ribbon caught in the slipstream, just as a spiraling line around a spinning wheel is not the edge of something or the wake of the wheel in smoke or steam but just an external indicator of the wheel turning swiftly on itself. The foremost edge of an object can be shown clearly, and the remainder indistinctly though if motion is blurring one part it should blur the whole.

In other words, the shape of something can be changed, added to

or subtracted from, with internal or external modifications, to indicate movement. The portrayal involves the object in question with its own features altered—a far cry from say importing some questionable independent object like a scythe into a scene to give a hint that Death is at issue.

Modifications of shape and the addition of graphic marks pertaining solely to the object in question are used to tell us about more kinds of events than movement. Shouting and other noisy events can be indicated by tell-tale concentric lines. Pain, luminosity, and fizzing drinks are shown by graphic marks that pertain to the object, not simply by adding a context of doctors, shadows, or Coke labels as external giveaways.

Metaphor romps through caricature and the strip-cartoon and it is becoming increasingly accepted in textbook illustration. It is a cheap, efficient way to say a lot inexactly, calling for tolerance from the beholder rather than canons of versimilitude. For present purposes the crucial feature is the unarguably psychological nature of the device. Metaphor does not exist in nature. It requires a nonliteral rendering. Cameras do not make metaphors without trickery by the cameraman.

Some might object that not all of the examples of curling or extra limbs or blur are metaphors. There are literal examples to relate these examples to, it might be said: There are often impressions of a wake of half-visible lines behind a moving dancer, so that the form of the phrase over time is continuously present in vision. There are two counters to this point. Firstly, it is not being argued that there is never a possible correlate, only that these correlates are not being invoked by the usual picture. Secondly, the viewer can take the drawing as nonliteral, and does so usually. The cases of children, and non-Western children especially, who find comic strip devices for showing motion puzzling (see discussions by Kennedy,[13] Friedman and Stevenson[14]) confirm the interpretation of particular devices, though of course numerical evidence like this does not clarify the distinction being devised here. Also salutary is some evidence from deaf children. It happens that deaf children are taught that radiating lines from a mouth or a collision mean the event creates loud sounds. Thus they are given tuition in the meaning of what is usually acquired by other children in more informal fashion (by guesswork in the main I

expect). The deaf children are taught about sound indicators, and not about movement indicators, and they are not explicitly taught the metaphoric basis for these indicators, nor are they exposed to the rich currency of child discourse with its plentiful metaphor. Hence one would not expect much transfer from sound indicators to movement indicators. This is precisely what is found. Deaf children recognize pictures of common objects as readily as the hearing, do much better than their hearing peers on pictures with sound indicators, and much worse than their hearing peers on movement indicators.[15]

III. Selection

Pictures may often have etcetera principles and metaphors in their service, and these may be psychological rather than physical in their nature. But is there anything in the nature of depiction per se which welds it to psychology rather than physics? One theme that has been clearly enunciated by Gombrich provides a cast-iron link.

Pictures are *selective*. They cannot ever show all.

To complement the etcetera principles, where a series casts a spell on its context, it should be recognized that whatever marks are present are only a few of the possible marks that could specify a referent, and only a few aspects of the marks are relevant. Let the marks be lines, for example. Their color and thickness are probably irrelevant. In any case it is necessary to take their color and thickness as irrelevant *sometimes*! At other times the color may be relevant while the thickness is an indifferent matter.

Pictures are selective in what they show of their referent, and the aspects of the display that are representational are a matter for selection that varies from occasion to occasion. The selection is again a matter for people, not just physics; the artist and the viewer must proceed judiciously (though the artist does not set aside the physics of his subject nor the viewer discount the physical marks on the display). From the Pandora's box of intended referents, the artist or a photographer must consider his point of view seriously, if it is to be revealing. From the display given to him the viewer must take in a disciplined manner if the revealing view is to become evident. Both must glide over some of the possible anchors for attention and seize what is cogent.

The task here is selection, not construction, it might be noted. As Arnheim has it, the task is to find the essential structure of the object and establish an equivalent on the display's surfaces.[16] As Gibson puts it, one must find the informative components of the optic array and regenerate them from marks on a surface.[17] Finding what actually works perceptually, not inventing some arbitrary language and inculcating it into others is what is being emphasized by both authors. However, the physical factors that work are presented alongside what is irrelevant, and the determination of "relevancy" is a psychological matter.

In sum, in all cases pictures have some features that are relevant to their being representations; sifting these features is a matter of determining what is relevant, and that is a psychological factor endemic to depiction.

IV. Artifice

To turn the screw yet tighter, it is important now to consider the view that all pictures are artifacts, part of man's world, not nature's. Gibson makes this view central to his definition of pictures.[18] To Gibson, a picture is a surface treated by a person in such a way that the same kind of optic information is yielded by the treated surface as would come from a natural source.

The reason for Gibson's insistence on artifice is his loyalty to a realist position. To defend the view that the senses are supplied with information, it is crucial to have some way of setting aside the opportunities for trickery offered by pictures. Gibson uses the natural/artificial distinction as his wedge. Once pictures can be dismissed as an irrelevant case in the initial stage of the argument, the Gibsonian analysis can begin. The first step is to define the conditions under which information can be said to be present, and the second is to test the natural world—the world without artifice—to determine if optic information is present in that world.[19]

In terms used by Gibson and some other psychologists (e.g., Miller),[20] information is present in light if there is both correspondence between the source and the resulting optic array, and something so distinctive about the optic array that it could only have come from its actual origin. It is plain that pictures disturb the roots of information by being an additional source besides the natural

origin that could provide optic structures telling us about some kind of source of light.

Besides its usefulness to realism, is there any support for the view that pictures are always artificial? Common experience does lend some support. We do not find portraits in nature, outline drawings in caves never visited by man, objects that look like photographs in nontechnological regions of the earth. Occasionally we find partial resemblance between veins in a flat rock and some other three-dimensional object. But the resemblance is inevitably poor compared to what any reasonable artist could achieve in a sketch of a few seconds. Any depicting properties of a natural object are cause for comment, the object becomes a curio, a place in Ripley's "Believe It Or Not" is opened.

Even if it were true that not all pictures are artificial, it is sure that nearly all are. And nearly all occur on artificial surfaces, and their status as man-made is unmistakable. Magazines, newspapers, posters, books, photograph collections, museums, and even the mere presence of frames, covers to the sketch book, or the appearance of the sketching pad are all giveaways. The pencil line, the printed line, the brush stroke, and the imprinted color are testaments to man's agency.

Gibson's aim in introducing the natural/artificial wedge was to fob off critics armed with special displays they had invented to circumvent his laws of optic information. His work has explored natural optic information, and then he like Kennedy[21] has claimed pictures piggy-back on the laws of informative optic structure. The claim is not being gainsaid here; rather in the service of the theme that pictures are more than physical it is important to seize afresh on the natural/artificial distinction. If it is true that pictures are typically plainly artificial, then they can be taken by the viewer as intended to be used in a particular way. Presumably, the viewer notices that the object is man-made, the marks are man-made, the configuration and marks are pictorial rather than, say, writing, and the graphic elements are understood to have some function in human communication. Precisely this kind of understanding allows the viewer to accept that some curves are intended literally, and some are intended metaphorically, or that some line-endings are intended as ends of wires and others are merely the borders of the sketch, or that some color is relevant and others are not.

Conversely, what is unintended can be apparent. Too often the amateur photographer or draughtsman ends up with a peculiar juxtaposition, where bushes grow at the ends of peoples' noses. Rubin became so experienced with figure-ground reversal that his eyes would deflate his aesthetic moments, turning grounds into unintended figures, and leaving beautifully painted rounded rumps in the clutches of unintended lobster-like claws.[22] Rubin fully recognized what was meant and ruefully admitted his eye was not doing justice to the Sistine chapel. He was not forced to take what his humorous eye found, but could readily distinguish what was supposed to be depicted and what jest his figure-ground tool could play in addition.

In essence, the viewer of a picture is in a position to understand that another person expects him to take the picture as a communication. This statement in mind, let us revisit two hoary puzzles of depiction—the El Greco fallacy, and the relationship between element and configuration.

V. The El Greco Fallacy

El Greco painted conspicuously elongated people. Could this be because of an eye problem? Did he see people elongated? Unfortunately for this analysis, if he saw people elongated he would paint them normally and still see his work elongated.

The rebuttal to the El Greco fallacy has merit but it can be taken too far. It is possible to use pictures to convey something idiosyncratic about one's vision. For example, my friend Jay, whose near vision is better than his far vision, could see something clearly from up close that would remind him of his impressions of a more distant object. Let us say he draws an object fuzzily, looks at it from 30 cm and tells me it looks like a fuzzy object from 30 cm or it might just as well be a sharp object 100 cm distant. His comment and the picture together can be most useful. I learn that increase in distance has a close relationship to increase in fuzziness for Jay, just as it does for me on a misty day.

Presumably El Greco's rather kitschy style stemmed from his own odd sense of the impressive. It is unlikely that he had an elongating eye. But it is not illogical to interpret his manner as involving an affliction. All that we need do to avoid the logical pitfalls is to

suppose that he sees people elongated sometimes (in the distance, at night or whenever) and sees his pictures differently (close up, during the day or whenever).

It would be far-fetched to suppose El Greco was trying to show something about an eye condition—his ideas were loftier. But we should realize that pictures can be of good use in telling us about someone's ways of seeing. The picture can be examined in one set of circumstances and pronounced to be a good representation of an object seen under very different viewing conditions.

Notice here that the viewer is acting from one vantage point, with particular lighting and at a certain distance from the display. But he may be taking the picture as related to a different vantage point, different lighting and different distances from the depicted object. A vivid case from my youth comes to mind. One of my first exposures to Cubist paintings was in the Ulster Museum, at a travelling exhibition. Quite unfamiliar with Cubist activities, I was struck by one particular large painting, which was in subdued almost achromatic tones, of an indefinite figure which had a profile nose and a face front nose, and multiple eyes, and two rather vague outlines. It seemed to me at the time that this was the first attempt I had ever seen to picture the double-images I have of someone's face when I am close up and have both eyes open! The attempt was respectably successful so far as I was concerned, even down to the subdued lighting which normally accomplished being close up in my experience at the time.

In sum then, pictures can be admirable vehicles for conveying impressions we have of objects. Depiction can be aimed either at the object, a very physical matter, or at impressions we have of the object, a more psychological matter.

VI. Element and Configuration

Gibson argues that pictures provide the same kind of information as the natural optic array. His use of optic information nimbly allows him to dismiss definitions founded on the viewer's impressions, problems with similarity, and to scuttle the sensation-perception issue. His bow to psychology is simply to say that pictures are "treated" and thus are creatures of artifice. But there is much that calls us back to psychology, and much that will either have to be reconciled to Gibson's physics or be given pride of place, dislodging

some of the physics. The relationship between line and figure is a case in point.

Usually, these days, the configuration is held to sway the element. In a good story from Arnheim, the Peasant sees his cottage being put on canvas by the Painter. The Peasant asks why the Painter's lines of the house are drawn "crooked," because he does not understand about perspective. Then as the picture nears completion the Peasant exclaims that now the roof's sides no longer look askew. The lesson is that the elements on their own give one impression and in the total configuration another impression results.

Logically, a single line cannot be specific to anything. And if the line is made into a simple outline form like a circle or square there is still no specific referent. The circle outline for example could depict a disc, a ball, a hoop, a cave, indeed any foreground-background relationship one might care to try. The peculiar thing, however, is that the circle is a *successful* depiction of each of these foreground-background relations that one can try. That is, if one cares to see the circle as a ball, the convexity of a ball is apparent, and, as Rubin pointed out, the ball will be foreground against an indeterminately distant background.[23] The ground which is left unshaped by the circle can be in front of the figure, if one desires—in which case one can see for example a shape like a ball being pressed from the back against a foreground surface, just as one can see a tongue-in-cheek. The list of depicted foreground-background variations is as wide as physics permits in the real world (Figure 8-3).

Rubin left many people thinking the ground had to be behind the figure, which is much too narrow a claim. The fact is that with a circle, any foreground-background relation can be seen. Rubin was correct however, in emphasizing that we do see foreground and background. We do not take the circle to be some kind of asterisk whose purpose is to make us think about or recall some factor. We actually see something near and something far, something shaped by the line (the figure) and something not shaped by the line (the ground). The figure seems to have object quality, precisely as a consequence of its having shape, and it may also appear substantial, textured, denser than its surrounds. The ground is the underlay (in Rubin's examples), though it can also be an overlay (like a draped opaque curtain, or a transparent sheet or whatever reveals the figure's shape in some fashion). The simple line form allows us to see

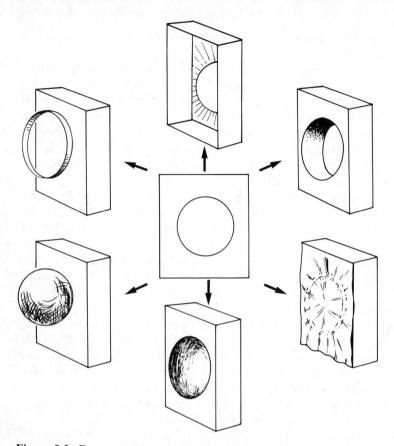

Figure 8-3. Foreground-background formats depicted by a line, including overlay and underlay.

relative distance, overlap and shape. The shape is depicted shape—for two lines that converge can look like parallel tracks at a slant. The overlap is depicted overlap because of course the lines can be ink on a paper. The relative distance is depicted distance because the lines can be flat on a flat surface.

In sum, simple forms depict. And they do so without being specific to a source. Since a simple form can depict any of the possible foreground-background relations, and all the form participates equally in all these depictions, there is no information in the form for any of these relations in particular.

To underline the message, notice the difference between a simple

form depicting and a complicated ambiguous picture. In a complicated ambiguous picture like Dali's *Bust of Voltaire*, all the patterns necessary to specify Voltaire are present, and all the patterns necessary to specify people standing chatting are there too. The composite has two possible referents. The information for both referents is present. Not so with the simple circle. It depicts despite the fact that it specifies none of the foreground-background relations it enables us to see.

Specificity is a matter of physics, in the guise of ecological optics.[24] But some displays act as pictures without being specific to the referents they enable us to see. Hence a certain class of pictures totally escapes a physicalistic or optic criterion for being a representational display.

What then of the relation between line and configuration? One thing at least is clear. The line can be taken as depicting even if the configuration is not specific to the referent. Also, the line can change its referent even if the configuration is constant—and the range of referents through which the line can change is as wide as the range through which the line can be forced when placed in different configurations. In effect, the line and the eye alone can do whatever the eye customarily does with the line in a complex informative display. The element does not require the distinctive configuration to be taken as a depiction. What the Peasant lacked when he first looked at the Painter's work was not simply the appropriate massive configuration but was also the gumption to try another way of seeing the simple lines.

There is nothing here of course to say that the configuration cannot be helpful, cannot be specific and informative. Rather, the point is that specificity is not the only means to depiction.

VII. Simplicity

In one possible view of the origins of picture making, man initially enjoyed scribbling for its own sake much as infants like to make things happen under their own control. In the course of scribbling some persistent fellow made more and more ornate displays, and then stumbled onto a sufficiently detailed design to specify a three-dimensional referent, X. The artist called to his fellows "Look at this—it's an X!"

However, as we come to understand the comparative freedom of the element from the specifying configuration, that view of early picture making must be suspect. More likely, the barest and most simple designs were drawn while the artists pointed out that they could be seen as Xs, or Ys, or Zs. Depiction was probably enjoyed before specificity was attained, quite some time before anyone could draw something that was an X and nothing else.

There are many examples of the power of simple forms in depiction. Smile buttons and droodles come to mind as contemporary exploitations of simplicity, while the stick-figure is antiquity's foremost contribution.

The smile button is a few dots—2, one for each eye, or 4, including two for the nose—and a line for the mouth. The schematic face of a smile button may include a line for a nose, or the eye-dots may be exchanged for lines.

How do smile buttons work? If we were to follow ecological optics we would try to prove that the dots specify eyes and the line specifies a mouth. The attempt would not be credible even to the most sympathetic listener. It is perfectly obvious that a circle does not specify a head, the dots provide nothing that is distinctive to eyes alone, and the line could be any of a host of things rather than a mouth. The pattern, too, taken as a whole is obviously closer in physical reality to a button with a crack in it than to a head with a semi-circular mouth.

Should it be said that the schematic faces of smile buttons and the like are entirely conventional, in the sense that they are no more like their referent than the word face is? Hardly. Smile buttons are "dense" symbols, as Goodman would put it,[25] varying their expressions with minor modifications of the elements, and one need not tell the viewer what to see, the pattern will be pictorially effective.

Perhaps the only powerful factor is the configuration of elements, it might be proposed, since the eye-dots can be replaced with lines, the line for a nose can become a dot, and the mouth line can be replaced with a dot. The only constant then would be the configuration. However, there are two counters to this proposal. Firstly, the change of a dot for a line does not leave the expression unchanged. The mouth for example, will seem firmly set as a horizontal line and pursed in surprise as a dot. Secondly, if placement were all that mattered then any element could stand for an ear. But in fact dots

Figure 8-4. Smile buttons. Different elements—dots and lines of different shapes—can be used for facial features and a more restricted set for an ear, where only the semi-circle is appropriate.

and straight lines make very poor ears, though a semi-circle is an acceptable ear (Figure 8-4).

As J. Campbell (personal communication) pointed out to me, when a dot stands for an eye it is taken to be one part of the eye (like the iris if it is small, or the whole socket if it is big) while a line is taken to be a different part, e.g., only the lines are readily taken to be the eye-brows. Thus, not only does the element have to suit its location, but also relevant parts of its referent are sought out and selected as a good fit.

The configuration is not specific to its referent, and the elements are not distinctively presenting their referent and none other. Rather, in the absence of specificity, the configuration and the element are taken as depictions of a particular referent and fitted by vision to that referent as best it can, now matching up one part of the referent (e.g., the brows) now another (the iris).

Much the same analysis can be made of droodles.

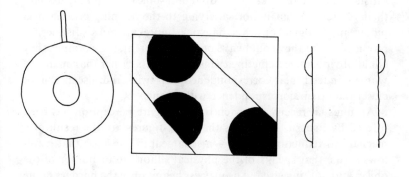

Figure 8-5. Droodles. Mexican riding a bicycle. Giraffe passing a window. Bear climbing a tree.

Droodles are amusing designs that at first are empty of signifi-
cance and then, with a cute caption, they turn into graphic witticisms.
The famous ones include Giraffe passing a window, Mexican riding a
bicycle, Bear climbing up a tree (Figure 8-5). They are all subjects
drawn from unrevealing points of view. The caption dispells the mys-
tery by telling the subject, and the lines fall into place as fitting useful
parts of the referent, but with most of the referent hidden. One does
not pick out distinctive information that was previously overlooked,
once the help of the caption is available. Instead, the lines are tied to
the referents given by the caption, the configuration serving only to
tell which line should be tied to which referent. Again, however, it
must be noted that pictorial effects of shape and depth arise vividly
once the droodle is fitted to its referent.

Smile buttons and droodles may seem trivial matters, and the
lessons to be drawn from them merely footnotes to the study of
depiction. Be that as it may, there is no way that their sibling the
stick-figure can be relegated to back pages, for stick-figures are
present in almost every culture, have come to us from the caves of
prehistory, arise from the struggles of children to master depiction,
and have an efficiency and universal power that must not be over-
looked.

What does the theory that pictures are patterns specific optically to
their referents have to tell us about stick-figures? Unfortunately, very
little. Ecological optics might be satisfied with some aspects of stick-
figure, but some crucial characteristics it finds indigestible. What is
satisfactory is that stick-figures do retain some correspondence with
their referent. What is not satisfying to the defining criteria of a
picture in ecological optics is that stick-figures are not so distinctive,
physically, that they could have only one referent; for example, they
could obviously be depicting twigs and insects rather than men and
women; indeed their correspondence with twigs and insects is a lot
closer than their correspondence with people.

An unusual recent approach to stick-figure perception has been
offered by Psotka. He argues that stick-figures are the result of a
mechanical reduction process—mechanical in the sense that it fol-
lows a rule that speaks of the physical silhouette or border of the
object and nothing else.[26] The process begins once the borders of the
object are established. Then uniform reduction occurs, proceeding at
right angles to the contour towards the center of the referent, if the

contour is an outer contour, and in the opposite direction if the contour is, say, the inner border of a doughnut. The process may be likened to a fire lit at the borders of a straw figure (or to acid eating away the figure's substance after being applied at the borders); it will meet fire coming from the opposite side of the object and the two fires will then be quenched, along a line we can call the "quench line." This line to which the object is reduced is the stick-figure of the object. Hence, the stick-figure of a finger is a single line, and each limb of the body could be depicted by a single line.

The reduction process Psotka describes has some merit. The quench line theory provides a simple method of abstraction, one that could readily be given either a physiological basis, or a counterpart in Gestalt terms. It is a process that could be believed to be innate and universal without troubling even the most die-hard anti-cognitivist—and an innate process is probably called for by the remarkable cross-cultural universality of stick-figures. However, the theory is damned by its own predictions. Let us note what it predicts to be the stick-figures of some standard shapes. The stick-figure of a circle the quench theory gives us a dot. This is not entirely a happy prediction, because the usual stick-figure representation of a head is a circle whose size is larger than the lines being used for the limbs, not simply a dot. (If one were to contend that for some reason the quench theory did not include a precise prediction for human heads then the realistic and practical issues behind stick-figures would be entirely missed by the theory). The stick-figure for a square would be the two diagonal lines of the square, which seems unlikely, in the first place, and no more likely than the two lines which divide the square into quadrants, in the second place.

The stick-figure for a rectangle would be a line along the long axis of the rectangle, a line which eventually divides into four, short lines which bisect the corners of the rectangle (Figure 8-6). The rectangle's stick-figure may seem improbable, but Psotka deems it a crucial test

Figure 8-6. Rectangle shrinking to a stick-figure, the "quench-line."

Figure 8-7. Psotka's figure for a cross, a cross in outline, and the stick-figure for a cross.

of the quench line theory, and he claims to have found evidence in support.[27] Even if we were to accept the quench line theory's prediction for a rectangle, we would surely not accept some implications for more complex figures built of rectangles for example the cross. The cross is made of two rectangles at right angles, and the stick-figure for a cross is two straight lines at right angles (Figure 8-7). The stick-figure is not what the quench line theory says it ought to be, namely two straight lines with four Vs, one at each line end[28] (Figure 8-7).

The counter-examples to straight applications of ecological optics and a quench line theory may help us to understand stick-figures anew. It is clear that there is some correspondence but not as much as could be achieved by a physical match with twigs and insects. It is clear too that the main axes of a figure may be related to stick-figures, not just the borders directly. Let us assert then that stick-figures preserve the main axes of a figure, and in so doing preserve *some* of the significant *relationships* of the referent. Not all the relationships that make the referent particular are preserved. Presumably, then, stick-figures should be considered a *style* of representing, in which it is special to the style that the closest physical match to the display is not at issue, not intended.

While realistic picturing aims to capture enough to single out the referent beyond any other normal ecological referent, stick-figure depictions aim to portray at a less specific level. Thus, we can understand the use of a plain circle to depict a head—the circle indicates the head in general terms without specifying a head. Only in the context of a stick-figure does the circle indicate a head.

What is being said here of stick-figures is true of style in general of

course. In a given style, a mark is to be taken one way, and in another style the mark may have a different referent. In the case of stick-figures, marks do not have enough physical detail to specify their referents, and the reviewer accepts the limitations and takes the absence of specificity as not relevant to determining the referent. Style can be present with or without specificity, and what stick-figures show us is that the absence of specifying detail can be a style itself.

In sum, when we look at stick-figures why do we not see twigs and insects depicted? The answer seems to be that something tells us that detail is irrelevant, and the figure can then fit perceptually into an object far removed from twigs and insects, objects like people, deer, and boats. It is precisely because we take a four-limbed mark to be a person, one moment, and a mere stroke atop a canoe to be a person, the next moment, that something less mechanical than a rule based on contours or borders is called for. The stick-figure is fitted to its referents with wide variance in the amount to which it fits and how much has been left out. Stick-figures, then, have much in common with droodles.

The assessment of simple, schematic figures here has suggested several things. Firstly, figures of this brevity are widespread and of considerable antiquity. They are not a product of modern shorthand or impatient technology. Secondly, they give rise to phenomenologically definite effects like fitting the available display's elements to suitable elements in the referent, under guidance by captions or understanding of style. Where some pictures press their detail on the viewer, and force him to select rather than be swamped, schematic simple pictures permit the viewer to work with the elements to follow suggestion and style.

VIII. Neighbors and Relations

For a picture that is a profusion of features, a full and sophisticated version of a landscape for example, the viewer's role is very different than when he is confronted with the dash of a line sketch. The landscape requires the viewer to look here and there, finding out about the river, the fields, the trees, the livestock, the roads, and so on. There is little need to think of the viewer hunting for a suggestion about what the brown ridges are between the "hedges." They are depicting furrows. We might, in a figure of speech, think of the viewer as an assessor of the picture, examining to find what neigh-

bors on what, what is settled on the landscape.

With the line sketch, a different figure of speech is called for. The viewer is more of a canvasser, and needs to know what kind of family the picture is from. Is the picture of one style or another—vis-à-vis such basic questions as the absence or presence of specifying detail? It is not so much the immediate neighbors of a mark on the paper that are being assessed, but the relations of any mark to the type of use they require. Should one inquire from the neighbors, or ask distant relatives like the caption which is outside the picture frame altogether? What kind of relations should we bear in mind—what types of pictures are there, and while there are many types, what are some of the distinctions that reflect on the physics and psychology aspects of pictures?

The frankest contrast between the physics and psychology of pictures must be in pictures of physically impossible things, though there are other kinds of pictures that can help to undermine any attempt to rest an analysis of pictures solely on physical criteria.

IX. The Impossible Picture and the Depicted Picture

There are a lot of well-known impossible pictures. Waterfalls that create rivers that lead back to the original waterfall, stairs that come back to their origin, three pronged forks that become two-pronged because surface turns into air, triangles whose sides jut forward but end up back at the original apex, etc. These are a class where depth information from the flat picture can continually say "onward" so A is on from B and C is on from A and yet B is on from C.

There are other kinds of impossibles, too, where solidity can become vacuum, the mirror can be showing the wrong side or the image can be becoming solid. Anything that can be indicated on a picture can be contra-indicated too, provided the two indications can be displayed in separate places. (If the indicators were in the same place an ambiguous figure or a hidden figure would result.)

Such impossible figures, however, pose a problem only for a theory that wants to find a physical object which is a fair equivalent to the picture's referent. No serious difficulty arises in ecological optics when it deals with impossibility. The point of ecological optics is the study of the relation between light and its ecological origins, so a distinction between light and object is a *sine qua non*. Ecological optics acknowledges that pictures are human creations, and might be

devised to have incompatible information arising from the display's surface.

Children often draw a table (say) with 2 legs up the page and 2 down. This is a picture for it uses the elements pictorially, and it specifies its referent physically—it has enough physical features to specify its referent. It is only if we were to take the picture, erroneously, as drawn from an optic or perspective vantage point that it would be misleading or problematic. Notice, then, it is not an impossible picture in its own terms.

One of the curious departures from nature possible in a representation is a *representation of representation*. While Nature provides shadows, imprints, tracks, and other natural signs it does not offer us shadows of shadows, imprints of imprints, or tracks of tracks. Man on the other hand communicates, and can communicate that he can communicate. He can depict a depiction, containing one picture within another. Thus there are pictures of pictures of pictures. . . . Most people recall being struck as children by cans that had on them small pictures of the can, which therefore contained within the pictured can an even smaller picture of the can, which contained a tiny picture of the can, which . . . and so on. Levels of reference like this are often invoked by Steinberg, Escher, and Dali, and they crop up in comics and cartoons, with a hand shown drawing a picture, which may be the same picture, or a smaller picture. If the drawn hand is drawing itself, the picture is an impossible picture. If it is drawing another hand, which is drawing another hand, which is drawing another . . . then the picture is not impossible at any level, for it might be someone's attempt to show Danby's hand drawing Picasso's hand drawing Constable's hand drawing Dürer's hand drawing. . . .

The viewer sorts out both the different objects depicted, and the interconnected levels of representation. The levels of representation do not cause one another or contain one another spatially as a box can surround another box. Nor do they form one another as a square can be made up of small squares or circles (nested forms within forms). Representation of representation begins with the psychological fact that people know that they know, and are aware that they are trying to communicate. The capacity to deal with messages about messages is a fundamental part of the human makeup. Pictures of pictures are a particularly clear example, but the lesson from etcetera

principles, metaphors, the determination of relevance, the El Greco puzzle and simplified sketches is that the viewer is typically aware of human intention and agency in pictorial perception. It is not just when we examine a serious work to determine who painted it that the artist intrudes in picture perception. Psychological factors, rather than just physical traces, have to be influential as our perceptual system sifts a picture for its referent.

X. Pictures Show and Tell

It would be easy to overestimate the power of psychological factors in picture perception, and to underestimate the physical influences that save pictures from being Rohrschach ink blots, and from being creatures of tuition and convention solely. Steinberg for example goes too far in thinking of pictures as merely graphic symbols.[29] Pictures are far removed from asterisks and question marks. Although the present discussion has argued for a crucial role for psychological factors in picture perception, at all points it was added that the influences have phenomenological effects, and depend on certain elements to obtain the effects.

To clarify the kinds of phenomenological effects that pictures benefit from, and the relation of the effects to depicting elements, consider the line. In an outline drawing the line can "show" us spatial layout, and "tell" us about color or illumination or texture changes on a surface. Here the term "show" is being used in the sense of allow us to "see" employed by Wollheim.[30] The relative location of surfaces is indicated by lines in a manner that enables us to *see* depth where there is flatness, occlusion where there is a uniform plane, various slants where there is only one surface, and thus we are "shown" the layout. In contrast, if there are lines to indicate borders of color stripes on a zebra, lines to demarcate the edges of shadows or lines to distinguish between two different textured knits on a sweater, then we can "tell" the significance of the lines but we do not see the colors, shades, or textures.

However, used in a different fashion than in outlines, lines can show us what they only tell us in outline. It was as early as cave art that the outlining properties of lines were discovered—cave art often recognizes that a solid body does not have to be "shown" by a solid mass of pigment—but it is clear now from the work of op artists and

psychologists[31] that brightness and hue can be shown where there is only blank space between lines.

Consider Figure 8-8. Note that it engenders two kinds of effects, namely a darkening or assimilation effect between the lines, and a bright or contrast effect at the ends of the lines. These effects can be picked out reliably by most people, who have never had training in seeing them, just as happens with outline drawings of spatial layout. And just as in outline drawings, the observers, young and old, can tell that the phenomena are not real. (On viewing an outline drawing we notice depth and notice it is not real, and similarly here we notice colors and notice they are not real.) Hence, Figure 8-8 is showing us a kind of pictorial brightness, akin to figure/ground pictorial depth.

The pictorial brightness of Figure 8-8 it should be noted, is manifested despite the absence of any genuine physical brightness. Nor is there any optical pattern from the display that "specifies" one part of the display as representing a brighter region like a sun or lamp or pool of light from a radiant source shining on a surface. Just as the circle can enable us to see foreground/background differences, so the lines of Figure 8-8 enable us to see bright/dark differences, in the absence of optical information to specify these differences.

If the lines are colored (e.g., red) the assimilation effects are colored (pink). If the lines are white on black, the effects are reversed so the assimilation will be a misty grey on a black background and the contrast will produce a blacker-than-black figure.

Presumably, it is the presence of conflict that permits us to see both depth and flatness together, with outline drawings.[32] So too with the subjective brightness and color figures, presumably it is the presence of conflict that enables their appearance in perception to be accorded an unreal status. The conflict may be from foveal regions, or two different levels of processing in the brain, or it might simply be that the rods of the retina say one thing and the cones say another.

In sum pictures show things, and tell us about things—sometimes they do both and sometimes they only tell.

XI. Limits of Correction

Pirenne has pointed out that if we view a picture from the side it may appear undistorted to us, even if it was designed to be an accurate projection of a scene from a point directly in front of the picture and

Figure 8-9. Pointing and leaning. The pointing arm points at the viewer whether one views from left, right, or in front. The leaning arm stays with the picture plane. Hence, the angle between the arm varies from acute to a right angle to obtuse as the picture is viewed from the left, front, and the right. Sketch by T. Westbrook.

Figure 8-8. Subjective contour display. A strong bright contrast effect is engendered at the ends of the lines and a modest assimilation darkening at the sides of the lines.

not to the side.[33] It is tempting to judge this "correction" for an inappropriate vantage point as proof of the freedom of the eye from physical constraints. The judgment would be unwise, however.

In the first place, the correction may be achieved partly by employing the optical patterns from the picture, tempering them with the information for the slant of the picture surface. In other words, the very constraints that were judged to be irrelevant would in fact be the phenomena that make "correction" possible.

In the second place, there is often no need for correction to occur to make correct perception possible. Many of the informative relations in a picture are invariant when one walks in front of it. Across the vantage points in front of a picture, what is beside what in the picture, what is symmetrical and what is in a given direction can all remain invariant. Though two parallel lines may project differently to vantage points in front and to the side of the picture, their relation to the horizontal/vertical or to the frame of the picture remains constant.

Goldstein points out that the "freedom" of an object's depiction from the vantage point of the picture depends very much on the relation of the object to the picture surface.[34] Objects that are parallel to the picture surface tend to follow the picture's orientation to the viewer. Objects that point out at the viewer tend to continue to point at us, irrespective of whether we stand in front or to one side—as the eyes and pointing fingers of recruiting posters do (Figure 8-9).

Is there any physical reason why parallel objects should swing with the picture, and face-forward objects need not? One reason is that objects depicted face-forward cannot show more of their *sides* and therefore are always face-forward. However, objects intermediate between parallel and face-forward *do* show some of their sides, and could swing therefore as much as parallels if the complete absence of sides were the only crucial factor. But objects intermediate between parallel and face-front swing by an amount directly related to their angle to the picture surface—a 45° object swings by an amount intermediate between a parallel object and a face-forward object.

What may be occurring in the conditions described by Goldstein is a very close correspondence between the convergence of the light reaching the eye and the percept. An object drawn as slanted to the picture surface (at angle A) will have its sides depicted by lines that are converging (at angle A). As the picture changes its orientation to

the viewer, the converging angle projects light that could have come from converging angle b on a surface directly in front and not tilted. The viewer's perception may be guided by angle B, Goldstein's evidence suggests (for the geometry of compensation).[35]

The ultimate, overriding factor, however, is that we cannot see any thing sticking out the back of pictures—pictures are physically flat in the last analysis. If there was a road, say, leading up to the opaque rectangular frame of a picture, then if we went slightly to one side we would see part of the road; it would be visible past the side of the picture frame and it would no longer be entirely occluded by the picture as it is from the vantage point in front. In other words, pictorial depth is potentially infinite when we view from in front. When we view from the side, less and less pictorial space is available for objects to fill—less and less is occluded by the picture, less and less can be in a pictorial space directly behind the picture frame. Hence, if the rectangular frame had a picture of the road within it, and we were to view from the side, full "compensation" could only be achieved by seeing the road sticking out the back of the picture sufficiently far that some of the road would not be occluded by the frame. Of course, this does not occur in perception. Just as this constraint would have it, pictures viewed from the side are somewhat "flattened," becoming flatter and flatter as the angle of incidence of one's gaze approaches the plane of the picture. What Goldstein is describing is, finally, the result of objects gradually flattening as they are restricted more and more to the plane of the picture.

XII. Depiction and the Blind

The discussion thus far has given configuration the role of making a display distinctive, specific to a particular referent, and yet allowed the elements that can be configured to depict when they are in simple, nonspecific patterns. It has given the observer an opportunity to involve the artificial status of pictorial displays in the search for possible meanings of a picture, bearing etcetera principles and metaphor in mind when the picture is taken as selective and as communicative.

The discussion's points become more striking when we see them working in a new setting, particularly one where those unpracticed with pictures are concerned. Briefly then, consider some skills of

congenitally or early blind adults dealing at length with pictures for the first time in their lives, on being asked to use a sheet of drawing material that makes raised lines when a ball-point stylus crosses its surface.

Blind people have an intuitive untaught appreciation of the possible referents of lines, in that they use lines in outline drawings much as sighted people do (Figure 8-10). They also make configurations that make sense to the sighted, and spontaneously, describe the point of view that is relevant to their drawings (Figure 8-11). They occasionally take very simple drawings presented to them and choose a referent that is far beyond the power of the drawing to specify e.g., a circle with two small dots inside it would be taken to be a face. Also, stick-figures crop up in their own drawings. Furthermore, metaphor is often apparent in their solutions to pictorial problems e.g., to show a wheel was spinning (Figure 8-12).

The success of the blind in understanding depictions[36] has many sides, now lending credence to one side of our discussion of pictures, now supporting another. On the role of physical commonality, for example, it is instructive that a blind person might say "all the legs of the table are at the corners" and that feature would be replicated exactly. At another time the fact that something was omitted on the drawing would be due to the fact that it would not be apparent from a certain vantage point, which is a matter of perspective. At yet a third time, something metaphorical would be added, e.g., one child noted he had a man's legs long to show he was running fast, made the arms too long too, streaming in the wind, and went on, giggling, to make the ears long to add to the picture of the speedy, running man.

In sum, the blind, who are unfamiliar with pictures of course, can emphasize "getting it physically right" or "adopting a point of view" or "the psychology of depiction," playing one factor down in order to raise another to a useful pitch, much as we the sighted do.

XIII. Diagrams and Pictures

Just as there is a danger of oversimplifying pictures by only accounting for perspective fidelity to a scene, or in stressing how accurately informative pictures may be, and a danger in taking pictures to be Rohrschach ink blots, there is also the danger of blurring the line between pictures and diagrams.

Take an instance from the work of blind adults trying to draw an

Figure 8-10. Outline drawings by congenitally blind people. Three tables. Sketch of dog. Man rolling a wheel. Cabinet.

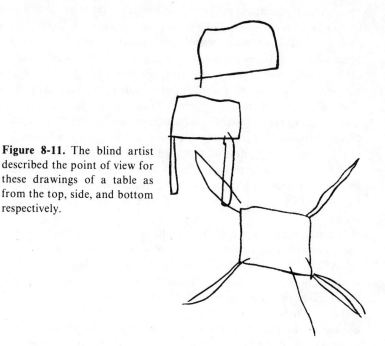

Figure 8-11. The blind artist described the point of view for these drawings of a table as from the top, side, and bottom respectively.

Figure 8-12. Wheels, static and spinning, drawn by a blind adult. The curved spokes suggest movement, without indicating that the spokes are actually curved.

object made of cubes, projecting cubes left, right, up, down and forward and back—a kind of z in all three dimensions. Drawing this object would daunt most people, not only the blind! Solutions the blind offered at times involved drawing some surfaces as triangles, other as squares, making any up-projecting cube be drawn as a square with extra squares inside it, or outside it, drawing the sides of some squares with many outlines ("building-up" the outline, one said), putting special marks on parts representing high cubes while leaving others blank, drawing the object as though it was folded-out much as one might fold-out a cardboard box and trace its flat outline, etc. The systems were many and various, almost one idiosyncratic system per blind adult, which is quite unlike the impressive uniformity of solutions to drawing objects like hands, glasses or tables.

What the blind seem to have done with simple objects is draw *pictures*, which varied in the point of view chosen, or the features selected to be replicated. With the 3-D-Z object, they seem to have dropped into inventing isolated systems, where anything can be used to stand for anything, in other words a *diagram*.

The difference between pictures and diagrams is enormous, and critical to the present discussion. In a picture, the element is phenomenologically effective, and only some elements can stand for some referents, and each element has its set of possibilities. The configuration enables the set to become more restricted, and the configuration is constrained by physical or optical (perspective) conditions, and is to be understood within the psychological conditions that arise from the implications of pictures being artificial. Diagrams dispense with the set of depicting possibilities of an element, and have no regard for perspective and its point of view. Since there is no basic set of elements with their allied referents in a diagram, the question of metaphors (or etcetera principles) does not arise for diagrams in the manner in which it arises for a picture. Diagrams can be functional, and deal with relations like importance or value or force that can be quite distinct from the layout or perspectives of a set of surfaces. Their subject matter, then, is distinct from pictures (though overlapping at times) and their ways of arranging the elements being used are different from pictures.

XIV Coda

The study of pictures touches our basic beliefs about this world and its objects, about representation as it relies on elements and their structures, and about people perceiving, communicating, and knowing. If we take the world to manifest itself for our perception in informative light, then we can distinguish the real and the representational, the literal and the metaphorical, the actual and the implied. We can distinguish the presence of information and its absence, and ask coherent questions about how perception works when a representation is or is not informative—and claim the right to describe a display is being perceived as a picture when it is not in fact yielding light that specifies a referent. We can distinguish cases where a display lets us see something from cases where it only tells us something. And we can separate the special kind of display called a picture from the other kinds of useful representational displays.

If this assessment of pictures had been written ten years ago it would not have treated elements as having depicting powers, nor would it have emphasized the communication side of pictures, and certainly it would not have had evidence from the blind to discuss. The past decade has seen a serious interest in the optics and perception of depictions that has called for clearer distinctions between physics and psychology, distinctions that have made conceptions like an optic array "specifying" its origin necessary, distinctions and conceptions that have made research on special kinds of people and special kinds of pictures of scholarly importance.

What pictures do in the last analysis is show something. Pictures can show things because of the depicting capacities of elements. The elements can be lines, ends of lines or contours, for example. The elements are arranged in a display, with a particular configuration. The configuration can specify a referent through being optically definite and detailed, or the style of the configuration may play a role in defining the referent or the display may be simple enough for the viewer to be able to select suitable referents from the depicting powers of the elements to satisfy a caption or suggested referent. The configuration in a picture is not like that of a diagram, in that only the depicting powers of the elements can be employed, and the

arrangement must fit the perspective of a layout from a vantage point, or the physical layout of the referent.

Since the elements are artificially arranged on a picture's surface, and the eye can tell their artificial status, pictures can well serve communication, and what is intended and unintended, literal and metaphoric becomes important in picture perception.

Notes

1. Rudolf Arnheim, *Art and Visual Perception* (Berkeley, 1954).
2. J. J. Gibson, *The Senses Considered as Perceptual Systems* (Boston, 1966).
3. J. E. Hochberg, "The Representation of Things and People," in M. Mandelbaum, ed. *Art, Perception and Reality* (Baltimore, 1972).
4. Nelson Goodman, *Languages of Art* (Indianapolis, 1968).
5. M. Black, "How do Pictures Represent?" in M. Mandelbaum, ed. *Art, Perception and Reality* (Baltimore, 1972).
6. E. H. Gombrich, *Art and Illusion* (2nd ed., Princeton, 1961); "The Mask and the Face: The Perception of Physiognomic Likeness in Life and Art," in M. Mandelbaum, ed. *Art, Perception and Reality* (Baltimore, 1972).
7. J. M. Kennedy, "Pictures, Perception, etcetera," in R. B. MacLeod and H. Pick, *Perception: Essays in honor of J. J. Gibson* (Ithaca, 1974).
8. Rudolf Arnheim, *Art and Entropy* (Berkeley, 1971).
9. *Art and Illusion.*
10. J. S. Bruner, "The Course of Cognitive Development. *American Psychologist,* 19 (1964), 1–16.
11. J. M. Kennedy, "Pictorial Metaphor: A Theory of Movement Indicators in Static Pictures." Paper presented at the Information through Pictures Symposium, Swarthmore College, 1976.
12. *Art and Visual Perception.*
13. "Ancient & Modern Picture Perception Abilities in Africa," *Journal of Aesthetics & Art Criticism,* XXXV (1977), 293–300.
14. S. Friedman, and M. Stevenson, "Perception of Movement in Pictures," in M. A. Hagen, ed., *What Then is a Picture? The Psychology of Representational Art* (forthcoming).
15. J. M. Kennedy, "Pictures and the Blind." Paper presented at the American Psychological Association Conference, Toronto, August, 1978.
16. *Art and Visual Perception.*
17. J. J. Gibson, "The Information Available in Pictures," *Leonardo,* 4 (1971), 227–35.
18. J. J. Gibson, ibid, and "The Ecological Approach to the Visual Perception of Pictures," *Leonardo,* 11 (1978), 227–35.
19. J. M. Kennedy, *A Psychology of Picture Perception* (San Francisco, 1974).

20. G. A. Miller, *Language and Communication* (New York, 1951).
21. *A Psychology of Picture Perception.*
22. E. Rubin. *Synsoplevede Figurer* (Copenhagen, 1915).
23. Ibid.
24. *The Senses Considered as Perceptual Systems.*
25. N. Goodman, ibid, p. 136.
26. J. Psotka. "Perceptual Processes that may Create Stick Figures and Balance," *Journal of Experimental Psychology: Human Perception and Performance*, 4 (1978), 101–11.
27. The "evidence" for the stick-figure of a rectangle was obtained by asking people to put dots in a rectangle. Summed over lots of people, the dots roughly lay along a central axis plus two Vs at the end of the central line. This evidence may be (1) beside the point since the people were never asked what the stick-figure of a rectangle was (2) misleading because the people may have been guided in placing dots by the aim of putting the dots on the main axes. If many of the people were putting their dot on the central axis, and many were putting their dots on the diagonals, the upshot of summing all the dots would be, roughly, the line with Vs that was obtained. Thus, the explanation that the upshot was "the stick-figure" is uncalled for; alternative views have not been ruled out.
28. Thanks due to J. Campbell for his helpful discussion of these points.
29. S. Steinberg, "The Eye is a Part of the Mind," *Partisan Review*, 20 (1953), 194–212.
30. R. Wollheim, *Art and Its Objects* (London, 1968).
31. G. Kanizsa, "Contours Without Gradients or Cognitive Contours?" *Italian Journal of Psychology*, 1 (1974), 93–113.
32. The conflict between depth and flatness is not as some might think uniquely pictorial. In transparency perception a flat surface can be seen, with depth behind it to another surface. Also, two brightness can be seen in one direction, e.g., in highlight perception, perception of reflectance and illumination, or transparency perception.
33. M. H. Pirenne, *Optics, Painting and Photography* (Cambridge, England, 1970).
34. E. B. Goldstein, "Rotation of Objects in Pictures Viewed at an Angle: Evidence for Different Properties of Two Types of Pictorial Space," *Journal of Experimental Psychology: Human Perception and Performance*, (1979), 78–87.
35. R. R. Rosinski, T. Mulholland, D. Degelman, and J. Farber, "Picture Perception: Analysis of Visual Compensation," University of Pittsburgh Display Lab Technical Report 3, 1979.
36. J. M. Kennedy, "Ancient & Modern Picture Perception Abilities in Africa"; "The Blind Can Recognize and Make Pictures," in M. Hagen, ed. *What Then is a Picture? The Psychology of Representational Art* (forthcoming).

9 Dynamics and Invariants

Any study of the relation between art and perception must depend on two disciplines, neither of which is ready to offer sufficient help. In one of these disciplines, the theory of art (aesthetics), nothing can be considered settled with any finality. Trained thinkers have worked out several neatly defined positions, which face one another unreconciled. These controversies are enveloped by a dust cloud of approximative concepts, often inspired by excellent intuition, which serve artists, critics, and educators in their daily business. It is a situation that offers the student of the psychology of art many good leads and tempting suggestions but not much of a solid base.

In the other discipline on which we rely, the psychology of perception, a large body of facts on sensory phenomena has been gathered over a century, and expert knowledge is progressing fairly systematically. But when these laboratory findings are applied to the arts, at least two obstacles prevent them from being directly useful. Scientific stringency demands that the object of inquiry be kept simple since only under surveyable conditions can one be sure of the variables at work. This limitation works well in sciences in which the fundamental laws are of greater interest than the complexities of the individual case, for example in physics or chemistry. It works less well when the objects or processes to be studied concern us in their particularity as in meteorology, medicine, or the exploration of the human personality in its various manifestations. Works of art—at least those that matter most—are as intricate as the nervous systems by which and for which they are made. They are nightmares to the scientist. Faced

166

with their bewildering complexity, the scientist tends to limit his investigations to elementary aspects extricated from their context. He studies the shape relations of figure and ground, or the applications of color contrast, or he tries to establish the overall complexity level of compositions. To be sure, these partial phenomena must be understood if we are to discuss their role in the artistic structure. But unless one pursues the functions of these aspects far beyond the observations accessible to our present experimental methods one cannot hope to touch the essentials of art. Consequently the results offered by today's scientific aesthetics are sometimes reliable but rarely relevant.

Furthermore, laboratory science limits itself for good reasons to facts that can be quantified, that is, measured and counted. But even at an elementary level of perception there exist phenomena that cannot be verified quantitatively, at least not with present methods, but whose neglect sadly cripples our understanding. Some of these aspects are indispensable for the study of art. They call for a conception of science not limited to what can be proven by numbers. In the meantime, many students of the history and theory of art operate to their own satisfaction with antiquated notions of perception that have seeped into popular consciousness during the past century. Or they subject the latest discoveries of their scientific colleagues to premature generalizations.

Given this challenging state of affairs, I propose to devote the present paper to a sketchy discussion of two problems that at the time of this writing are in urgent need of more elucidation.

I. The Shift Toward Dynamics

The first of these problems calls on us to revise the generally accepted account of what one sees when one looks at a scene of nature or a work of art. Common observation has it that in both instances one perceives a world of self-contained things that are said to display a persistently static quality, no matter whether they are mobile or immobile, hard or flexible, animate or dead. A wooden table, a tree, a pigmented area on a canvas, but also a speeding car or a drifting cloud share this perceptual property. Or so it seems as long as our attention is controlled by an approach to the world that asks for

neatly definable objects, limited in their appearance to what identifies them stably, objects that allow for addition and subtraction and for cause and effect but that otherwise leave one another safely alone.

This world view reflects itself not only in the practical philosophy of our time but also in the direct evidence of our perception. It is unlikely, however, to be shared by all other cultures. In fact, since perception is an instrument of biological functioning it views things more naturally as vehicles of action, configurations of forces. In such a world view, each object or situation is seen as the locus of kinetic or potential energy, performing actively or passively, as an obstacle or a facility, a friend or foe. Even perception itself is more than "information" arriving at the receptor organs of a detached observer. It is rather an integral part of a total engagement by which the organism lives in its world, acting upon it and being modified by it.

This dynamic conception of human experience requires that each thing be not only understood but directly perceived as a constellation of forces.[1] In elementary visual experience triangles send out streams of energy from their corners, trees or pagoda roofs spread into space, and an arch yields passage while a wall blocks the way. Although this is probably the natural and spontaneous way of looking at the world, it happens to be concealed by the dominant mode of our particular civilization. Nevertheless it operates potentially in everyone of us. It manifests itself in the responses of children, in descriptions by poets, and in the way shapes, colors, movements, or sounds must be perceived in the arts in order to convey expression and meaning.

Although this mode of looking at the world is potentially accessible to every human being, our language, having been shaped by a different world view, is poorly equipped for the direct description of the dynamic qualities of percepts. We resort to terms that were originally coined for physical behavior. Although they are quite appropriate, they make the perceptual phenomena appear to be nothing but analogies imported from other universes of discourse; I have in mind such terms as stretching, bending, pressing, radiating. Or we borrow the names of mental behavior types whose dynamics resembles that of direct perception, for example, yearning, retreating, attacking. This roundabout and indirect way of talking is in keeping with the popular notion that the forces inherent in percepts are merely imposed upon perception from other realms of ex-

perience. Theories such as that of the "pathetic fallacy" or "empathy" reflect this interpretation.

Our Western tradition to the contrary, the dynamic qualities of percepts belong as genuinely to sensory experience as do shape, color, or movement. In fact, they are probably the primary element of all human experience. Therefore visual perception can be defined as "the experiencing of visual forces."[2]

What then is the ontological status of perceptual dynamics? To set the stage, we need to realize that perception is not just one among many other mental powers, as textbooks of psychology make it appear, but rather the roof category embracing them all.[3] All psychological functioning, that is, everything of which we are consciously or unconsciously aware, comes under the heading of perception since awareness and perception are the same thing. This broad definition of perception allows us to realize that the quality of perceptual dynamics is shared by all mental happenings, be they the pangs of hunger or pain, the straining we observe in a tree shaken by a tempest or a in a dog pulling at his leash, but also in the yearning for past happiness, the striving toward the solution of a mathematical problem, or the radiance in the remembered face of a child. Only if we acknowledge that dynamics is universal in human experience can we understand the metaphorical devices of symbolism, fundamental for the language of art. How could the validity of indirect speech ("Whether 'tis nobler in the mind to suffer the slings and arrows of outrageous fortune, or to take arms against a sea of troubles") persuade us with such immediacy if we did not feel "in our bones" the dynamic qualities of tolerating attack both physically and mentally as against striking out in defense?

Thus, perceptual dynamics is an ingredient of experience. Does it also have an equivalent in the physical world? To the extent to which works of art are made of inorganic materials, it hardly ever does. The tension we sense in the body of a painted figure has no physical equivalent in the canvas and the pigments; nor does the upward thrust of a Gothic arch reside in the stones. But in the performing arts the dynamics inherent in the kinesthetic sensations that are experienced by dancers and actors and in the visual images received by the spectators are indeed reflections of the muscular forces animating the bodies of the performers. In addition, we expect on theoretical

grounds that the dynamics experienced in perception has its equivalent in physiological processes occurring in the perceivers' nervous systems. According to gestalt psychology, percepts come about through corresponding organizational field processes in the projection areas of the brain. Assuming that these organizational pushes and pulls remain perceivable in sensory experience, we can point to them as the physiological counterpart of perceptual dynamics.[4]

If we are correct in describing dynamics as a primary aspect of perception, the failure of experimental psychology to acknowledge its existence might seem astonishing. But, as I mentioned in the beginning, laboratory research limits itself for good reasons to quantifiable data. It therefore refers to instances of dynamics only when they produce measurable effects. The so-called optical illusions are a prime example. Under certain conditions, perceived shapes appear lengthened or shortened, bent, displaced, or distorted. The textbooks take note of these phenomena; but since they ignore the general principle of perceptual dynamics, of which the deformations give tangible evidence, the "illusions" are presented as isolated curious irregularities, provocative to the layman, but unexplained because devoid of a place in the framework of psychological principles.[5]

For the most part, the dynamic components of perception are not measurable with procedures at our disposal today. They are experienced intuitively by mere inspection, and their presence can be verified only by the interrogation of judges. This is not a foolproof method, but, as Charcot reminded Freud when they discussed phenomena beyond the reach of the science of the day, *cela ne l'empêche pas d'exister.*[6]

The shift to a dynamic approach has far-reaching consequences for the theory of art. I mention here first the phenomena of proportion and compositional equilibrium. The traditional account of what is seen in perception can refer only to objects of various shape and size occupying visual space at various places. It has no way of explaining why certain ratios look better than others, why certain objects look out of place, or why certain shapes are too big, too small, too close to each other, or too far apart. Any shape or size or spatial relation should do as well as the next. (The assertion that such "preferences" are due to historical conditions ignores the primary issue.)

The experience of proportions, as distinguished from purely arithmetical ratios, derives from relations between forces. Only by considering the resultant of the diagram of forces that derives, say, from the relation between the two dimensions of a rectangle can we hope to understand why excessive length will "run away" with the structure or why too much breadth may interfere with the shape's principal direction.[7] Similarly the distance or location of elements within a composition can be established as correct or incorrect only by sensitive attention to the field forces that are felt to push in the direction of a different arrangement. Composition must rely on equilibrium; and equilibrium, as any pair of scales will show by analogy, can exist only between forces. Compositional rules are not an alternative to such perceptual evaluation but merely its codification.

Let me illustrate the issue further by sketching certain developments in the theory of figure and ground. The distinction between figure and ground, that is, between a foreground object and its surroundings is a primary accomplishment of perception. It discriminates between things and non-things and thereby creates the base for cognitive orientation. Correspondingly, much art relies on the same device to distinguish foreground from background. However, in the descriptions offered by the psychological literature the relation between figure and ground is simply static: of the two components one lies in front, the other in the back. The "figure" possesses a rigid shape, the "ground" is unstructured. The two do not influence each other. Such a description omits essentials of what we see when we look at a painting, sculpture, or work of architecture—not because in the arts we look "differently" but because art is the prototype of what perception is like when it functions fully.

Any array of visible things is a "field," in the sense of an all-pervasive interaction of forces. Components that do not influence the rest of the structure or are not influenced by it can exist only in crippled vision. As a first approximation we observe that the structure of any perceptual object irradiates its environment within a range that depends on the strength of the object's structure. A building will organize the space around itself in accordance with its own size, shape, orientation, etc. "Empty" space begins only where the field effect of the building ceases. But this outward-directed effect of the "figure" is only one side of the phenomenon. We remember that art

teachers urge their students to watch the "negative spaces." In compliance with this request, the student temporarily reverses the dominance of the figure. He pulls the ground forward, endows it with the contours, and thereby makes it into figure, which enables him to judge its shape and proportions.

The artist must inspect the negative spaces not only because in a work of art nothing can remain shapeless, no space can remain "empty," that is, unstructured. The interstices must be controlled also for the much more important reason that they hold the positive shapes in place. Dynamically considered, a perceptual object is the resultant of the interplay between antagonistic forces. Take the simple example of a red disk placed in the center of a blue square. The disk, acting as "figure," comes alive perceptually and aesthetically only when its stable boundary is seen as the balance of antagonistic forces. The visual forces inside the disk are expansive. They press outward. This tendency is counteracted by the forces inherent in the surrounding square, which seeks to "contain" the intruder, i.e., to restrict its presence to a minimum of space. Think by analogy of a curtain blown at from both sides: the visible shape of the curtain at any moment will be the resultant of the interplay between the opposite physical forces. The rigid firmness of a shape reveals itself to the sensitive eye as the equilibrium between force and counterforce. A physicist, Cyril J. Smith, has expressed it as follows: "Without both tension and compression and the balance between them nothing could exist, for it would either expand to infinity or shrink to nothing."[8]

By acknowledging the dynamic character of all experienced form we obtain a decisive refinement of perceptual sensibility. Someone looking in the usual static fashion at Bernini's colonnades on St. Peter's Square notices the semicircular shape of the two halves. He can measure the distance between them and calculate, without much profit, the ratio between that distance and the height of the columns. He can also establish the symmetry of the total design. It is an exercise in taking a geometrical inventory, which accounts neither for the enjoyable "correctness" of the dimensions nor for the symbolical meaning of the architecture.

A dynamic view of the same sight reveals the constrictive tendency of the two semicircles, which look as though they have been pulled

apart and strive to reunite in one complete circle. Without viewing the portico dynamically, how could one appreciate Bernini's own assertion that it "accurately expresses [the mother church's] act of maternally receiving in her open arms Catholics to be confirmed in faith . . . ?"⁹ Enlarge or diminish the distance between the two "arms," and their relation will lose the right degree of tension.

Observe now further that the two lateral concavities of the colonnades determine a center, which is marked by an obelisk, and that this center acts as a focal generator of counterforces. From the center, expansive forces radiate in all directions, trying to make the square as large as possible. This expansion is counteracted by the pincer movement of the colonnades. The dimensions of the square, established by Bernini's design, result from the delicate balance between the expansive and the constrictive forces at play. No measurement will prove that this is so, but one could use a model of the Square to vary the proportions and thereby to demonstrate to the eye that Bernini did right.

The decisive step of our investigation is not yet taken. So far we have pointed out that the perceptual correctness of shapes, proportions, and other relations can be understood only as resulting from the interplay of field forces. Without them, there is no perceptual and aesthetic sense to such fundamental notions as equilibrium, harmony, order, beauty; without them just any arrangement would be as good as the next.

But why insist on equilibrium or beauty? Are these values anything better than traditional preferences, responses to timebound cultural needs? I am touching here upon a problem to be taken up in the second section of this paper. Suffice it to insist at this point that dynamic conditions, such as equilibrium or order, are indispensable prerequisites for the legibility of a perceptual statement. "Beauty," for example, is understood in our context as the formal condition that makes an artistic statement legible. Without it there is no way of understanding what a given work of art is trying to say.

It remains to be shown that the message itself—"what the work is trying to say"—also relies on the dynamic character of perceived form. The following example will serve. In one of his paintings on the ceiling of the Sistine Chapel, Michelangelo shows God separating the earth from the waters (Figure 9-1). The viewer can identify the story

Figure 9-1.

told by the picture; he can remember its origin in the Book of Genesis and receive a very strong experience from its literary, mythological, religious impact. But if he takes from the picture nothing but the narration, that strong experience is not generated by the art of the painter. It is only released by it. The picture serves as a mere reminder of powerful substance existing elsewhere.

To create an aesthetic experience of their own, the shapes invented by Michelangelo must display their dynamic qualities in a manner that transmits the meaning of the work perceptually. We see the figure of the Creator surrounded by an oval that is formed, quite unnaturalistically, of his flying cloak. The voluminous man, together with three putti, fills the section of that oval container with so much force as to make it burst. The connotation of the egg shape helps us see that we are witnessing the dynamics of a birth. Superhuman power breaks through the boundaries of the oval into the uncreated

space. In particular, the hands of the Creator reach out to perform the shaping, while his head, retained within the shell and with eyes closed, conceives in thought the form to be materialized in the outer world.

The mood of Genesis is transmitted through a configuration of visual forces that can be directly apprehended by any sensitive observer. As in all great works of art, the fundamental meaning is symbolized in the behavior of the shapes most evident to the first glance.

II. Are There Objective Percepts?

I have presented evidence for some perceptual phenomena with the implication that they exist in just that way for any normally functioning nervous system. As confidently as one would expect observers to distinguish a red traffic light from a green one I described what they see when they look at Michelangelo's painting. The percept of the picture seems to be treated here as a fact that can be considered "objective" because the variability of the observers' responses can be neglected.

Such a procedure is automatically rejected by social determinists, who insist that depending on their upbringing in a particular cultural setting people see different things, attribute different meanings to them, and evaluate them differently. Apart from such cultural influences one can also insist on inherent personality types, so different in their make-up that individuals can only politely respect one another's responses but never appreciate or share them. This was the view, for example, of Carl Gustav Jung, who wrote in the conclusion to his book *Psychological Types:* "In my practice I am overwhelmed again and again by the fact that human beings are nearly incapable of understanding a point of view other than their own and to concede its validity."[10] Jung believed that the mind is "collective" only at the very depth of the unconscious. Carried to this extreme, the doctrine maintains that no person can expect to share the reactions of the next since no two people are alike. In the arts, such an approach can lead to the contention that, for example, "black art" cannot be understood by anybody outside the black community; and certain nihilistic

thinkers, anxious to contribute with their own weapons to the destruction of society, have insisted that communication of any kind is impossible from person to person.

In the arts, views of this type seem to be supported by impressive evidence. Not only do people vary in their preferences, they also attribute different meanings to a given work. Most important for our present purpose, they actually see different objects when they look at the same things. We find it hard to believe nowadays that when the young Kandinsky visited in the 1880s an exhibition of French Impressionists in Moscow he did not recognize the subject represented in a painting of Monet: "The catalogue told me that this was a haystack. But I could not recognize it, which I thought embarrassing. I also felt that the painter had no right to paint so unrecognizably."[11] And as late as 1904 the art critic of the *Petit Parisien* compared Cézanne's method of spreading pigment "with a comb or toothbrush" to the pictures produced by schoolboys who squash the heads of flies in a folded piece of paper.[12] Little research has been done so far on the challenging question of how it is possible that under certain conditions observers may see incoherent blotches where we recognize precise subject matter without effort. The problem becomes approachable only when one realizes that perception is not the mechanical recording of optical projections but an active grasping and creating of structure. Perception organizes stimulus material by integrating a twofold input. On the one hand, it structures the optical projections, received by the retinae of the eyes, in keeping with the configurations inherent in those projections. On the other hand, it applies the form patterns to which the recipient person is geared by his cultural training and individual disposition. The interaction between the structural organization responding to what is introduced from the outside and the structural organization reflecting the particular conditions of the inside results in the visual experience. A changed disposition will make for a different response to the same stimulus. For example, in Impressionist paintings the slight differences in color shades enable an attuned viewer to distinguish a building from the sky even in the absence of the sharp contours that used to be needed for the purpose.

Are we then to conclude that a given painting does not exist "as

such," and that instead there are only those infinitely many and different paintings seen by the painter himself and by each of the many viewers who happen to look at it? In the natural sciences, the "objective" status of careful observations is generally accepted without question. Granted that even in the exact sciences the selection of research problems and the approach to solving them are influenced by the philosophy and the practical needs of a particular period. But nobody questions the objective validity of Newton's laws of planetary motion on the grounds that they were nothing but outgrowths of seventeenth-century England. In experimental psychology, studies such as those in psychophysics are similarly immune. The investigation of sensory thresholds, for example, can readily exclude the influence of individual differences, expectation, or attention. The same is true for perceptual studies of color contrast, figure and ground, or the grouping of elementary shapes. But when it comes to looking at works of art, responses do indeed vary in many ways—for several reasons. The visual patterns of most pictorial compositions are so complex as to fit a number of perceptual structures in rough approximation. Equally complex are, within the viewer, the so-called higher mental processes of memory, attention, level of organization, and motivating needs, which therefore can influence the percept of a complex pattern in many different ways. And furthermore, the perception of a work of art always involves its meaning and therefore is affected by a host of connotations.

Even so, an observer's mind cannot manipulate visual patterns in just any way it pleases. This is most evident at the elementary level. The optical projection of a simple figure recorded by the eye will yield to some structural interpretations but offers resistance to others. A clearly exposed cross shape can be perceived as two diagonal wedges touching noses (Figure 9-2), but the resistance to such a reading is considerable; and no effort will let us see that cross as a circle. When it comes to a highly complex composition, a first approach may be able to choose among several possible readings. Art historians, for example, often vary in what they see. But a thorough consideration can lead finally to the one organization that fits all aspects of form and meaning. It pays to train one's sensitivity to the demands of what psychologists call the stimulus pattern because without it no work of

Figure 9-2.

art can be understood. Also there is no better way of demonstrating for aesthetic theory that the objectively given qualities of a work exert control over the ways it can be legitimately seen.

If, then, on one hand, a work of art prescribes the correct way of its being perceived and if, on the other hand, viewers are geared by their own cultural constraints to a particular mode of perception, how are we to explain the fact that in practice we respond to art of different kinds and feel enriched by the experience? Ironically the same century that exposes us in theory to the strictures of relativistic dogmatism has also seen an unprecedented broadening of the public taste by which the same ten thousands of visitors wait in line today to admire the treasures of the pharaohs and tomorrow to enjoy the late paintings and watercolors of Cézanne. Do these masses of art devotees seek so eagerly the company of objects they are unable to perceive correctly? Or are they endowed with an unheardof flexibility that lets them switch acrobatically from mode to mode?

In recent years the German art historian J.A. Schmoll gen. Eisenwerth has argued against the common conviction that cultural periods are, and ought to be, ruled by a unitary style of art. He maintains that especially since the time of the middle-class revolutions and evolutions a pluralism of styles is not only characteristic but also desirable for the state of affairs in the arts. Eisenwerth suggests that it is "better to act creatively in the freedom of an open space" than to complain about the loss of universally valid standards.[13] The point is well taken, but if the culture is not to crumble into as many groups as there are styles, the consumers' ability to respond to a variety of

artistic expressions is a prerequisite. We must inquire into the psychological conditions for such flexibility.

Remember here that works of art come in layers. Even in the purely perceptual sense a visual object is organized in a hierarchy that leads from the broadest overall shapes to the smallest details. Although a viewer may begin his exploration perversely by concentrating on an attractive detail, he cannot hope to do justice to what he is shown unless he succeeds in seeing the top layer of the compositional organization as the overall theme that refines and specifies itself from level to level.

This road of purely sensory apprehension leading from the overall structure to the details reflects at the same time the logical sequence of the process of understanding more in general. The first level for the understanding of the Michelangelo painting I discussed earlier is the highly abstract image of a container's contents bursting through its boundaries. Being of great generality, this theme can embody itself in many kinds of events biological, political, psychological, philosophical. At a next level the image specifies itself into that of a powerful old man reaching across the boundary of his coat; and a further specification limits the event to the Bible story.

Obviously, the most generic conception of the image fits the experience of every human being, whatever his cultural or historical setting (although the particular pictorial form given to the theme by Michelangelo might not). Each further specification of the meaning narrows the range of viewers capable of receiving the message of the work. Iconographic understanding presupposes familiarity with the Old Testament. And beyond intellectual erudition, only a viewer who devoutly believes in the miracle of the Creation can receive the full impact of Michelangelo's religious vision.

Notice here that each level of the work is complete, in the sense in which a theme is complete without the refinements of its variations. Thus a person confronted with the product of an alien culture will follow it to the level of specificity accessible to him as a fellow human being who shares with the maker of the work important basic experiences. On his part, the viewer will supply this general but complete statement with connotations of his own, foreign to the work's maker but compatible with what the viewer is able to apprehend. Think of a piece of African sculpture deprived of its cultic specifica-

tion but exposed to the eyes of a Western artist whose Cubist mentality makes contact with the work at the level of its shapes—shapes that interpret human experience in a manner congenial to him.

Within the range of compatibility a viewer's understanding can reach far beyond the particular forms to which he is predisposed by his own cultural setting. If a modern viewer's appreciation of an Irish book miniature were limited to his recognizing a robed man sitting at his writing desk, the yield would be poor. Instead of arresting his understanding at the level of the narrowest common denominator, the viewer is able to profit from the novelty of conception he discovers in the object that reaches him from elsewhere. As we wander through an art museum with its overwhelming variety of human likenesses, from Cycladic figurines to Giacometti bronzes, we are deeply enriched by witnessing the "plenitude" of human manifestations, of which our own are such limited specimens.[14]

This remarkable ability to adapt to a wide range of pictorial styles raises psychological problems upon which I can touch here only in their perceptual aspects. We must ask: Of what nature are the differences that distinguish works of art from one another? The decisive answer seems to be that the differences that matter aesthetically are not differences in kind but in degree. Since all works of art are made by and for human beings for essentially similar purposes, their characteristics are not mutually exclusive but mostly vary by their positions on a number of dimensional scales that apply to all of them.

A systematic investigation of the dimensional scales by which works of art vary would be a laborious but worthwhile contribution to the theory of style. I mention some of these dimensions at random: simplicity vs. complexity, homogeneity vs. inhomogeneity, dominance of the whole vs. dominance of the parts, closedness vs. openness, endlessness vs. finiteness, consonance vs. dissonance, hierarchy vs. coordination, low vs. high tension. The categories which Heinrich Wölfflin used to distinguish Renaissance art from Baroque art belong here.

We conclude that the differences to which the consumers of art can adapt are essentially quantitative. They are differences of degree, not of principle. Just as in other realms of organic functioning adaptation refers to degrees of heat, speed, oxygen content, intensity, etc., it refers in the arts to perceptual dimensions. The proportions of an

Etruscan bronze figurine, twenty times as tall as it is wide, or of a pudgy paleolithic "Venus" may startle the viewer momentarily. But the shift of attitude needed to adopt the standards of the foreign conception demands little effort. It is essentially an act of transposition. (When differences in principle do occur, communication is indeed threatened; consider the change from representational to "abstract" art, from music to noise, from visual to "conceptual" imagery in recent art, etc. But I venture to say that such qualitative differences are of secondary importance aesthetically. They act like works written in a foreign language. Once the new language is learned, the properties applying to the works lie once more along the familiar universal dimensions.)

So far I have described some of the psychological conditions that enable observers to respond to a broad variety of artistic styles. But I have not yet dealt with the question that was raised at the beginning of this section. If we maintain that there is an objectively correct view of a work of art, how can this view be ascertained, given that every person who looks at the work will be biased by his or her own individual and cultural idiosyncrasies? That there is need for establishing the objective properties of the "target" cannot be doubted. An example from psychology will make the point. The Rorschach inkblots are used to discover the personality characteristics of observers as expressed in their perceptual responses. Unless the structure inherent in the test percept is known, there is no way of telling whether a trait reported by the observer belongs to the pattern itself or is imposed upon it by him.[15] Even if a large number of subjects report seeing a particular feature, one cannot exclude the possibility that they all share the same bias.

Similarly, in the history of art one cannot evaluate descriptions of what, ·say, Vasari saw when he looked at sculptures of his time without knowing what that sculpture was like an sich. This prerequisite exempts not even the maker himself. Balzac's painter Frenhofer saw a beautiful woman where his colleagues saw nothing but meaningless scribbles.[16] Or, to use a less extreme and quite common example: artists are rarely aware of the particular style of their own work—the quality that strikes the outside observer first. It is surely important to know how Delacroix's or Van Gogh's descriptions of their pictures compare with what the works actually "are."

The problem of how to establish the objective properties of a work would be simplified if it were permissible to identify the work with the material object by which it is generated. To some extent the analysis of the physical situation is indeed helpful. If one wishes to determine the architectural effect of the narrowness or breadth of a street, one can measure the physical dimensions of the opening. But the physical measurements of the street or of its optical projections upon the retinae of the eyes are by no means identical with what we are after, namely, the norm percept of the street. How are we going to disentangle this image from the experiences of individual observers, given that what looks oppressively narrow to the prince may look amply broad to the pauper? Whose percept shall we trust?

Experimentalists try to overcome this predicament by means of extrapolation. If they want to know how much light is needed to produce a just noticeable difference, they ask a sufficient number of "subjects" and average the results. That average gives them the percept as such, its objective characteristics. Such a procedure will not quite do in the arts. Suppose we are puzzled by Van Gogh's statement that he wanted the painting of his bedroom to be suggestive of rest and sleep. "Looking at the picture ought to rest the brain, or rather the imagination."[17] To find out whether the painting "really" conveys such a mood, it is useful but not sufficient to ask a random number of observers what they see. More nearly appropriate is the technique of the public opinion pollers who try to establish the relevant characteristics of the persons they interview. For an investigation of the Van Gogh painting it is essential to know whether a given statement on the painting comes from an American art historian, a French psychiatrist of 1890, a modern interior decorator, a Japanese housewife, or the painter himself. One can try to take into account the relevant determinants of the observers and weigh them in their contributions to what these persons see. By comparing and integrating the weighted results one can arrive at the desired approximation of what the picture is in and by itself.[18] Then, on the basis of what is known about a given observer, who might be the artist himself, one can begin to understand what he saw when he looked at the work.

In art history one takes the personal and cultural determinants of viewers into account in order to explain why they experienced certain

works in certain ways. One intends thereby to establish the "authentic" interpretation of the works, that is, to derive the proper way of viewing them from the way they were perceived by their makers and by contemporaries who were in tune with the artists. This authenticity, of course, is not identical with what I mean by the "objective" character of a work since any historical perspective, no matter how valid, is only one of the infinitely many possible views. By its very nature, the work as such, the objective percept, can never be matched completely by any actual perception. Any particular view occurs in the context of the viewer's particular outlook. This does not prevent the objective percept from being entirely real. The following example from elementary perception, although referring to a somewhat different situation, might clarify the point: It is not possible for any pair of eyes to see a cube in its completeness; one sees only one or two or at most three of its six surfaces, and those more or less foreshortened. Yet the cube in its objective shape is a participant in everyone of these percepts. It is truly present in consciousness although modulated by the particular context.

Another procedure for arriving at a valid interpretation consists in testing a given view of a work by asking whether it fits all of the work's accessible properties. When two observers disagree on a composition's perceptual structure and meaning, the disagreement is not the final state of affairs, to be accepted with a shrug of the shoulders. Rather it is a challenge to be taken up by a thorough discussion of the perceivable pros and cons offered by the object—a discussion, of course, that makes sense only if one goes by the assumption that an objectively correct view does in fact exist. Within the limits of his own perspective, each viewer examines all available data in order to arrive at an interpretation that fits them all. Educationally, the rewarding experience of "opening the eyes" to facts previously overlooked or misinterpreted presupposes that there is, out there, something to see.

Only when the objective properties of an art object are reasonably well established, are we justified in attempting an analysis, that is, to inquire about the factors that enable the work to convey its message. How are the configurations of shapes and colors obtained, and how do these configurations convey their meaning? To undertake such an

investigation with confidence, one must be convinced that one is dealing with an objectively existing creation of the human mind rather than pursuing a will-o-the-wisp.

Notes

1. Cf. R. Arnheim, *The Dynamics of Architectural Form* (Berkeley and Los Angeles, 1977), and *Art and Visual Perception* (Berkeley and Los Angeles, 1974), chapter 9.
2. Arnheim, *Art and Visual Perception,* p. 412.
3. R. Arnheim, *Toward a Psychology of Art* (Berkeley and Los Angeles, 1966), p. 309.
4. Arnheim, *Toward a Psychology of Art,* p. 62. I need not comment here on the intramural controversy among psychologists concerning the physiological evidence for and against field processes in the projection areas of the brain. Since the phenomenal structure of percepts is best explained as the outcome of field processes, the most economical assumption on their physiological counterparts is that they, too, are field processes.
5. *Art and Visual Perception,* p. 419. See also Wolfgang Köhler and Hans Wallach: "Figural After-Effects" in *Proceedings of the American Philosophical Society,* October 1944, vol. 88, #4.
6. S. Freud, *A General Introduction to Psychoanalysis* (Garden City, 1943), chapter 9. Cited also in Freud's *Autobiographical Study.*
7. *The Dynamics of Architectural Form,* p. 220. Also pp. 68 ff.
8. Judith Wechsler (ed.), *On Aesthetics in Science* (Cambridge, Mass., 1978), p. 25.
9. Timothy K. Kitao, *Circle and Oval in the Square of St. Peter's* (New York, 1974), p. 14.
10. Carl Gustav Jung, *Psychologische Typen* (Zurich, 1960), p. 353.
11. Wasily Kandinsky, *Rückblick* (Baden-Baden, 1955), p. 15. Significantly, however, Kandinsky was profoundly impressed by the painting whose subject he did not recognize.
12. Ambroise Vollard, *Paul Cezanne* (Paris, 1924), p. 198.
13. Friedrich Piel and Jörg Traeger (eds.): *Festschrift Wolfgang Braunfels* (Tübingen, 1977), pp. 341 ff. See also Werner Hager and Norbert Knopp (eds.), *Beiträge zum Problem des Stilpluralismus* (Munich, 1977), pp. 9 ff.
14. Arthur O. Lovejoy, *The Great Chain of Being* (New York, 1936).
15. Arnheim, *Toward a Psychology of Art,* p. 90.
16. See Balzac's story *Le Chef-d'oeuvre inconnu.*
17. *The Complete Letters of Vincent van Gogh* (Greenwich, Conn., 1959), vol. 3, #554, p. 86.
18. For a simple version of this procedure see the concept of the "personal equation" in the studies of reaction time. Robert S. Woodworth, *Experimental Psychology* (New York, 1938), p. 300.

MONROE C. BEARDSLEY

10 The Role of Psychological Explanation in Aesthetics

I

Eighteen years ago, George Dickie startled his fellow-aestheticians by asking one of those improper questions that contribute so much to the stimulation of fresh philosophizing: "Is Psychology Relevant to Aesthetics?" His (guarded) answer was No, and his vigorous argument made an interesting case for the logical separation of questions in philosophical from questions in psychological aesthetics. He pointed out, apropos of Bullough's concept of "psychical distance" (which he later subjected to still more severe criticism), that some lapses from aesthetic experience (another concept he later rejected) are not really cessations of "some special kind of psychological process" that can be experimentally studied, but a failure to follow a "rule" of an "art game." We must not "mistake the observance of rules, conventions, and maxims for peculiar psychological processes" requiring scientific explanation.[1]

Though there was something intellectually healthy, to my mind, in Dickie's emphasis on these distinctions, and though he did succeed in exposing serious confusions in some naive attempts to apply experimental psychology to philosophical aesthetics, I have not been convinced of his general conclusion. Even setting aside, as Dickie did, questions about the processes of art creation—which are certainly psychological questions, though intertwined with others that can reasonably be assigned to aesthetics, or the philosophy of art, taken broadly—the nature of aesthetic experience has continued to seem to

me, especially in its bearing on philosophical questions about the distinctive value of art, or of individual arts, to present clearly psychological questions and to demand psychological inquiry.

In the light of all that has happened in aesthetics and psychology over the past couple of decades, it is a good deal easier now to see why psychology is indeed relevant to aesthetics. But it is not so obvious just what forms this relevance takes, or what are the consequences of admitting it. I hope in this essay to cast some light on at least part of the problem.

The philosophic aesthetician who is seriously interested in explaining why artworks are worth creating and enjoying must seek to understand how receivers of artworks perform their requisite receptive (or interactional, or transactional) activities. There is a confrontation, an engagement, with a physical object or event—a variously-colored canvas, the concerted actions of a number of musicians, or dancers, a token (written or spoken) of a literary text. The data (using this term as noncommittally as possible) generated in this engagement have to be processed (using this term with appropriate reluctance, and sparingly). So there are inevitably vital questions about what the receiver must do, how active he must be and in what specific ways, for the engagement to be completed and for its potential value or values to be realized. There must be some things that receivers are able to do—what might be called their "aesthetic abilities"—if they are to take in the painting, the music, the dance, the poem, and achieve some level of satisfaction, or at least some form of mental arousal, that could justify the efforts required.

An essential part, at least, of what happens in this interchange belongs under the heading of *perception*. There is always what I call a "perceptual object" (that is, an object some of whose properties, at least, are perceivable)[2]—even in the case of the novel's seen script or heard dict,[3] or the "conceptual piece" with minimal inherent interest. In no strained extension of the term, the world of the novel, into which the reader is admitted by the text, as a special sort of very intimate observer, is also a perceptual object. So we may speak of the novel-reader as perceiving the world of the work, insofar as he forms images of the intentionally objective contents of that world, under the guidance of the text. But when we begin to contrast other cognitive processes (by which I mean mental activities eventuating in belief

that is justifiable to some degree)with perception, no doubt the borderline is very hard to fix and especially to keep stable from context to context. There is always, we are given to understand, a certain amount of what might legitimately be called "interpretation" even in perception, and perhaps also of what can be called "unconscious thought." Of course, not all interpretation (as a conceptual and semiotic process) can be subsumed under perception, so some contrast is preserved, and it is not desirable to let "perception" do all the work. Therefore, I adopt and adapt the term "apprehension" when I want to avoid entanglement in the task of saying where perception ends and something else begins: we do, in my sense, apprehend the painting and the dance and the symphony, and the text we read and the world it projects, and also what is meant, expressed, represented, symbolized, etc., by these things—for though an object be a perceptual object, in my sense, this does not entail that it has *only* perceivable properties. Moreover, the broad term "apprehension" may serve to keep us mindful, when we come to consider psychology, that what it tells us about perception, in some restricted sense, may also hold for all the distinguishable ways in which we take things in, the ways in which we process what we are given in our encounters with the world.

II

There seem to be at least two sets of aesthetic abilities, whose differences and relationships we must first look into. The distinction between them is the one noted by Dickie in the quotation above.

To the first set belongs the ability to follow a learned rule or convention in processing the artwork's data. To develop this notion, I begin with a reminder of Chomsky's concept of *linguistic competence:* the general ability of a user of a language to produce and to understand novel sentences in his language, to recognize deviant ones and detect ambiguous ones, under the guidance of his "linguistic intuitions." It is this competence that, on one important view, the linguist attempts to model by articulating the set of rules that the speaker can in some sense be said to follow in the exercise of his linguistic competence—i.e., in his linguistic performance. The concept is not without puzzling features and hidden complexities, which

188 / Monroe C. Beardsley

have been most illuminatingly discussed by Julius Moravcsik.[4] The speaker, for example, may not be able to state the rule he is following when he intuitively rejects a sentence as ungrammatical, but he may acknowledge it when it is proposed to him.

Now reading a poem is also a linguistic performance, requiring linguistic competence; but poems, as literary works, have special features that call for special abilities in the management of language. And so some literary theorists, for example, Jonathan Culler and Martin Steinmann, have introduced the concept of *literary competence* for this set of second-order abilities.[5] Just as sequences of sounds are organized into units and into elements of phonological, syntactic, and semantic systems by the internalized grammar that we apply to them, so (the theory goes) a discourse is a literary work—or a literary work of a certain genre—in virtue of the appropriate conventions we bring to it. To know how to literate (my term for apprehending and enjoying a discourse as literature[6]) is to have mastered the system of literary conventions and to be disposed to apply them readily and correctly when the occasion arises.

Though no one has worked out systematically the set of rules that would define literary competence in general (or poem-competence or narrative-competence), Culler has described the task well and has offered examples of such rules. For example, he says of lyric poems, apropos of Blake's poem on the sunflower.

> The primary convention is what might be called the rule of significance: read the poem as expressing a significant attitude to some problem concerning man and/or his relation to the universe.[7]

There are some problems about this example. First, it is framed as a simple imperative, and though that may be acceptable, we might want to consider alternative formulas, for example: "The poem is to be read as . . ." Second, the rule refers to "the poem," and thus presupposes that we shall have to recognize that the text is a poem before we can know that it is appropriate to apply the rule. But I think Culler himself would not wish us to think that we actually *had* a poem until we applied this rule, among others; so perhaps a more accurate version of the rule will turn out to be something more like this:

> A text that has certain "poem-indicating features" (its lines do not run to the margin, it is in a book labelled "poetry," etc.) is to be read as expressing a significant attitude . . .

A comparable rule belonging to narrative-competence (not from Culler, but I believe in keeping with his discussion),[8] might be this:

> When a text describes an action, the reader is to think of answers to the questions: (1) Why was the action performed? (2) What does the action show about the personality or character traits of the agent? (3) What are the likely consequences of this action? (*Narrative Rule I*)

It is worth noting that studies of children's experience with drama provide evidence that the growth of competence in dramatic literating is at least in important part a matter of catching on to the rules of the game. For example, Howard Gardner remarks that

> When children attending the theater cover their eyes until the hero has been saved, they reveal that they have not yet achieved the status of an informed audience member. The latter can retain distance, and participate in the feeling or quality being described, without ascribing to it the same reality status of his own life experience.[9]

It is not too difficult to formulate, at least roughly, the rule that these inexperienced playgoers have yet to learn.

Culler has been criticized[10] for the asymmetry in the relation of reader to writer in literary competence, as contrasted with its symmetry in linguistic competence. The readerly intuitions that are, on this view, to be explained by a theory of the narrative, for example, are those involved in following plots, in describing them, and in summarizing them at some assigned level of abstraction. But if the reader can in this way manifest his ability to understand the narrative as a *hierarchical structure,* in which some events are more significant than others, if he can re-tell the story in a condensed form, he is revealing a certain kind of skill, and one that quite plainly involves a complex sort of knowledge of how to recognize correct or incorrect, detailed or sketchy, intelligible or unintelligible, summaries.

The next question is whether we can carry Culler's generalization of competence one step further and form the concept of *aesthetic competence.* Under this heading we would perhaps place all the

diverse sets of rules involved in adequate experiencing of artworks of all sorts, and—if it is possible to find and frame them—universal rules that are constituents of aesthetic competence in any of its manifestations.

Whether there are such universal rules will be a controversial question, obviously connected with familiar aesthetic problems about the definitions of the arts and the concept of aesthetic value in general. But perhaps the concept of aesthetic competence gives us a way to bypass some of these ancient issues. For example, aestheticians of very different persuasions might be persuaded to agree on a rule such as this:

> When there occurs confrontation with an object indicated as an artwork, or probably an artwork, attention is to be given to qualities expressed in it (or, in terms of another aesthetic system, metaphorical properties exemplified by it). (*Universal Rule I.*)

If this rule seems somewhat bland as it stands (and I hope we will not hastily resort to that knee-jerk term of philosophical dismissal, "vacuous"), we should remember the child covering his eyes and imagine him at an early age in a large museum of art: it may not be much, but it is surely *something,* to learn that the proper way of approaching paintings and sonatas as well as poems and stories is to seek out their human regional qualities—among other things, of course. There are even plenty of adults who are covering their eyes, as well as their ears.

But the significance of the concept of aesthetic competence does not depend alone on the extent to which it comprises universal rules of approach or access to artworks; what is also commendable in it is the scope it allows, and even invites, for diversified strategies of approach appropriate to particular kinds of artwork. It seems that a person may be competent in hyperrealistic or in impressionistic paintings without being competent in surrealism or hard-edge minimal abstractionism: he knows what to look for, what to pay special attention to, what sorts of connections to try to make, even what to ignore or play down. Or (to refer to a matter of current controversy) he knows how to "read" representational paintings in one system of perspective, but not another. Of course there are overlapping abilities, to ease the transfer of learning in many such cases, but transfer can be blocked, and that is understandable on the theory that what is

required is the learning of certain rules. So, too, artworks of past or distant cultures, reaching us without external aids to learning, may not yield up the secrets of their proper rules, or may require much study. We can allow for unlimited cultural and historical variation in the rules connected with changing styles and genres—without, of course, embracing any relativism, so long as the rules are followed in the artwork and are in principle learnable: we need only take cues from our first perception of the work to tell us which kind of competence we are to bring into play—or if the yield to that approach is disappointing, we can always try another kind of competence, approaching the work as though it were, or might be, one of a very different sort.

Aesthetic competence, like its linguistic analogue, would be manifested by the art-receiver in his successful processing of an artwork; and it would be manifested by the artist—not in his success at creating fine works (for we are not talking about artistic competence, or genius), but in his success at designing his work in such a way that the receiver can process it successfully. The artist *uses* the rules, is governed by them; in just this respect he is like the speaker of a language, as the receiver is like a listener. If the dialogue seems rather one-sided, that is characteristic, in all walks of life, of communicational encounters in which one party happens to have, on the present occasion, more to say.

The exercise of aesthetic competence does not require conscious consideration of the rules invoked, nor does learning the rules require that they be explicitly stated. We can think of experienced and expert receivers of artworks as having internalized a lot of what they know, of their know-how, and as being guided by intuitions that bear some analogy (though we now must tread warily) to those of the language-user. This point requires much more explanation, but I shall have to be content with mere hints. Consider Universal Rule I, suggested very tentatively above: the receiver whose competence embodies this rule will naturally be sensitive to works that yield the sought-for, the expected, expressiveness; will be disappointed when the search is blocked; will be puzzled by ambiguities or indeterminacies in the expressiveness apparently present, etc. He will know when he is doing the right thing or the wrong thing, so to speak, by the conventional cues he has learned to follow and by the comparative

success or failure of his efforts to process the work in terms of this rule.

It would be welcome support for the concept of aesthetic competence were I able to cite developmental evidence—beyond my earlier example from Howard Gardner of children watching plays—of the stages in the learning of aesthetic rules. If a child of three is (according to Gardner) "capable of representing and of appreciating a representation" and thus "has become a participant in the artistic process of painting,"[11] this small child has supposedly acquired some proficiency in applying rules of a representational symbol system (i.e., one that is, according to Nelson Goodman, semantically and syntactically dense). Gardner speaks of "knowledge of the code" in appreciating artworks,[12] and attributes the young child's (normal) inability to produce very satisfying artworks—his artistic "immaturity"—partly to insufficient mastery of linguistic codes and art traditions. But even in this notable work there is less than one might expect to show what part of growth in aesthetic abilities consists of increase in aesthetic competence.[13] So many other developmental factors are involved. Nevertheless, it seems clear that when we set about to explain how receivers come not merely to endure but even enjoy artworks, not merely to notice but to understand them, an essential part of this explanation is going to make reference to the specific or generic rules these receivers are following in their experiencing of artworks.

III

The second important set of aesthetic abilities is best approached, I think, by way of a brief consideration of the nature of explanation. This topic bristles with so many disputed features that in order to get to the matters central to this essay I shall have to make some sheer assumptions as I go along. The first of these is that explanation is a relationship between facts. Explanations (or at least the kind that concern us here) can thus be represented, with utmost simplicity, in sentences that fill out the following schema:

The fact that P *explains the fact that* Q.

Thanks to its abstractness, the schema accommodates explanations

of two very important types. The first of these is explanation by causes (or *causal explanation*), for example:

> *The fact that* Jane's watch fell off the shelf *explains the fact that* Jane's watch stopped.

Of course, this explanation (in its concrete context) would take a lot of things for granted, about other conditions contributing to the watch's malfunction. These could be made explicit, for my schema is not meant to exclude facts that are multiple conjunctions of facts. The second type of explanation is explanation by reasons (or *rational explanation*), for example:

> *The fact that* Jane wanted to get up early *explains the fact that* Jane set her alarm.

Again, other relevant conditions and circumstances may be assumed for the explanation to be acceptable. If we distinguish, in every explanation, between the *explaining fact* and the *fact explained,* we must note that in a rational explanation the fact explained is always the fact that an action was performed. Whether rational explanations are a species of causal explanation is a question we can safely bypass here.

In any case, explanations in terms of rule-following appear to be causal explanations. We might say

> *The fact that* Jane, in reading *Oliver Twist,* followed Narrative Rule I *explains the fact that* Jane apprehended the events in *Oliver Twist* as constituting a coherent and intelligible plot.

Again, that's not the whole story, but it might be a crucial part of the explanation. On the other hand, we might also say

> *The fact that* Jane, in reading *La Maison de Rendez-vous* followed Narrative Rule I *explains the fact that* Jane apprehended the events in *La Maison de Rendez-vous* as constituting an incoherent and unintelligible sequence.

And here the interesting question would arise: to what extent does this impression of Jane's constitute the *right* impression, because the desirable effect of *La Maison de Rendez-vous* depends on the text's being able to frustrate the attempt to follow Narrative Rule I—or is Jane's impression in this case to be taken as a signal that following

Narrative Rule I is *not* the proper way of reading *La Maison de Rendez-vous?* This is another question we need not try to answer now, for our concern is only to note how the rules defining aesthetic competence (in general, or in some limited form) would enter into explanations of experiences of artworks.

If one fact is to explain another, I take it that there must be some connection between them: more specifically, a true generalization that connects facts of the first kind with facts of the second kind. We do not need to know (indeed we do not believe) that every time a watch, or a watch belonging to Jane, or a Timex belonging to Jane, falls from a shelf it stops. But there must be some set of conditions under which there is some tendency for falls to stop watches, or the explanation offered cannot be true. This holds even for extremely rare events; even if Jane's watch suffered from a one-in-a-million defect that made it peculiarly sensitive to blows, we must still assume that most watches *with that defect* would be stopped by a shelf-high fall. I shall use the term "laws" for such true generalizations, whether universal or statistical. I assume that we would not swallow the proposal:

The fact that Jane neglected to butter her watch *explains the fact that* Jane's watch stopped,

because we have no reason to believe any law that would serve to connect these facts (which is why Jane's not having buttered her watch is not really a case of neglect).

The law must make the explaining fact constitute a reason (however weak) for believing the fact explained, supposing we did not already know it. In explanation, of course, we begin with the fact-to-be-explained, which becomes an explained fact when we cite some other fact that helps to lend it credibility. I should probably add that this does not mean we could necessarily have predicted that Jane's watch would stop if it fell from the shelf; prediction requires more than explanation after the fact.

When we turn to the explanation of psychological facts (for example, about our experiences of artworks), we will require laws to connect these facts with the appropriate explaining facts. And among such laws will be those describing certain propensities of art-apprehenders: tendencies to react in certain ways to certain data,

to process data in certain ways, to seek out certain kinds of data when opportunity arises. Such propensities will evidently play a crucial role in explaining experiences of artworks, and their existence consists in the truth of psychological laws. It is precisely here that psychology becomes relevant to aesthetics—if psychologists do in fact supply such laws and they can actually be used in framing explanations of artwork-experiences.

I propose to discuss some of the philosophical problems that arise at this juncture of psychology and aesthetics. Since we are concerned with a subclass of psychological laws—those pertaining to perception, or apprehension—and since we require examples of laws that have actually been applied to the explanation of artwork-experiences, I take the laws offered by gestalt psychology as my examples, and I consider some of the ways in which these laws have been used in theoretical works concerned with visual arts, music, and literature. It may be that Julian Hochberg is right in saying that experiments have given "a simple and direct demonstration that the whole does not determine the appearance of its parts. Since that is precisely the premise on which gestalt psychology rested, we have also put a belated end to that theory."[14] Still, the destruction of this theoretical premise does not entail the falsity of the gestalt laws of perception.[15] And if, as Hochberg so persuasively argues, "perception is the intentional formulation and testing of sensory expectancies"—to which he presently adds "or mental structure"[16]—the gestalt laws may in fact be operating in the very arousal and testing of these expectancies.

IV

In considering the application of gestalt psychology to visual arts, we naturally turn to the work of Rudolf Arnheim, and especially his impressive book, *Art and Visual Perception.* It may be that "the links between gestalt theory and Arnheim's analyses of various paintings and perceptual situations are nowhere near as intimate as those between psychoanalytic theory and Ehrenzweig's similar application,"[17] but they are close enough for our purpose, which is to take another look at the way some gestalt laws are formulated and used in explanation. The first thing to be clear about, of course, is just what sorts of facts are to be explained. One of Arnheim's early examples

196 / Monroe C. Beardsley

shows how the gestalt laws of perception might be used in explaining why an anonymous fifteenth-century painter placed "a large dark patch on the angel's robe" to provide visual balance to match the balance depicted in St. Michael's weighing of a pious soul.[18] But this explanation of an artistic act is in terms of what the painter presumably wanted his viewers to see. So, more fundamentally,

> This will be the first task: a description of what sorts of things we see and what perceptual mechanisms account for the visual facts. . . . There is no point to visual shapes apart from what they tell us. This is why we shall constantly proceed from the perceived patterns to the meaning they convey . . .[19]

The facts to be explained, then, are of two sorts: (1) that the viewer sees certain things—or, as he puts it later, his aim is to "discover what makes a visual object or event look the way it looks"[20]—and (2) that the viewer finds certain "meanings" in what is seen. Of what sorts, then, are the explaining facts? Let us see.

The psychological law that Arnheim most often invokes in his explanations of varied perceptual phenomena,[21] is the "principle of simplicity," which is stated in this way:

> *Any stimulus pattern tends to be seen in such a way that the resulting structure is as simple as the given conditions permit.*[22]

Despite the word "stimulus" here, the "conditions" referred to in the actual explanations are themselves visual features, though presumably of a different order from the visual features explained. The black disk off-center in a white square is seen as "restless" or unstable.[23] Being a black disk, being in a white square, and being off-center are presumably the "given conditions" (and the explaining facts). The concept of simplicity, applied in this context, presents many well-known difficulties, but I think they are not insuperable and am prepared to ignore them for present purposes. Arnheim says that simplicity "implies parsimony and orderliness whatever the level of complexity."[24]

Arnheim also remarks that

> psychological systems exhibit a very general tendency to change in the direction of the lowest attainable tension level. Such a reduction of tension is obtained when elements of visual patterns can give in to the directed perceptual forces inherent in them.[25]

("Giving in" occurs, for example, in perceptual illusions, when a line looks shorter or longer than it really is or when two segments of the same line seem disconnected, as in Poggendorff's illusion.)[26] Unfortunately, it is not clear from Arnheim's discussion how he conceives the relationship between this law of tension-reduction and the law of simplicity: whether they are the same law in different words, or complementary, or the first is a special case of the second, or one derives from the other (that the tension in the black disk is the cause, or the effect, of lack of simplicity in its location).

However wide-ranging its explanatory utility, simplicity has its limits in Arnheim's psychology of visual art. It turns out that in trying to draw briefly-seen figures, some subjects simplify the originals, others complicate them. The tendency to simplify ("levelling") and the tendency to complicate ("sharpening") are said to be manifestations of a more general "tendency to make perceptual structure as clear-cut as possible."[27] This "law of *Prägnanz*" is also described in terms of our other basic concept: levelling is reducing tension, sharpening is increasing it.

Degrees of visual tension are fairly open to intersubjective comparison; degrees of simplicity are not inaccessible, despite the difficulties; but degrees of clear-cutness are surely much more dubious— which may be the reason why, after this brief reference to it, Arnheim appeals no further to the law of *Pragnanz*. Thus he is left with two pairs of laws: one, that there is a propensity to structure the data of the visual field as simply as possible, and also a propensity to complicate them; two, that "We envisage the human mind as an interplay of tension-heightening and tension-reducing strivings."[28]

Now, it may seem that there is something wrong with a system whose laws provide (1) a tendency to simplify the visual field and (2) a tendency to complicate the visual field. Not necessarily so. It is to be presumed that there are certain conditions under which the first tendency prevails and other conditions under which the second tendency prevails. (And the simplifying tendency seems to be regarded as the normal one.) Of course, so long as we remain ignorant of these conditions, our explanations will not be wholly satisfactory, for they will be rather incomplete. Still, we may gradually discover some of the conditions that make the difference, and we may have adequate reason to believe, in a particular case, that the simplifying tendency is operative, so that we are permitted to invoke the

law of simplicity (or perhaps the law of tension-reduction) in explaining that particular phenomenon.

Nor need we fear that the introduction of such psychological laws into the realm of art is forbidden by the complexity of artworks or their high level of individuality. The explanations we seek here—which Arnheim's discussions show us how to give—are not different in principle from those we confidently accept in other spheres. Take one example: in El Greco's *St. Jerome* (in the Frick Collection), "the slight movement of the beard to the right counterbalances the location of the hands and the book at the left."[29] What Arnheim says about this example might be formulated in different ways; let us try the following:

> *The fact that* St. Jerome's hands and book are seen at bottom left and his torso is seen as turned leftwards *explains the fact that* St. Jerome's rightward-turning beard is balanced and held in place.

The law that is needed to connect these facts and thus back up the explanation could hardly be the law of simplicity itself, which is much too abstract and general. We need one or more laws that concern the perception of visual designs: what we may call "intermediate laws." For example:

(a) When opposing forces or masses are perceived in a visual design, they will tend to be perceived as having as much balance as their properties permit.

(b) When two parts of a visual design are perceived as in balance, they tend also to be perceived as highly stable.

These intermediate laws could be regarded as subsumed under the law of simplicity, if we assume that a design seen as balanced tends to be seen as simpler than a design seen as unbalanced, and that a design seen as simpler than another also tends to be seen as more stable (as having less tension). But it also seems clear that the intermediate laws could be discovered independently of any knowledge of the general law of simplicity, though knowledge of that law might serve as a guide in seeking them out. If we place it in the province of the visual art theorist to discover such intermediate laws, we can say that the gestalt psychologist then comes to his aid, not by giving him new

intermediate laws, but by explaining his intermediate laws in terms of higher, more general, principles.

We need not, I think, be tempted into skepticism about the possibility of discovering such intermediate laws. No matter how complex the context, or how many other things are going on in the painting, the propensities to establish balance and to find it stable may be at work, and may be detectable. We do not, of course, obtain the laws by simple induction from a sample of paintings by El Greco or paintings of St. Jerome, but by a judicious application of Mill's Method of Difference. Cover the bottom two-fifths of the picture in a reproduction, advises Arnheim, and "balance is destroyed. The beard now looks as though it were being blown sideways by an electric fan and wanted to return to a vertical state of rest." To be sure, the Method of Difference can lead us astray if we don't know that we have varied only the feature whose impact we are testing. And paintings are often in such delicate equilibrium that any alteration might affect the way various other parts of it are perceived—the case of El Greco is not as simple as the case of Jane's watch, where plainly the only thing that happened just before it stopped was its fall from the shelf. But we can refine Arnheim's experiment—as long as we are performing it on a reproduction—by painting out the book and hands to see what difference that makes. If that destroys, or seriously weakens, the balance, and unsettles the beard, we have a convincing demonstration of the lawful connection of explaining fact and fact explained.

We have now happened upon a most difficult and fundamental problem. For the intermediate laws, as I have framed them, are themselves psychological—they are about visual perception. Thus it seems that what the theorist of visual art does is a kind of psychology, and many of his key explanatory principles turn out to be psychological laws. But the theorist may strongly protest this conclusion, disclaiming any qualifications to do psychology. He may say that, strictly speaking, it is not perceptions that he is interested in explaining, but features of the painting itself: its balance or stability. And that what he discovers, *qua* theorist, are not psychological laws but laws about the connections among objective features of visual de-

signs: what we might call (for contrast) "objective laws." Then (a) and (b) should be cast in quite different terms:

(a′) When opposing forces or masses appear in a visual design, they will tend to be as balanced as their properties permit.

(b′) When two parts of a visual design are in balance, they tend to be highly stable.

(Note that Arnheim's remarks about the El Greco, are a mixture of psychological and objective language.)

The problem that rises before us concerns the ontological status of artworks—too large a problem to cope with here, beyond noting a few of the logical relationships between it and the problems we have been discussing. Faced with the challenge of the objectivist art theorist, there are at least two familiar ways to go. One is the phenomenalist way: visual artworks themselves are nothing but experiences, or classes or ideal limits or some other construction of experiences. Then explaining why the artwork is balanced is just the same as explaining why it is perceived (perhaps under certain ideal conditions) as balanced. Intermediate laws (a′) and (b′) are merely elliptical versions of (a) and (b). Arnheim himself evidently leans in this direction when he writes that "What [the artist] creates with physical materials are experiences. The perceived image, not the paint, is the work of art."[30] The other is the physicalist way: visual artworks (such as paintings) are physical objects with both physical and perceptual properties. That certain perceptual properties (shapes, colors, lines, and their interrelations) give rise to certain others (balance, stability) is a genuine discovery about the extra-psychological world, in which such emergence regularly occurs. Laws (a′) and (b′) are not reducible to laws (a) and (b), but are needed in answering quite distinct questions. One who discovers (a′) and (b′) need never have heard of (a) and (b).

The work of the gestalt psychologists may compel both parties to agree that if laws (a) and (b) did not hold for perceptual processes, we would not be able to confirm laws (a′) and (b′). The phenomenalist can make this fact a strong argument for his position, on the principle of Occam's Razor. The physicalist will support a kind of parallelism between the objective processes of nature and the subjective pro-

cesses of perception. Others, adopting more complicated forms of transactionalism, will seek a third way, in the hope of avoiding well-known difficulties for both phenomenalists and physicalists. But on the present occasion I cannot pursue these issues.

V

Among those who have applied laws and concepts of gestalt psychology to music, Leonard Meyer is outstanding. Though his work deserves extended discussion, we must confine ourselves to the philosophical problems it raises—most of which we shall recognize as those we have met in Arnheim. Notwithstanding Victor Zukerkandl's interesting remarks about the limitations of gestalt theory in the explanation of the dynamics of Melody,[31] Meyer's chief work[32] makes fruitful use of gestalt concepts. Though an important part of his contribution lies in the development of a theory of musical style as internalized rules (or, in my term, as a species of musical competence), much of his book concerns the psychology of musical response. Without accepting the basic theoretical commitments of gestalt psychology, Meyer appropriates the "law of *Prägnanz*": "Psychological organization will always be as 'good' as the prevailing conditions allow."[33] He assumes that "the mind is constantly striving toward completeness and stability of shape,"[34] so that, given some leeway, it will improve perceived figures and when it finds stable shapes will resist change. This tendency is fundamental to all his wide-ranging and illuminating discussions of music examples. Especially important in music is the "law of continuation," apparently regarded as a corollary of the *Prägnanz* law: that the smoothest progressions will be accepted, but gaps, breaks, and shifts from one manner of progression to another will be perceived as disturbing.[35] But what we perceive as continuity will be in part determined culturally by our apprehension of the stylistic system to which the particular musical progression belongs.

There are many puzzling features of Meyer's use of psychology in *Emotion and Meaning in Music*. For example, in his important discussion of closure, or completion of a pattern, in music, he says:

To assert that incompleteness gives rise to expectations of completeness is tantamount to tautology. For things seem to be incomplete only because

we entertain definite feelings, latent expectations, as to what constitutes
completeness in a given stimulus situation.[36]

Such a remark blurs the distinction between phenomenally objective
and phenomenally subjective elements of experience and exhibits
some confusion about what exactly is being explained. Meyer first
seems to be saying that we explain the fact that we have certain
expectations about forthcoming musical events by the fact that we
perceive a passage as incomplete, as lacking closure, in a certain
respect. But then he seems to say that on the contrary the fact that we
perceived the passage as incomplete is to be explained by the fact that
we listened to it with just those expectations. Of course we can't have
it both ways, but I judge from the context that what Meyer means is
that we listen with a set of *dispositions* to form certain expectations,
given certain types of musical event (these dispositions constitute our
grasp of a musical style), and with certain *concepts* of what would
constitute completeness in certain types of progression. These dispo-
sitions and concepts explain why we perceive incompleteness; but
that perception explains the consequent *particular* (occurrent) ex-
pectation that closure will ultimately be attained.

Rather than pursue this line of thought, it will be more enlight-
ening to turn to Meyer's more recent theoretical discussion and
practical music criticism.[37] As Alan Tormey has pointed out in his
review of *Explaining Music*, there is a considerable ambivalence in
Meyer's view of what sort of thing it is that music criticism (i.e., his
book) is supposed to explain.[38] Indeed, I find three (perhaps four)
rather diffⲉrent doctrines, whose relationship calls for a good deal of
explanation itself. I do not wish to take away any of the great credit
that this book deserves for its studies in music theory, but I want to
emphasize the magnitude of the philosophical problems about the
relation of psychology to music theory that this book leaves in its
wake.

Meyer first declares that "criticism seeks to explain how the struc-
ture and process of a particular composition are related to the
competent listener's comprehension of it"[39]—or "why and how it is
experienced and understood."[40] Since the explaining facts are facts
about "structure and process," the implied schema seems to be the
one we found in Arnheim: the fact that certain features of the music

are perceived explains why certain other features are perceived (or apprehended, or comprehended). But presently we are given a quite different account: "Criticism endeavors to understand and explain the relationships among and between musical events, not the responses of individual listeners."[41] The word "individual" here has ambiguous weight: what other kinds of listeners are there? we might be tempted to ask; but perhaps it is meant to rule out idiosyncratic aspects of musical experiences. Further remarks seem to underline the objective character of this second concept of music explanation: critical analysis explains "the function and structure of this specific harmonic progression, . . . the reason why there is a *sforzando* on this note or why this theme is interrupted at this particular point."[42] The notion of function seems to be the key here—Meyer also speaks of "how a musical event 'works'—how it fits together and functions"[43] —but it needs further clarification. If it is the presence of this specific harmonic progression that we are explaining, teleologically, by saying that it performs a certain function—that is, it makes possible the work's having some *other* feature—then this functional explanation seems to rest upon, to presuppose, a second sort of explanation which is analogous to what we first found in Arnheim. As the visual balance in the St. Michael painting is explained by citing the presence of the large dark patch, so the strong closure of a musical passage is explained by citing the presence of a particular harmonic progression (which is then said to have the "function" of producing that closure). So within Meyer's second concept of musical explanation, we should take care not to confuse these:

> *The fact that* the passage has harmonic progression H *explains the fact that* the passage has strong closure.
> *The fact that* the harmonic progression H contributes to producing strong closure *explains the fact that* the work contains H.

The first of these statements is objective explanation of the sort we have considered above; the second puzzlingly embodies the first, but appears to go beyond it in the direction of a third concept of musical explanation.

"Looked at from another point of view," says Meyer, offering his third proposal, "criticism attempts to understand and explain the choices made by a composer in a particular work."[44] Now musical

explanation takes the form of rational explanation, as this was briefly defined above. Why (to take one of Meyer's examples) did Palestrina, after making his melody leap upward by a sixth, immediately make it descend in stepwise fashion?

We might, for instance, cite the Gestalt law of completeness, which asserts that the human mind, searching for stable shapes, wants patterns to be as complete as possible. A skip is a kind of incompleteness: the listener is aware of the gap between the first pitch and the second, and "wants" the gap to be filled in, which stepwise motion in the opposite direction does.[45]

So the explanation takes the form of citing a reason:

The fact that Palestrina wanted his melody to be perceived as complete and believed that if he gave it stepwise downward motion after a leap of a sixth it would be perceived as complete *explains the fact that* Palestrina gave his melody the stepwise downward motion.

Here it is neither psychological processes nor objective features of music works, but composers' actions, that we are explaining.

But Meyer, of course, does not really commit himself to such a view. First, he is careful to withdraw any implication that these explanations would benefit from independent evidence about the composer's intentions (which they would, if they were genuine rational explanations): It is important that "understanding the choices made by composers" does not mean knowing what actually went on in the composer's mind when he wrote a particular work.[46] The trouble is that this concept of musical explanation easily slides over into a fourth one, which Meyer does not take care to block. Discussing the brilliant interruption in the finale of Mozart's E-flat symphony (No. 39), he writes:

Therefore, had the consequent phrase closed in the expected way, the whole theme would have seemed obvious and anti-climactic. One could, of course, formulate a general law covering the case: what is too predictable is uninteresting and is, as a rule, avoided. But this is scarcely necessary.[47]

It is worth noting that Meyer here, as elsewhere in his writings, [48] makes good use of Mill's Method of Difference by rewriting passages of music to show how their qualities are affected by particular

alterations. What is most important here, however, is that in this Mozart case we seem to have, not so much an explanation as a *justification* of the interruption. (Or, if you prefer, an explanation of why it is *good*.) Once we say we are explaining why Mozart or Palestrina made a compositional choice, but we are not interested in what was going on in his mind, we are likely to be giving *our* reasons for approving what was done. The interruption "is simply a decision—though the critic can suggest, as I tried to do, why it is not an unreasonable one. The interruption is acceptable for a number of reasons."[49] This is no longer explanation, but value-judgment.

I conclude that it is the second concept of musical explanation, in which some parts or features or properties of the work explain others, that Meyer is really concerned with. His language in *Explaining Music* is generally objective rather than psychological, and even more so in a recent long essay.[50] When, in his review, Tormey questioned Meyer's remark about internal relations that "contribute to the impression of unity,"[51] and objected to "Meyer's tendency to psychologize aesthetic concepts," Meyer withdrew the word "impression" as not correctly representing his position.[52] His general view is, then, objective. Thus the first theme of the finale of Dvořák's "New World" Symphony, returns with significant alterations. "To balance the greater motion of this version of the melody and to emphasize the closure of the whole section, the cadential pattern which follows the B is extended for three measures."[53] This fits the schema of causal explanation well, and the back-up intermediate musical law is not hard to formulate roughly. But it could not be a psychological law about perceptions, or it will not serve to connect the facts reported in the explanation. So it seems that psychological laws, as such, do not enter into music criticism as Meyer conceives it; and it remains a difficult question how psychological laws are related to the objective laws that do enter into it.

VI

Barbara Herrnstein Smith's thorough and illuminating examination of *Poetic Closure* declares an assumption that is "axiomatic to this study: namely that, other things being equal, we expect to find what

we have found before."[54] This "psychological tendency" manifests itself variously in the reading of poems, reflecting the law of "good" continuation, for which Smith refers to Koffka and Leonard Meyer:

> The perception of poetic structure is a dynamic process: structural principles produce a state of expectation continuously modified by successive events. Expectation itself, however, is continuously maintained, and in general we expect the principles to continue operating as they have operated.[55]

But her principal concern is with those features of poems that block this tendency by invoking a counter-tendency to seek stability and completeness. In short, her task is to explain closure. But what is that? It is "the sense of stable conclusiveness, finality, or 'clinch' which we experience" at a certain point.[56] Or it is something that has as its "function or effect" what is described as "that expectation of nothing, the sense of ultimate composure we apparently value in our experience of a work of art, . . . variously referred to as stability, resolution, or equilibrium."[57] "Closure occurs when the concluding portion of a poem creates in the reader a sense of appropriate cessation . . . it gives ultimate unity and coherence to the reader's experience of the poem . . ."[58]

It is not easy to tell from these accounts whether closure is a property of the poem, a phenomenally objective character, or a phenomenally subjective state, like an "expectation." It seems, on the whole, to be apprehensions of closure that are taken as the facts-to-be-explained, and in these explanations, the key role is played by intermediate laws of poetry, some of which Smith makes explicit by a somewhat casual application of Mill's Method of Agreement and Difference—as in Chapter 2, where "formal" and "thematic" devices for obtaining closure are distinguished.

An example of a formal device is given in answer to a question about blank verse, which sets up a strong tendency to continue in the same way. "What, then, will distinguish the end of a blank-verse poem? Is there any way in which the sense of finality can be strengthened apart from thematic closure?"[59] Consider how Shakespeare gives an ending to his scenes by concluding the final speech with a rhymed couplet: "The play's the thing / Wherein I'll catch the conscience of the King. *Exit*." Here it is our perception of the couplet

that explains our sense of closure. An example of a thematic device is George Herbert's "Mortification."

> Lines 31 to 34 [in the final stanza], which do indeed present a summary recapitulation, answer to the expectations set up by the logical structure of the poem and, more particularly, to those set up by the poem's resemblance to moral verse of a certain tradition.[60].

Here the intermediate law assumed, or discovered, seems to affirm a tendency of poems apprehended as ending with a summary recapitulation to be apprehended as having closure. These two examples are quite representative of the book.

Evidently Smith conceives of her inquiry as one that issues in intermediate psychological laws about the experience of poetry. It is not evident, however, that this inquiry depends in any way on more general gestalt laws or on the discoveries of psychologists. Her "axiomatic" assumption that "other things being equal, we expect to find what we have found before" is so extremely loose that it neither entails nor is entailed by the law of "good" continuation. It is of no help in explaining anything: the explanatory weight must in each case be carried by the intermediate laws, which cannot be deduced from the axiom but must be learned through a study of poems. We need to know what things we have "found before" in a poem tend to raise expectations of continuing. So in Smith's work we seem to have a paradoxical situation: the literary theorist does psychology, but scientific psychology is of no use to her. This same paradox we found to characterize a large part of the work of Arnheim and Meyer.

We may well wonder, then, whether it also holds for a more recent contribution to literary theory by Wolfgang Iser, in which phenomenological and psychological concepts are also featured. So considerable is the complexity and subtlety of Iser's book that it strongly resists summary, and in some places it also resists comprehension, so I am uncertain of my ability to do justice to his ideas here. But I am convinced that his work is important, and the role of psychology in his literary theory is, I think, instructive. His ontology is a modernized variation of Ingarden: "the virtual position of the [literary] work is between text and reader, its actualization is clearly the result of an interaction between the two."[61] The work, as aesthetic object, is produced through an act of "concretization," involving processes of

"focusing and refocusing that take place during the reading of the literary text. . . . The aesthetic object [i.e., the poem, the novel] has no existence of its own, and can consequently only come into being by way of such processes."[62] There could be no difference, on this view, between psychological laws of apprehension and objective laws about the literary work, since the properties of the work are those it acquires through the psychological processes by which it is constituted.

Iser's use of gestalt psychology brings out a point that could also be illustrated from our previous discussions but that we did not pause to remark: one contribution that gestalt psychology makes to the literary theorist (or other art theorist) is in supplying *concepts* to be used in finding and framing explanations. This is not, of course, the same as supplying usable laws, but it may be important. Thus Iser notes that in our apprehension of a literary text there are essential figure-ground relationships, which shift as we gather more data and are led by the narrator to transfer attention from, say, a character to a setting or from an action to a character-trait.[63] But Iser is also careful to point out ways in which this feature of literature is different from the strict figure-ground relationship of gestalt psychology. Again, "As meaning is not manifested in words, and the reading process therefore cannot be mere identification of individual linguistic signs, it follows that apprehension of the text is dependent on gestalt groupings"[64]—another borrowed concept. "The reader's task is then to make these signs consistent"; for example, at the beginning of *Tom Jones,* we are warned by the narrator that he cannot vouch for the truth of Dr. Blifil's appearance of piety, and we are assured that Squire Allworthy is morally perfect.

> The realization that the one is hypocritical and the other naive involves building an equivalence, with a consistent gestalt, out of no less than three different segments of perspectives—two segments of character and one of narrator perspective. The forming of the gestalt resolves the tensions that had resulted from the various complexes of signs. But this gestalt is not explicit in the text . . . [65]

There is a suggestion in this passage that the process of gestalt-formation is to be explained with the help of Arnheim's principle of tension-reduction. And this reading of Iser is supported by his ex-

tended discussion of the concept of good continuation in its applicability to literature. What is significant about literary works, as fictional discourse, is for Iser just their lapses from good continuation, i.e., from what he calls "connectability." He invokes what purports to be a law:

> A gestalt closes itself in proportion to the degree in which it resolves the tensions between the signs that are to be grouped. This is also true of gestalt sequences dependent on the *good continuation* principle of coherence.[66]

There is a great deal of penetrating discussion of "blanks"—i.e., suspensions of connectability. Blanks call upon the "constitutive activity of the reader,"[67] as connectability requires to be restored; the reader must seek for gestalts that will constitute a coherent character or action.

> Through gestalt-forming, we actually participate in the text, and this means that we are caught up in the very thing we are producing. This is why we often have the impression, as we read, that we are living another life.[68]

But the conditions of and constraints on "the reader's task" can differ deeply from one kind of prose fiction to another; Iser is especially interesting on this point. In one kind of modern novel, the text "resists all attempts at integration into a single unified structure," as every tentatively formed gestalt is shortly overturned.[69] If the reader insists on forcing a unified gestalt, the text becomes inane or hopelessly abstruse. The point of the openness of structure is to make the reader conscious of the openness of the world; "the incessant invalidation of established connections" that the reader tries to fit to the work makes the reader experience "the historicity of his own standpoints through the reading itself."[70]

But this line of thought takes us away from psychological propensities to rules constituting aesthetic competence. The allusion to the reader's "task" is of a piece with Iser's further view that such initial "open gestalts" can often be closed in more than one way, and a reader's selection of one possibility rather than another may reflect his decision about what the higher-level "significance" of the plot-segment, say, should be.[71] There is a good deal of uncertainty in Iser's own text about when he is concerned with psychological propensities

and when he is concerned with conscious choices in accordance with a rule: "Try to connect consistently." We might in fact derive from his book an argument that the very distinction between rule-following and obeying a psychological law is not as sharp or clear as I have made it out to be. Or we might conclude that Iser is at fault for not giving adequate recognition to this important distinction. Or we might learn from him another lesson: namely the intimate cooperation of propensities and rules in the processing of literary texts. The rules cannot even be applied until some groupings are apprehended and unitary segments are obtained to apply them to; and the restoration of connectability, when it can be done, may involve not only the fitting of known patterns of behavior (we classify what is happening in the novel as a case of rape), but the tendency to seek for the simplest possible orderings. There are evidently some extremely difficult problems about the interrelationships of rules and propensities that call for study if we are to understand how literary works, or other artworks, are experienced; these problems seem as yet hardly to have been discerned.

Notes

1. *The Philosophical Review,* 71 (1962), 299–300. Cf. his *Art and the Aesthetic* (Ithaca, 1974), p. 178.

2. See my *Aesthetics: Problems in the Philosophy of Criticism* (New York, 1958), pp. 29–46; in that context, I discussed "aesthetic objects," but I would include artworks within that class.

3. For this term, see "Aspects of Orality: A Short Commentary," *New Literary History,* 8 (1976–77), 521–22.

4. See "Competence, Creativity, and Innateness," *The Philosophical Forum,* 1 (1969), 407–37.

5. See Jonathan Culler, *Structuralist Poetics: Structuralism, Linguistics, and the Study of Literature* (Ithaca, 1975), chs. 6–9; Robert L. Brown, Jr., and Martin Steinmann, Jr., "Native Readers of Fiction: A Speech-Act and Genre-Rule Approach to Defining Literature," in Paul Hernadi, ed., *What is Literature?* (Bloomington, 1978).

6. See "The Philosophy of Literature," in George Dickie and Richard J. Sclafani, eds., *Aesthetics: A Critical Anthology* (New York, 1977), 317–33.

7. Culler, p. 115.

8. See also his essay, "Defining Narrative Units," in Roger Fowler, ed., *Style and Structure in Literature: Essays in the New Stylistics* (Ithaca, 1975).

9. *The Arts and Human Development: A Psychological Study of the Artistic Process* (New York, 1973), p. 152.

10. For example, by Barbara Herrnstein Smith, *On the Margins of Discourse: The Relation of Literature to Language* (Chicago, 1978), pp. 174–85.

11. Gardner, p. 162.

12. Ibid., p. 227

13. Some interesting work on "the development of narrative competence in early childhood" has been done by another participant in Harvard's Project Zero, Barbara Leondar: see "Hatching Plots: Genesis of Storymaking," in David Perkins and Barbara Leondar, eds., *The Arts and Cognition* (Baltimore, 1977). She includes impressive examples to show how very early (after the second birthday) some children respond to an invitation to tell a story in ways that show a grasp of fundamental narrative conventions. Cf. Nancy L. Stein, "The Comprehension and Appreciation of Stories: A Developmental Analysis," in Stanley S. Madeja, ed., *The Arts, Cognition, and Basic Skills* (St. Louis, 1978), who discusses a number of "rules used during encoding and retrieval" of narrative.

14. "Visual Art and the Structures of the Mind," in Madeja, ed., op. cit., p. 162.

15. For an account of which, see Ronald H. Forgus, *Perception: The Basic Process in Cognitive Development* (New York, 1966), pp. 112–16.

16. Hochberg, pp. 164, 169.

17. James Hogg, "Some Psychological Theories and the Visual Arts," in Hogg, ed., *Psychology and the Visual Arts: Selected Readings* (Baltimore, 1969), p. 80.

18. *Art and Visual Perception: A Psychology of the Creative Eye* ("The New Version") (Berkeley, 1974), p. 20.

19. Ibid., p. 4.

20. Ibid., p. 410.

21. See ibid., p. 410.

22. Ibid., p. 53.

23. Ibid., pp. 10–12.

24. Ibid., p. 59.

25. Ibid., pp. 14–15.

26. See M. Luckiesh, *Visual Illusions: Their Causes, Characteristics, and Applications* (1922) (New York, 1965), p. 85.

27. Arnheim, p. 67.

28. Ibid., p. 411.

29. Ibid., p. 415.

30. Ibid., p. 17.

31. See *Man the Musician* (Princeton, 1973), ch. 11.

32. *Emotion and Meaning in Music* (Chicago, 1956).

33. Meyer, p. 86, quoting K. Koffka, *Principles of Gestalt Psychology* (New York, 1935). p. 110—where Koffka adds that "good" covers such properties as "regularity, symmetry, simplicity, and others."

34. Ibid., p. 87.

35. Ibid., p. 93.

36. Ibid., p. 128.

37. See *Explaining Music: Essays and Explorations* (Berkeley, 1973).

38. See Tormey in *The Journal of Aesthetics and Art Criticism*, 33 (Spring 1975), 351–54—a review that has been very helpful to me in writing this essay.

39. *Explaining Music*, p. ix.

40. Ibid., p. 15.

41. Ibid., p. 4.

42. Ibid., pp. 6–7.

43. Ibid., p. 17.

44. Ibid., p. 18; cf. p. 117.

45. Ibid., p. 8; on the general principle, see also *Emotion and Meaning*, pp. 130–35.

46. Ibid., pp. 22–23.

47. Ibid., p. 11.

48. See, e.g., "Some Remarks on Value and Greatness in Music" (1959), in M. C. Beardsley and H. M. Schueller, eds., *Aesthetic Inquiry* (Belmont, CA, 1967), pp. 262–63.

49. Ibid., p. 20; cf. p. 233.

50. "Grammatical Simplicity and Relational Richness: The Trio of Mozart's G Minor Symphony," *Critical Inquiry* 2 (1976), 693–761.

51. *Explaining Music*, p. 66.

52. In a letter of November 8, 1974, to Tormey.

53. *Explaining Music*, p. 187.

54. *Poetic Closure: A Study of How Poems End* (Chicago, 1968), p. 29.

55. Ibid., p. 33.

56. Ibid., p. 2.

57. Ibid., p. 34.

58. Ibid., p. 36.

59. Ibid., p. 80.

60. Ibid., p. 116.

61. *The Act of Reading: A Theory of Aesthetic Response* (Baltimore, 1978), p. 21.

62. Ibid., p. 113.

63. Ibid., pp. 94–95.

64. Ibid., p. 120.

65. Ibid., p. 121.

66. Ibid., p. 124; cf. 185–89.

67. Ibid., pp. 182, 186, 195.

68. Ibid., p. 127.

69. Ibid., p. 210.

70. Ibid., p. 211.

71. Ibid., p. 123.

JOSEPH MARGOLIS

11 Prospects for a Science of Aesthetic Perception

There is a strong tendency in those disciplines termed empirical or experimental aesthetics, psychological or psychobiological aesthetics, semiotic or information-theoretic aesthetics to get on with the research. Results, we are told, have been positive or promising. The fitful early starts of investigators like Fechner[1] or more recently perhaps like Birkhoff[2] have now been caught up in a more organized and more systematic undertaking enlisting the most broadly based and sophisticated professional talents. Disputes begin to take on the familiar form of established quarrels. One ponders the statistical significance of correlations now measured, and one speculates about extending the fruitful range of "scientific" aesthetics, whether of the quantified or still largely qualitative or "descriptive" sort. Two recent collections of essays capture the spirit of this relatively new undertaking and, more or less inadvertently, betray its conceptual limitations. One, D. E. Berlyne's *Studies in the New Experimental Aesthetics* (sub-titled *Steps Toward an Objective Psychology of Aesthetic Appreciation*), which appeared in 1974, is more or less exclusively oriented toward the "collative" or information-theoretic studies of art that Berlyne himself—almost as a sort of contemporary Benthamite—had nearly singlehandledly organized, during the middle sixties, within North American professional psychology.[3] The other was published, in England, in 1976. Edited by Don Brothwell and titled more hopefully but less explicitly *Beyond Aesthetics* (subtitled *Investigations into the Nature of Visual Art*),[4] it is decidedly more eclectic—and correspondingly more tentative—about the direction

213

of scientific aesthetics. Generally speaking, the second is oriented rather more to comparative animal studies, cognitive development in children, the psychophysiology of perception, and cross-cultural psychology. But to state the conceptual preferences of these two anthologies thus is already to suggest that there are sensible and straightforward, antecedently fashioned specialties from which honest scientists, trained this way or that, are distributively likely to choose.

Now there is no need to suggest that ethology, physiological, and ecological psychology, gestalt psychology, behaviorism, semiotics, genetic epistemology, psychoanalysis, cross-cultural psychology, and similar disciplines have nothing or little to contribute to our understanding of the perception and appreciation of art. But there lurks a prior conceptual question regarding the specific pertinence and power of such empirical studies, that tends, curiously, to be submerged in the seeming advances of the dominant new forms of scientific aesthetics. By and large, the most serious pretensions rest with information-theoretic and gestalt studies, which as it happens, have been rather self-consciously opposed to one another.[5] Economy suggests two strategic issues: first, there are alternative conceptual strains within both information-theoretic and gestalt investigations that affect the kind of research that each may be said to undertake; secondly, there are conceptual constraints on the very nature of the perception and appreciation of art that affect the relevance of studies from either of those disciplines. By parity of reasoning, findings on these two scores cannot but clarify the possible relevance of other empirical disciplines. Also, the two issues are themselves rather more closely related than may at first appear.

Berlyne and his associates inadvertently offer some particularly explicit clues about the potential misfiring of the new psychological studies. Berlyne has identified a branch of empirical aesthetics that he terms psychobiological aesthetics.[6] It is primarily addressed to the study of human and animal behavior and, in particular, to the empirical testing, by manipulating independent causal factors, of the effect of informational elements on aesthetic perception, aesthetic preferences, and the like. Specifically, it excludes so-called correlational studies, that is, studies of factors that vary naturally (non-manipulatively) in some statistically significant way, as well as so-called

content analysis, that is, the measurement of statistical characteristics of the artifacts of particular groups or historical periods. It is obvious that Berlyne's associates are quite devoted to his own theoretical model.[7] Other authors, also committed to some version of semiotics or information-processing, tend to be rather more speculative, systematic in the classificatory sense only, rather than experimental.[8]

Berlyne's theory offers the following: "1. A work of art is analyzed in information-theoretic terms as an assemblage of elements, each of which can transmit information from four distinct sources." The sources are identified as semantic, expressive, cultural, and syntactic.[9] Berlyne concedes that there may be some "overlap (redundancy)" among the four sorts of information "reaching the work of art"; nevertheless, "to some extent, the four sources emit independent information," hence compete for the limited capacity of the channel linking them with the work and thereby affect differences in style and the like.[10] Two other principles complete the sketch: "2. A work of art is regarded as a collection of symbols in accordance with the conception of signs and symbols developed by the semiotic movement 3. A work of art is regarded as a stimulus pattern whose collative [i.e., information theoretic] properties, and possibly other properties as well, give it a positive intrinsic hedonic value."[11]

This *sounds* sensible. But is it really? Bear in mind that, in canvassing the prospects of the semiotic or information-theoretic approach (also, in due course, the gestalt), we are addressing ourselves to considerations affecting the validity and precision of aesthetic perception and appreciation. What objections can be raised? First of all, Berlyne and his associates formulate experiments for psychological aesthetics in terms solely of "measures derived from information theory," in the sense in which C. E. Shannon has developed information theory. But Shannon's work is entirely concerned with the merely technical transmission of messages regardless of their content—regardless of their meaning or value.[12] It may be conceded that messages significant in some semantic and syntactic sense are, precisely, what are relevantly transmitted; but discriminating such messages does not bear on Shannon's work at all. Secondly, Shannon is concerned with messages (physical events) generated from discrete, independent, and randomly selected sources. There is no reason to

deny that some subset of *physical* events, involved in *some* (as yet unexplained) way with aesthetically relevant messages or materials (adopting the idiom for the sake of the argument) behave in accord with Shannon's constraints. But it is plain that the analysis of aesthetic perception and appreciation cannot possibly be reduced to or derived from information theory in the manner suggested. The culturally informed and independent nature of aesthetic materials is against it. Berlyne seems actually to be aware of this. Yet he persists, apparently in the hope that, in the visual arts or in music, for example, one may "think of a work as an arrangement of elements, each of which has been selected from a particular sample space (alphabet, vocabulary)."[13] Doubtless, interference phenomena—for instance, the masking of rhythms or tonal sequences by others—may render an intended musical form indiscernible; but apart from such minimal considerations, Shannon's model is concerned with quite different issues.[14] It seems clear, therefore, that either Berlyne (and his associates) have reduced aesthetically relevant materials, without argument, to the merely physical or, without theoretical justification, have supposed that such materials will exhibit properties isomorphic with those of the analysis required. The fact remains that the best Berlyne could hope for is that an independent analysis of the information-theoretic features of artworks would be congenial to Shannon's venture; but neither he nor his associates have provided such an analysis or shown that there is any likelihood of (or relevance in) adjusting it to the terms of Shannon's account.

The difficulties are quite straightforward: (i) Berlyne's group has relied on semiotic theories that neither they (nor anyone else) have satisfactorily refined; (ii) they have linked the information-theoretic features of artworks (whatever they may be) to the theory of the technical transmission of discrete messages (construed in physical terms), despite the difficulty of construing aesthetic messages as composed of suitably discrete elements and despite the irrelevance of the technical issue to the initial analysis of such messages; (iii) they have supposed a model of comprehensive communication based on a finite set of elements that combine in some syntactically formulable way to produce complex message units—a model for which there is not the slightest evidence in the domain of the arts; (iv) they have proposed as discrete, specific informational sources that cannot

possibly so function—that is, the semantic, the expressive, the cultural, and the syntactic. Apart from the use of natural languages in the arts and occasional nonverbal symbols, there *is* no viable sense in which the materials of the arts may be construed as exhibiting semantic and syntactic features that compare favorably with the systematic features of true languages; in whatever (more or less) analogical or metaphoric sense the nonverbal arts exhibit semantic and syntactic features, it is hopeless to treat such features as independent of the cultural or the expressive;[15] *and,* most importantly, the identification of such features corresponds to the salient aspects of a relatively unified and interdependent—intentional, purposive, significant, cultural—order of things rather than to the discrete causal sources of particular physical events. In this sense, the enterprise has got it all wrong. We may *factor* our cultural life in order to understand it, but it makes no sense to think of such factors as discrete causal forces that interact in accord with a Humean model. And we must allow, of course, for the historical contingency and transience of the elements of an art style. Brothwell, for one, quite correctly emphasizes the interpenetration of art and its environing culture and the dependence of analyzing its significance on some measure of "internal cultural integrity."[16] Admit that homely truth and there is no possible progress to be made in terms of Berlyne's model. There may be progress, of course, in spite of it.

The difficulty of outflanking the initial limitations of the venture are best seen in one of the more sustained efforts (by Berlyne's associates) to bring the analysis of art history within the required terms of reference. Consider G. C. Cupchik's endeavor. Searching for discrete causal factors, Cupchik identifies "at least four dimensions [that] underlie the perception of artistic style."[17] But in doing so, Cupchik introduces two characteristic distortions: first of all, he conflates *culturally* quite distinct stylistic distinctions; secondly, contrary to the evidence and the terms of their use, he treats the four dimensions as somehow suitably *independent* of one another and of historical time. For example, he holds that "the first dimension contrasts the pronounced use of outline with a more expressive adaptation of surface qualities that connote warm feelings and seem to correspond to Wölfflin's linear-versus-painterly dimension."[18] But Wölfflin's distinction is linked to a quite particular historical range of

paintings and concerns the solution of certain technical problems of representation as much as the factors Cupchik isolates.[19] In this spirit, Picasso's *Three Musicians* is treated as exhibiting the linear rather than the painterly style[20]—which is patently absurd. It is, as a matter of fact, also viewed as among the "brighter and more colorful paintings [of those displayed]" in opposition to paintings said to "emphasize tonal qualities"—for instance, Sisley's *The Road in the Woods* and Seurat's *Sunday Afternoon on the Island of La Grande Jatte;* the Picasso is also viewed as reflecting "the deliberate selection of detail" (along with Van Gogh's *Starry Night* and Cézanne's *The Gulf of Marseilles*) as opposed to those "characterized by a great deal of detail" (paintings by Steen, Fragonard, David, Bouguereau, and Vermeer)—again a rather meaningless contrast; finally, it is viewed as reflecting "the abstract style" (together with a Miró) as opposed to the "representational style."[21] But the whole exercise merely homogenizes and thereby distorts historical and stylistic distinctions, applies particular stylistic distinctions in a procrustean fashion, and *utterly ignores the intentional or cultural nature* of the works compared.

Cupchik maintains quite seriously that "the success of the dimensional approach will depend on the development of an exhaustive list of independent dimensions that can be applied to works of different cultures, historical periods, and media"; and that, in pursuing this objective, "the main virtue of the dimensional approach is that scholars can disregard period labels and explore the stylistic similarities as well as the differences between particular works."[22] But the venture is utterly self-defeating: there can be no grasp of *stylistic similarities* without attention to historically relevant period labels and distinctions that reflect the intentional life of the artistic community. Cupchik claims that "the art-historical treatment" of, say, the linear-versus-painterly dimension "is descriptive and lacks the theoretical and rigorous discrimination between the two styles that would be preferred by an experimental aesthetician"; his instructions to his *S*s, relatively inexperienced psychology undergraduates, are "to decide how stylistically similar or different each of the pairs of paintings [exhibited] were and to disregard specific content"![23] Cupchik then compares the judgments of undergraduates in fine arts courses, that is, the judgments of students *somewhat* more familiar

with historically relevant distinctions. In his zeal to ensure discrete sources of information, Cupchik simply ignores the cultural coherence intended in the judgments rendered—whether highly informed or not; and he takes his results to be scientifically significant *along the culturally indifferent or distorted scales he has indefensibly constructed.* The briefest scan, however, of Wölfflin's famous account confirms, first of all, that Wölfflin viewed the distinction of the linear and the painterly as one of cultural epochs and, secondly, that he held that "the painterly mode cannot be conceived without the earlier [linear]."[24] Cupchik attempts to *detach* Wölfflin's characterizations as discrete elements—intact and universally recognizable—that may appear in the work of any period or any culture, whereas they are no more than appreciative factors whose meaning can be grasped only in the context of the historical styles analyzed— regardless of alien affinities. (The detachment of course is methodologically required—anomalous though it may be—by the initial constraints of information-theoretic aesthetics.) Thus, for example, given Picasso's development of cubism, the witty play with the apparent "outlines" of figures (the allegedly linear feature of *Three Musicians*), that yields systematically ambiguous spatial relations utterly unlike the "linear" sense (as in Durer or Cranach or Holbein) in which "the eye is led along the boundaries and induced to feel along the edges,"[25] confirms at a stroke the impossibility of isolating the intentional, culturally informed features of *any* art style as merely universal, historically indifferent elements that may be variously "combined" in the composition of unrelated cultures. Physical resemblances are entirely inadequate, and irrelevant, and there is no "natural" template of culture on which, demonstrably, all historical societies have simply imposed their transient modifications.

There is, then, no reason to think that there could be an "exhaustive" scheme of "independent" dimensions of aesthetic perception or art styles—it is not even clear what such a proposal actually involves; there is certainly no elementary "alphabet" of all relevant aesthetic discriminations; there is no clear sense in which the culturally significant features of artworks could be sorted in terms of discrete causal or informational inputs; and there is no viable basis on which to argue that the perception and appreciation of art may be reduced to *any* account of the behavior of purely physical forces.[26]

Berlyne and his associates have also failed to take into account at least two further considerations. The first is that all perceptual images, however minimally construed, are ambiguous and may be interpreted in widely divergent ways depending on contextual cues and the interests, learning, and orientation of the perceiving agent.[27] The second is that even persistent phenomenal illusions—which (particularly among gestalt psychologists) are thought to favor perceptual "nativism"—may to some extent be shown to be variably subject to culturally variable interests and experience. For example, the Sander Parallelogram yields predictably different effects in Western and non-Western societies, based (presumably) on a difference in handling geometric space and on the prevalence (in Western societies) of representing three-dimensional objects on flat-two-dimensional surfaces.[28] Cupchik's students cannot then have been altogether culturally innocent; also, one cannot say *what* in their cultural orientation or the context of testing led them (however convergently) to respond to the paintings displayed. Rudolf Arnheim pertinently observes that "the perception of a complex visual pattern may be modified by the presence of a second pattern." Experiments conducted by a student of Arnheim's show that persistent and distorting changes in perceptual responses can be induced by pairing paintings with others of quite different style. For instance,

Rembrandt's painting of the Polish rider on a white horse in front of a backdrop of brown rocks was paired with Jean Dubuffet's *Landscape with Partridge*. In the Dubuffet, a similarly brown and textured mass fills much of the canvas, except for the top area, in which a bird is perched. The similarity of the two large, brown areas gave the background of Rembrandt's painting a new and unsuitable importance. At the same time, this very relation increased the depth between the foreground figure of the horseback rider and the backdrop, which looked too far away in contrast with its counterpart in the Dubuffet, where the textured mass filled the frontal plane flatly. When the Dubuffet was replaced with a large running chicken by Chagall, there was a sudden emphasis on the movement of the trotting horse in the Rembrandt and a corresponding fading out of the backdrop.[29]

It is but a step to conclude that the perception of paintings, even taken singly, must reflect the conventions, experience, interests, and orientation of the viewing agent and his environing culture. How, for

instance, can one judge *what* may be perceived in a Klee if one fails to appreciate Klee's persistent habit of experimenting with certain features of seeing—for instance, with the effects of fatigue on prolonged staring at particular forms or the way the eye may be tricked into moving through a particular scanning sequence? How could one possibly judge the "balance" of James Ensor's grotesques without appreciating the way in which he exploits the remembered balance of post-Renaissance perspectival space and tests it in the extreme? The upshot of course is simply that *if* there is to be a scientific aesthetics, it had better come to terms with the general problems of a science of culture.

About semiotic theory in general, one can only say (with the greatest of charity) that it has yet to take shape. The most ambitious recent efforts to formulate semiotic theory—with some interest in its application to the arts—are recorded in Umberto Eco's *A Theory of Semiotics*.[30] Yet, general semiotic theory remains almost trivial—certainly not much advanced beyond the seminal discoveries of Peirce and Saussure.[31] The heart of Eco's system is pretty well captured by the following sketch:

> If every communication process must be explained as relating to a system of significations, it is necessary to single out the *elementary structure of communication* at the point where communication may be seen in its most elementary terms. Although every pattern of signification is a cultural convention, there is one communicative process in which there seems to be no cultural convention at all, but only . . . the passage of stimuli. This occurs when so-called physical "information" is transmitted between two mechanical devices.[32]

Eco draws attention (fashionably) to the fact that, whatever the *code* by which signification, or culturally significant communication, is effected, messages must be conveyed by some physical medium. This is certainly true. But beyond that, Eco has practically nothing to say about the nature of the "codes" employed in the arts. First of all, he simply retreats to the standard picture of information-processing at the physical level, developed by Shannon.[33] In particular, he says nothing about the ontic or significance relationship between the physical medium of communication and aesthetically relevant (or otherwise culturally relevant) messages thereby conveyed.[34]

Secondly, he assumes, without argument, that the culturally signif-
icant messages conveyed through the arts must be analyzable in a
form congruent with the informational model proposed for the
technical level of successful transmission. But, as we have seen, the
latter notion is concerned only with the probability with which a
physical event can be unambiguously identified—only with fixing its
informational value in *that* respect, regardless of its "possible con-
tent . . . when used as a communicational device."[35] In that sense,
there is no reason for supposing that the "codes" employed in the arts
(apart from whatever holds true of genuine natural languages) need
exhibit *rules* linking "a set of [physical] *signals* ruled by internal
combinatory laws" and "a set of *notions*" about states of affairs (or
behavioral responses) as "a set of possible communicative con-
tents."[36] Instructively, Eco's paradigm is the Morse code. But *what*
are the rules and the determinate communicative content of forms in
music and painting? Here, one is obliged to recall the disastrous
career of Susanne Langer's notion of symbolic forms.[37] Absolutely
nothing has changed since Langer first launched the idea. No doubt,
we can always formulate, retrospectively, the approximate "rules"
(or alternative rulelike schemata) that fit particular works or particu-
lar sets of works *that we have come to appreciate in a certain way*
(Cubist or de Stijl paintings, for instance); but there is no sense in
which they were ever composed in accord with explicit rules or an
initial alphabet or lexicon—either deliberately or "innately" by
means of some "deep" grammar. And there is no sense in which, once
the idiom is imposed, *criteria* are generated by which the putatively
informational elements of a work may be discerned any more effec-
tively than our cultural intuitions would support. Hence, though he
himself notes that "information theory does not explain . . . the
functioning of a code as a correlating rule . . . [provides] neither a
theory of signification nor a theory of communication but only a
theory of the abstract combinational possibilities of an s-code [that
is, a system or structure 'that can also subsist independently of any
sort of significant or communicative purpose,']" Eco treats s-codes as
the model of effective communication (something that "may be
studied by information theory or by various types of generative
grammar"), more or less exhausting the entire range of significant
cultural exchange. So he says: "a code [in the minimal informational

sense] is continuously confused with the s-codes: whether the code has determined the format of the s-codes or vice versa, a code exists because the s-codes exist, and the s-codes exist because a code exists, has existed or has to exist. Signification encompasses the whole of cultural life, even at the lower threshold of semiotics."[38]

But that's just the trouble. *If* the "significance" of artworks cannot normally be formulated in terms suitably congruent with the informational model or with such claims as those Chomsky makes regarding the analysis of natural languages (waiving his innatist pretensions),[39] then the information-theoretic approach is simply doomed to failure. Alternatively put, Eco (and others committed to the informational model) merely *translate* whatever is the sense of artworks—*whatever* may be perceptually discriminated and *however* we succeed—in information-theoretic terms; nowhere does he (or others) provide *criteria* for correctly determining their putative content.[40] This is not to deny that aesthetic perception and appreciation must be informed by representational, expressive, and similar conventions operating within historically variable epochs and culturally divergent traditions. It is only to deny, on the evidence, that such conventions can be effectively reduced to any known semiotic model that supposes a finite set of discrete elements subject to a finite set of formational and transformational rules, linked in determinate ways to explicable messages, common to artist and audience.

In a curious way, the difficulty of such a reduction effectively undermines as well the adequacy of J. J. Gibson's version of the ecology of perceptual information.[41] Gibson's thesis is that "the senses can obtain information about objects in the world without the intervention of an intellectual process—or at least that they do so when they operate as perceptual systems."[42] Perception, then, is not based on sensation, on having sensations, or on interpreting sensations: "there can be sensationless perception, but not informationless perception."[43] But sometimes, as in the visual arts, "visual sensations *obtrude themselves* on the perception of true layout and cause the illusions of seeing partially in perspective. Putting it another way, sometimes we attend to the pictorial projections in the visual field instead of exclusively to the ratios and other invariants in the optic array. The pictorial mode of perception then asserts itself, since pictorial attention interferes with attention to information. The

compromise is not between the raw data and the complete processing of this data, but between two alternative kinds of attention."[44] Roughly, Gibson holds that, for reasons of evolution and survival, species are adjusted so that the ambient perceptual information routinely picked up through the senses is processed in terms of ecological invariants bearing on a creature's adaptation to the objects of the external world.[45] Gibson's basic perceptual model excludes the presence, therefore, of a cognitive agent, is relatively indifferent to cultural influences and historical conventions, and explicitly construes attention to "artificial" optic arrays—representational or nonrepresentational images—as functioning in a fundamentally different way from ecological perception:

> The structure of a natural optic array, including its invariants under transformation, specifies its source in the world by the laws of ecological optics. The structure of an artificial optic array may but need not specify such a source. A wholly invented structure need not specify anything. This last is a case of structure as such. It contains information, but not information *about,* and it affords perception but not perception *of.*[46]

Gibson suggests that the optic array in representational art "yields some of the same structural information as would the optic array from another part of the environment at a distant place or a different time But a non-representative display, one that is not an image, is not any of these things. Its optic array does not copy that of another object."[47] Structural information is already present, for Gibson, in an *external* optic array. It does not in any way require the imposition by the active mind of conceptual order on some given set of "passively" received sensations. Hence, the cognitive agent is fundamentally eliminable in Gibson's system; for the same reason, Gibson departs from the empiricist and sense-datum tradition as well as from the gestalt psychologists.[49] But this means that *all* culturally significant perceptual information must be explained on a basis that Gibson barely mentions, namely, the learning, by cognitive agents, of the contingent, historically variable codes with which—as in painting —information is actually conveyed. It will do no good to insist that *such* structure may be picked up from the optic array itself: discriminating such information requires conscious attention to the culturally informed elements of an artwork; the structure cannot merely

be present in the external optical array itself in the sense (if it were independently defensible) in which Gibson assures us ecological perception works, that is, without the admission of an active cognitive agent.[49] *What* is perceived is the culturally invested import of an optic array that does not otherwise (that is, merely physically) convey it.

In effect, Gibson substitutes optical invariants (in the setting of species survival) for the semiotician's informational codes and attempts, as does the semiotician, to interpret the culturally contingent and historically variable conventions of the arts as *somehow* expressible in terms of certain underlying ecological regularities. Having all but eliminated the cognitive agent, however, the very percipient who must be trained in the shifting, relatively informal practices of the arts (increasingly distanced from the immediate concerns of survival), Gibson provides himself no conceptual basis on which to explain the efficiency of the visual appreciation of painting. How for instance to explain the way in which we "read" classical Chinese or Egyptian representations of space (which diverge from geometric perspective as well as from our own conventions)? Or, the visual fields of Cubist painting (which cannot be construed in terms of a unified physical space at all)?

But there are more formidable difficulties facing Gibson's account. Nelson Goodman cites Gibson's view that "it does not seem reasonable to assert that the use of perspective in paintings is merely a convention, to be used or discarded by the painter as he chooses, . . . When the artist transcribes what he sees upon a two-dimensional surface, he uses perspective geometry, of necessity."[50] Goodman has no difficulty, therefore, in concluding, against Gibson, that "Pictures in perspective, like any others, have to be read; and the ability to read has to be acquired. The eye accustomed solely to Oriental painting does not immediately understand a picture in perspective. Yet with practice one can accommodate smoothly to distorting spectacles and to pictures drawn in warped or even reversed perspective."[51] Goodman is right of course and right also in drawing attention to the ambiguity of interpreting *any* optic array, the impossibility of fixing the correct interpretation from a fixed peephole, and the like.[52]

But the fact is that, even in so-called naturalistic representation,

one does not adhere to geometric perspective, the geometric perspective of actual light. R. L. Gregory usefully notes that

> When an artist employs geometrical perspective he does not draw what he sees—he represents his retinal image. As we know, these are very different, for what is seen is effected by constancy. A photograph represents the retinal image, not how the scene appears. By comparing a drawing with a photograph taken from exactly the same position, we could determine just how far the artist adopts perspective and how far he draws the world as he sees it after his retinal images are scaled by his constancy. In general, distant objects look too small in a photograph The camera gives true geometrical perspective, but because we do not see the world as it is projected on the retina, or a camera, the photograph looks wrong.[53]

The import of these remarks needs to be put with care. Gibson's theory is flawed for at least two distinct reasons: (i) he has no way to account for the learning of perceptual codes in the sense, say, of styles of painting or the rendering of perspective that *depart* from the way in which we normally perceive objects in the external world; and (ii) his favored theory does not account for the ineliminable cognitive element in learning how in the normal way to perceive objects in the external world. (ii) shows that the phenomenon of perceptual constancy (and even of illusions due to misplaced constancy) is itself cognitively controlled: as Gregory neatly observes, for a "figure to represent something unambiguously, we must know what the object really is—what its shape is—or how it lies in space."[54] Gibson, on the other hand, is quite explicit that the perception of constancy does not depend on "conception and belief," is achieved "without the intervention of an intellectual process."[55] (i) shows that the perception of reversed perspective in Chinese painting for instance or of mixed perspectives within a single painting must remain a theoretical mystery within Gibson's system.[56] Goodman rightly stresses the cognitive element, learning "to read" perspective even where the stimulus conditions involved correspond to those obtaining in some natural setting.[57] He also stresses the even more important point that "the rules of pictorial perspective [do not] follow from the laws of optics In diametric contradiction to what Gibson says, the artist who wants to produce a spatial representation that the present-day Western eye will accept as faithful must defy the 'laws of geometry.'"[58] Here, Goodman rightly presses the "conventionality of perspective."[59]

Where Goodman goes wrong, however, is in failing, within the admitted conventionality of representing perspective on a fixed two-dimensional surface, to concede that there *are* natural resemblances—that is, resemblances naturally favored by humans from certain perceptual stations, that painters *may* exploit, as in the development of naturalistic perspective. Here, Goodman wrongly tends to lump E. H. Gombrich's view with Gibson's.[60] Gombrich was intent on rejecting Ruskin's doctrine of the "innocent eye": perception depends on conceptual schemata; hence there is room for perspectival relativism. Gombrich always stresses the role of the cognizing agent. On the other hand, contrary to Goodman, Gombrich *is* committed (and rightly committed) to the possibility of "representational accuracy." He clarifies his point (inevitably directed against Goodman, who remains unidentified) in the Preface to the second edition of *Art and Illusion:*

> . . . I have tried to show . . . that the undeniable subjectivity of vision does not preclude objective standards of representational accuracy. A dummy can be indistinguishable from its prototype, and a view through a peephole at a picture may look the same as the view at a solid object quite regardless of who does the viewing or whether he admires or despises the trick.
> What may have caused this misunderstanding . . . is my repeated assertion that no artist can copy what he sees. There is no contradiction here, for the successful trompe l'oeil no less than the striking caricature are not only the result of careful looking but also the fruit of experimentation with pictorial effects.[61]

For reasons connected with his extreme nominalism, Goodman resists countenancing any biologically favored disposition on the part of humans to see certain patterns as more nearly similar than others. But he cannot defend an unqualified conventionalism, and a *biologically* grounded disposition is compatible with a moderate conventionalism.[62] All that needs to be admitted is that the ecological conditions of human survival tend to favor certain perceptual stations and certain perceived similarities without precluding cultural relativism. This seems to be all that Gombrich actually supports: Goodman's extreme conventionalism does not even provide for the ability to *perceive* hitherto uncollected similarities, *on the basis of whatever convention be adopted.* The upshot, for our present purpose, is quite straightforward: the science of aesthetic perception

must chiefly accommodate the conventionality of learned modes of representation and the like; but in doing so, there is no conceptual reason why, among such modes, certain ones may not be ecologically favored by the conditions of species survival (pictorial realism). Furthermore, it is difficult to see why we should deny that the effectiveness of *any* perceptual convention will require *some* biologically ingrained disposition toward favored similarities. Perception *cannot* be wholly conventional, though it be subject to the changing schemata of historical experience.[63]

The extreme opposite both to Gibson's theory of ecological perception and to Goodman's theory of the conventionality of perceptual resemblance is provided by the Gestalt theorists. To whatever extent he is able, Gibson eliminates the active cognitive agent from the perceptual field: *what* is perceived is, for Gibson, already suitably structured—*externally* but still congenially to the action of the moving eye of different species; and *what* is perceived is, for Goodman, subject to the learned schemata by which whatever is somehow given is systematically classified and classifiable—there is no sense in which the world is (cognitively) given or in which our mode of representation may be independently shown to resemble the perceivable world. Gibson, fails, however, to account for perceptions in which whatever structure, whatever informational pickup, may be discriminated makes sense only in terms of a conscious, culturally informed agent scanning the optic array *for* the marks of such (culturally accessible) structure. And Goodman fails to account for the fact that there is *some* biological, nonconventional disposition underlying all cultural conventions, in virtue of which they actually succeed when applied to new cases. The gestaltists rightly insist on the activity of the cognizing mind dynamically engaged with a structured world; they err in supposing that perceived structure is explicable solely or fundamentally in terms of physiologically, that is, nonculturally informed dispositions to favor certain structures over others.

Without a doubt, Rudolf Arnheim is the principal proponent of the gestaltist theory of aesthetic perception.[64] Certainly, Arnheim is compelling in drawing together evidence that human percipients (whether of artworks or not) are disposed to favor certain organizational forms (gestalten) rather than others on grounds that are more

or less indifferent to cultural changes or divergence. This is pretty well what is conveyed by the gestaltists' so-called "basic law of visual perception: *Any stimulus pattern tends to be seen in such a way that the resulting structure is as simple as the given conditions permit.*"[65] This putative law, however, is noticeably vague and difficult to interpret in a determinate way for all relevant cases of aesthetic (or even ordinary) perception; and to allow culturally favored or culturally determined *gestalten* (if that makes sense) undermines the fundamentally neurophysiological thrust of the original work of the gestalt psychologists—to which, of course, Arnheim means to adhere. The example (already mentioned) of the Sander parallelogram, therefore, raises essential difficulties for the adequacy—though not for the relevance—of the gestaltist position. This is not to say, of course, that gestalt psychology is committed to mere nativism, though there *is* a strong nativistic thread in the entire theory. At the very least, the work of the gestalt psychologists identifies the kind of experimental basis on which Gombrich's view tends to win over Goodman's—in spite of the fact that Gombrich has not entirely managed to reconcile his thesis about the cultural relativity of representational schemata and the "objectivity" of pictorial naturalism. But, as we have seen, these views are entirely compatible. Certainly, the repeated demonstration by gestalt psychology of the Phi phenomenon (that is, of perceived movement and even of causality among series of discrete, unmoving elements), alternating figure/ground illusions with unchanging stimuli, the difficulty of accounting for perceived forms in terms of discrete sensory elements, the ubiquity of gestalt phenomena across cultures and even across species, the strong disposition for closure in perceptual arrays, and the like confirm the permanence of the gestalt contribution.[66] These sorts of considerations strongly favor an ineliminable biological ingredient in the theory of perception that an extreme conventionalist could not possibly accommodate, though they by no means confirm the details of gestalt psychology itself.

For his part, Arnheim is entirely explicit about the structure of the perceived world:

. . . the life of a percept—its expression and meaning—derives entirely from the activity of the perceptual forces. Any line drawn on a sheet of

paper, the simplest form modeled from a piece of clay, is like a stone thrown into a pond. It upsets repose, it mobilizes space. Seeing is the perception of action.[67]

What he means by this is that perception cannot be understood either in terms of the passive pickup of externally structured information (*à la* Gibson), however active in the ecological sense a given organism may be, or in terms of the conventional imposition of an interpretive schema (*à la* Goodman) on a world indifferent in the relevant respect to alternative such schemata. Perception is to be understood rather in terms of "perceptual forces," which obtain on the occasion of perceptual interaction. Such forces are "assumed to be real in both realms of existence—that is, as both psychological and physical forces": there are, Arnheim contends, actual perceptual "pulls" having an actual direction and intensity, meeting thereby "the conditions established by physicists for physical forces." And these forces are physical as well, in the sense in which "we make the reasonable assumption that every aspect of a visual experience has its physiological counterpart in the nervous system."[68] Partly, this is metaphor. But partly, it is at least vestigially informed by Wolfgang Köhler's original thesis of an isomorphism between perceptual gestalten and neurophysiological patterns.[69] The following remark of Arnheim's is perhaps the clearest indication of the gestalt position *vis-à-vis* aesthetic perception:

> If it could be shown in the laboratory that a well-organized line figure imposes itself upon all observers as basically the same shape, regardless of the associations and fantasies it stirs up in some of them because of their cultural background and individual disposition, one could expect the same, at least in principle, with respect to people looking at works of art. This trust in the objective validity of the artistic statement supplied a badly needed antidote to the nightmare of unbounded subjectivism and relativism.[70]

Arnheim actually presses the thesis so strenuously that he maintains that the experimental evidence obliges us to conclude that "perceiving consists in the formation of 'perceptual concepts' "—where the expression "perceptual concepts" is *not* "intended to suggest that perceiving is an intellectual operation." On the contrary, "the processes in question must be thought of as occurring within the visual

sector of the nervous system" and signifies "a striking similarity between the elementary activities of the senses and the higher ones of thinking or reasoning." In effect, there appear to be perceptual universals that are activated in the nervous system on the occasion of perceptual stimulation by a particular stimulus: thus "stimulus configuration enters the perceptual process only in the sense that it awakens in the brain a specific pattern of general sensory categories."[71] But this leads gestalt theory in the direction of Platonism.[72]

The irony obtains, therefore, that, in Arnheim's hands, although the cognizing agent is—against Gibson—restored to the center of the perceptual situation, he is reduced to little more (at least as far as critical gestaltist work is concerned) to a neurophysiological system with a phenomenological face: wherever configurational forms arise, we are to suppose that the *brain* somehow is activated to impose order somehow required by the perceptual forces released within the stimulus context. Learning is not actually precluded; hence the gestalt position is not merely nativist. But Arnheim fails to grasp the full implications of the general Platonist line, namely, how to explain the comprehension (at any cognitive level—but particularly of that regarding a changing art world) of forms that are *not* part of the original conceptual repertory of a given organism—the modern version of the problem of platonic recollection. As Arnheim holds: "Strictly speaking, no percept ever refers to a unique, individual shape but rather to the kind of pattern of which the percept consists." "Identification . . . presupposes an identifiable pattern. One cannot recognize something as a thing known, expected, or to be reacted to unless it is discriminated by its sharply defined character."[73] All such patterns, apparently, are antecedently stored *or* awakened in the brain. Arnheim remarks: "it does not seem to me to make much difference how much of this complex feat of [cognitive] organization can be performed spontaneously and early in life on the basis of innate mechanisms. What matters is that the cognitive process which produces the so-called constancies is of a very high order of intelligence since it must evaluate any particular entity in relation to an intricate context, and that this feat is performed as an integral part of ongoing perception."[74] But he has clearly missed the essential point: he has failed to enter the argument between, say, Gombrich and Goodman. The problem remains: (i) whether a Platonism, however

modified, can accommodate the range of culturally informed perception; and (ii) how, if genuine learning be admitted, including the learning of historically contingent concepts not reducible to or analyzable into an original pool of innate concepts, gestalt psychology is to be supplemented. Arnheim utterly fails to address either issue.

The bearing of these lacunae on his aesthetics can be seen at a glance by considering one of Arnheim's own illustrations. He mentions a fifteenth-century painting representing St. Michael weighing souls: "one frail little nude," he says, "outweighs four big devils plus two millstones" in the scales that St. Michael holds. But since prayer alone "provides no visual pull," the painter adds a palpable dark patch in the folds of the angel's robe below the pale nude in order to create the weight to offset the dark forms of the devils.[75] True enough—and amusing. But the fact remains that the *need* for the visual balancing arises only in the context of understanding the symbolic import of the representation: there *is* no operative perceptual pull at the purely visual level *below* the level of thinking or reasoning. There is no possible application of a purely perceptual law here—in the sense Arnheim and the earlier gestalists intend—in which the visual field "requires" the patch. The patch is *not* required in the sense in which Arnheim holds that perceptual forces are "real": it is required in order to strengthen the intended *sense* of the whole painting. The thesis would have been visually weakened if the visual counterpart were lacking, but there would have been no relevant considerations at all if the thesis were not granted. Also, *if* the artist had wanted to, he could have represented St. Michael's weighing more or less in the spirit in which for instance Ensor paints Christ entering the city of Brussels, that is, "in triumph" but not only unnoticed by the enormous crowd of faces (in the painting) but also by ourselves, the viewers of the scene: one would then have changed the thesis of the painting and with it the putative configuration "required." But it is difficult to see how such considerations of form could possibly strengthen the gestaltist presumptions.

It is instructive to remember here as well that Julian Hochberg had attempted to bring the conception of "figural 'goodness,' " in effect, the gestalt conception of simplicity (already noted in Arnheim's account), within the control of the quantitative measures of information theory. His hypothesis is that, "other things being equal, the

probabilities of occurrence of alternative perceptual responses to a given stimulus (i.e., their 'goodness') are inversely proportional to the amount of information required to define such alternatives differentially; i.e., *the less the amount of information needed to define a given organization as compared to the other alternatives, the more likely that the figure will be so perceived.*[76] Hochberg does attempt to give empirical measures of information and of "goodness," but he actually offers no conceptual basis for counting informational ingredients. "Goodness" is simply measured by "the response frequency or the relative span of time devoted by S to each of the possible perceptual responses which may be elicited by the same stimulus." But when he speaks of information, Hochberg says that he specifically means "the number of different items we must be given, in order to specify or reproduce a given pattern or 'figure,' along some one or more dimensions which may be abstracted from that pattern, such as the number of different angles, number of different line segments of unequal length, etc."[77]

Two things, then, are clear at once. First, Hochberg obviously (and rightly) avoids the information-theoretic model appropriate to Shannon's work; so it is not clear *what* we are to understand by quantified measures here. Secondly, Hochberg provides only intuitive examples of measuring information for cases where gestalt-like preferences are already reasonably clear; he does not provide anything like *criteria* for measuring quantities of information in virtue of which "goodness" may be independently appraised in a wide range of cases, particularly those relevant to the perception of artworks. For example, it is quite impossible to see how the St. Michael painting could be analyzed in terms (a) of information of the relevantly restricted (nonquestionbegging) sort and (b) of quantitative measures of such information. Now, it may well be that, once a pertinent, culturally informed analysis of the "goodness" of a painting's organization is grasped, the details may be translated into the quantitative idiom Hochberg favors; but that is a far cry from the provision of criteria of figural goodness.

For instance, Arnheim spends a bit of time discussing Cézanne's painting of his wife (*Madame Cézanne in a Yellow Chair*). "What soon strikes the observer," he says, "is the combination of external tranquillity and strong potential activity. The reposing figure is

charged with energy, which presses in the direction of her glance."[78] But the account raises some serious questions. First of all, there appears to be absolutely no way in which to apply Hochberg's intended scales to the Cézanne painting or to Arnheim's analysis of its pictorial balance. Arnheim makes two pertinent observations here: (a) "the subject matter of the picture is an integral part of its structural conception"; and (b) "each relation [isolated within the painting] is unbalanced in itself; together they all balance one another in the structure of the whole work."[79] There is no clear sense in which the kinds of elements Arnheim isolates *could* be reduced to those that Hochberg attempts to manage quantitatively; and in his admission about the imbalances of isolated parts of the painting and of the putative balance of "the whole work," it very much looks as if Arnheim is admitting the impossibility or irrelevance of measuring figural goodness in additive or quantitative terms. It is simply the good gestalt of the whole work as such that gives meaning and point to the imbalances of the parts. Secondly, Arnheim's acknowledgment of the pertinence of the subject matter to the balance of the work is, effectively, an acknowledgment of elements that *cannot* be formulated in purely visual terms (elements that require representational, symbolic, stylistic, expressive considerations or the like); hence, it obliges us to note the equivocal way in which gestalt psychologists actually speak of good form. For, if nothing else is true, we cannot fail to admit that, with changes in those culturally variable elements or in their appreciation, the putative perceptual "pull" of the forces phenomenally noted are bound to be relevantly variable themselves. Along these lines, it is by no means clear that Cézanne's painting *is* or could be universally recognized as possessing the kind of strength Arnheim adduces. One cannot help feeling (perhaps sympathetically in our own day) that Arnheim has simply translated his taste in paintings into the gestalt idiom. It is in fact very difficult to see how that can be avoided. Regarding musical forms, Moles pertinently observes:

Research on exotic music (Curt Sachs, Von Horbostel) destroys the fundamental principle of universal scales, retaining only the term 'scale' as a frame of reference in a sociocultural system; the incredible variety of existing scales makes it unlikely that any particular one is fundamentally

superior. Works of historical musicology cast suspicion on rules as fundamental as those relating to major and minor. The expansion of neoprimitive music in the modern world reveals that it is not impossible to find elements of musical convention (for example, rhythms) other than those taught classically. The dissolution of chords in dodecaphonic music, as well as their continual variation, and the sudden expansion of experimental music due to technological possibilities are experimental proofs of the weakness of the foundations of 'musical theory.' The evolution of music seems to be a methodical violation of previously accepted rules.[80]

The parallel with the visual arts is obvious, though, as already noted, we need not be driven to an extreme conventionalism.

Finally, to round out our account, we may, rather briefly, consider Jean Piaget's position on perception *vis-à-vis* the gestaltists and the empiricists. The following may well be the most succinct statement of the relevant differences as Piaget sees them:

> [We must] oppose the geneticism without structure of empiricism and the structuralism without genesis of Gestalt phenomenology with a genetic structuralism in which each structure is the product of a genesis and each genesis merely the passage from a less evolved structure to a more complex one. It is in this context of an active structuring that the exchanges between subject and object take place.[81]

In effect, Piaget's view is that "perception is not . . . the source of knowledge, because knowledge derives from the operative schemes of action as a whole."[82] So Piaget provides an ampler setting for the discrimination of forms that do the gestaltists. But his own structuralist tendencies similarly fail to accommodate the contingencies of cultural development and discrimination. In effect, Piaget shares with Gibson an emphasis on the ecology of perception, on the impossibility of accounting for perceptual discrimination except in terms of the survival-linked activities of the members of a given species. He shares with the gestaltists, against Gibson, an emphasis on the active contribution of the cognizing subject. Against the gestaltists themselves, he emphasizes the phased development of the sensory-motor activity of the cognizing subject as well as the distinctly limited structuring disposition of perception as opposed to the developing phases of the structuring operations of intelligence.[83] All three oppose explicitly or in effect the atomism and associationism of

the empiricists and the strong conventionalism of a theorist like Goodman. Curiously, however, it is only theorists like Gombrich and Goodman who seek to accommodate in a full-fledged way the culturally-informed structure of the perceptual order of things—notably, artworks: Gombrich, with concessions both to cultural relativism and to an underlying biological disposition toward certain realistic forms; Goodman, by way of a much more radical conventionalism, in fact, a nominalism that countenances no naturally discriminable structures.

But concessions to culturally informed structures, to what *cannot be perceived* except in terms of contingent cultural learning, inevitably—however much we temper our conclusions in terms of nativism, Platonism, neurophysiologically induced gestalten, ecologically structured information, genetically serial structures of intelligence, or biological dispositions of other related sorts—commits us to some form of cultural relativism, conventionalism, historically groomed perception and intelligence, the complexities of linguistic influence and of other intensional distinctions. Thus committed, we find ourselves faced with the prospect that the perception of art, human perception in general, cannot be satisfactorily studied in the way in which the physical or at least the non-cultural disciplines can be pursued. Hence, to support a science of aesthetic perception is, on the evidence, to concede that the model of the required discipline cannot be found in any familiar reductive undertaking—informational, ecological, neurophysiological, behavioral, or structuralist. It cannot be found except in the company of a general science of human culture itself—the admission of which, we may suppose, requires a fundamental revision of the very paradigms of science.

Notes

1. G. T. Fechner, *Vorschule der Äesthetik* (Leipzig, 1876).
2. G. D. Birkhoff, *Aesthetic Measure* (Cambridge, Mass., 1933).
3. (Washington, 1974).
4. (London, 1976).
5. Cf. Rudolf Arnheim, "Gestalt and Art," *Journal of Aesthetics and Art Criticism*, II (1943), 71–75; and J. B. Crozier, "Verbal and Exploratory Responses to Sound Sequences Varying in Uncertainty Level," in Berlyne, op. cit.

6. D. E. Berlyne, *Aesthetic and Psychobiology* (New York, 1971).
7. Cf. *Studies in the New Experimental Aesthetics.*
8. Cf. Abraham Moles, *Information Theory and Esthetic Perception,* trans. Joel E. Cohen (Urbana, 1966); Charles Morris, "Esthetics and the Theory of Signs," *Journal of Unified Science,* VIII (1939), 131–50; Umberto Eco, *A Theory of Semiotics* (Bloomington, 1976).
9. D. E. Berlyne, "The New Experimental Aesthetics, in *Studies in the New Experimental Aesthetics,* p. 6.
10. Loc. cit.
11. Ibid., p. 8.
12. C. E. Shannon and W. Weaver, *Mathematical Theory of Communication* (Urbana, 1949).
13. D. E. Berlyne, "Concluding Observations," op. cit., pp. 305, 307.
14. Cf. Moles, op. cit., ch. 4.
15. Joseph Margolis, "Art as Language," *The Monist,* LVIII (1974), 175–86; and *Art and Philosophy* (Atlantic Highlands, 1980).
16. Don Brothwell, "Visual Art, Evolution and Environment," in Brothwell, op. cit., p. 43.
17. G. C. Cupchik, "An Experimental Investigation of Perceptual and Stylistic Dimensions of Paintings Suggested by Art History," in Berlyne, op. cit., p. 256.
18. Loc. cit.
19. Cf. Heinrich Wolfflin, *Principles of Art History,* trans. M. D. Hottinger (London, 1929).
20. Op cit., p. 249.
21. Loc. cit.
22. Op. cit., pp. 235–36.
23. Op cit., pp. 237, 246.
24. Wölfflin, op cit., p. 18.
25. Loc. cit.
26. Cf. Joseph Margolis, *Persons and Minds* (Dordrecht, 1978); *Art and Philosophy.*
27. Cf. R. L. Gregory, *Eye and Brain; The Psychology of Seeing* (New York, 1966).
28. Cf. Marshall H. Segall, "Visual Art: Some Perspectives from Cross-Cultural Psychology," in Brothwell, op. cit., pp. 108–11; also Marshall H. Segall *et al., The Influence of Culture on Visual Perception* (Indianapolis, 1966).
29. Rudolf Arnheim, *Visual Thinking* (London, 1969), p. 61. Cf. D. E. Berlyne *et al.,* "A Cross-Cultural Study of Exploratory and Verbal Responses to Visual Patterns Varying in Complexity, in Berlyne loc. cit.
30. Bloomington, 1976.
31. *Collected Papers of Charles Sanders Peirce,* (eds.) Charles Hartshorne and Paul Weiss (Harvard University Press, 1931–1958); Ferdinand de Saussure. *Cours de Linguistique Générale* (Paris, 1916).

32. Op. cit., p. 32.

33. Ibid., pp. 42–44.

34. My own proposal here concerns the *sui generis* relationship of *embodiment*, developed in *Persons and Minds* and *Art and Philosophy*.

35. Eco, op. cit., p. 42.

36. Ibid., pp. 36–38.

37. Cf. Susanne K. Langer, *Philosophy in a New Key* (Cambridge, Mass., 1942); Ernest Nagel, Review of Langer, *Philosophy in a New Key*, *Journal of Philosophy*, XL (1943), 325–26; and Susanne K. Langer, "On a New Definition of 'Symbol,' " *Philosophical Sketches* (Baltimore, 1962).

38. Eco, op. cit., pp. 38, 40, 46.

39. Noam Chomsky, *Language and Mind*, 2nd ed. enl. (New York, 1972). Cf. Margolis, *Persons and Minds*, ch. 7; and Ulrich Neisser, *Cognitive Psychology* (Englewood Cliffs, 1967).

40. Cf. Moles, loc. cit.

41. J. J. Gibson, *The Senses Considered as Perceptual Systems* (Boston, 1966).

42. Ibid., p. 2.

43. Loc. cit.

44. Ibid., pp. 306–07.

45. Ibid., chs. 12–13.

46. Ibid., p. 225.

47. Loc. cit.

48. Ibid., ch. 13.

49. Cf. Neisser, *loc. cit.*

50. J. J. Gibson, "Pictures, Perspective, and Perception," *Daedalus* (Winter, 1960), 227: cited in Nelson Goodman, *Languages of Art* (Indianapolis, 1968), p. 11.

51. Goodman, op. cit., pp. 14–15.

52. Ibid., pp. 11–13.

53. R. L. Gregory, op. cit., p. 175.

54. Ibid., p. 169.

55. Gibson, *The Senses Considered as Perceptual Systems*, pp. 2, 284.

56. Cf. Goodman, op. cit., p. 15, n15; also, Leonid Ouspensky and Vladimir Lossky, *The Meaning of Icons* (Boston, 1952), p. 42, nl (cited by Goodman).

57. Goodman, op. cit., p. 14.

58. Ibid., p. 16.

59. Ibid., p. 10.

60. Goodman, p. 10. Cf. E. H. Gombrich, *Art and Illusion* (New York, 1960); and Nelson Goodman, review of Gombrich, *Art and Illusion*, *Journal of Philosophy*, LVII (1960), 595–99.

61. (New York, 1961), pp. xii–xiii.

62. Cf. Joseph Margolis, "The Problem of Similarity: Realism and Nominalism," *The Monist*, forthcoming; also, W. V. Quine, "Natural Kinds,"

Ontological Relativity and Other Essays (New York, 1969), p. 123; and Patrick Maynard, "Depiction, Vision, and Convention," *American Philosophical Quarterly,* IX (1972), 243–50.

63. Cf. W. V. Quine, loc. cit.

64. Rudolf Arnheim, *Art and Visual Perception* (The New Version) (Berkeley, 1974).

65. Ibid., p. 53.

66. Cf. Max Wertheimer, "Principles of Perceptual Organization," trans. Michael Wertheimer, reprinted in David C. Beardslee and Michael Wertheimer (eds.), *Readings in Perception* (Princeton, 1958); A. Michotte, "Causality and Activity," trans. Michael Wertheimer, reprinted in Beardslee and Wertheimer, loc. cit.; Julian E. Hochberg, "Effects of the Gestalt Revolution: The Cornell Symposium on Perception," *Psychological Review,* LXIV (1957), 73–84; Rudolf Arnheim, *Visual Thinking.*

67. Ibid., p. 16.

68. Ibid., pp. 16–17.

69. Wolfgang Köhler, *Gestalt Psychology* (New York, 1947), ch. 5.

70. *Art and Visual Perception,* p. 6.

71. *Ibid.,* pp. 45–46; cf. also, *Visual Thinking.*

72. Jerry A. Fodor, *The Language of Thought* (New York, 1975); and Margolis, *Persons and Minds,* ch. 8.

73. *Visual Thinking,* pp. 28–29.

74. Ibid., p. 40.

75. *Art and Visual Perception,* p. 20.

76. Julian E. Hochberg and Edward McAlister, *Journal of Experimental Psychology,* XLVI (1953), 361–64.

77. Loc. cit.

78. *Art and Visual Perception,* pp. 37–41.

79. Ibid., p. 41.

80. Moles, op. cit., pp. 104–05.

81. Jean Piaget, *The Mechanisms of Perception,* trans. G. N. Seagrim (New York, 1969), p. 364.

82. Ibid., p. 359.

83. Ibid., pp. xxv–xxvi.

Index